Caspar David Friedrich
1774-1840

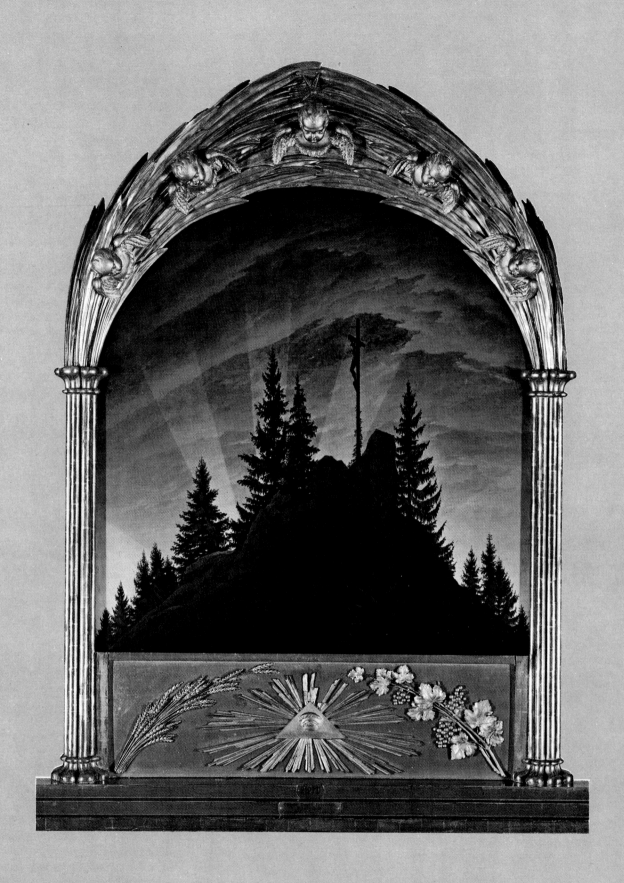

Caspar David Friedrich
1774-1840
Romantic Landscape Painting in Dresden

WILLIAM VAUGHAN
HELMUT BÖRSCH-SUPAN
HANS JOACHIM NEIDHARDT

THE TATE GALLERY 1972

Published by order of the Trustees 1972
for the Exhibition of 6 September – 15 October

The Tate Gallery acknowledges with gratitude the helpful provision of
Ektachromes for this book from the following museums:

Nationalgalerie, Berlin (West): Cat. 67 and 77 on pages 31 and 32.
Gemäldegalerie, Dresden GDR: Cat. 31, 33 and 100 on pages 2 (frontis-
 piece), 11 and 57. (Photographer: Gerhard Reinhold, Leipzig-Mölkau.)
Landesmuseum, Hanover FGR: Cat. 60 on page 22.
Kunsthalle, Hamburg FGR: Cat. 111 on page 42.
Museum der Bildenden Künste, Leipzig GDR: Cat. 102 on cover and
 page 41. (Photographer: Gerhard Reinhold, Leipzig-Mölkau.)
Nasjonalgalleriet, Oslo, Norway: Cat. 49 on page 41.
Staatlicher Schlösser und Gärten, Potsdam-Sanssouci GDR: Cat. 42 on
 page 12.

The German texts have been translated by the following:
'Ernst Ferdinand Oehme and Casper David Friedrich' pp. 45–9: Graham
 Davies.
Catalogue and Bibliography pp. 51–101: Alexander Potts.
Documents and Reminiscences pp. 102–109: George Katkov, Elisabeth
 Katkov, William Vaughan.

Cover
The Stages of Life 1835 (detail) (No. 102)
Oil on canvas, 72·5 × 94 cm.

Frontispiece
The Cross in the Mountains (The 'Tetschen Altar') 1807-8 (No. 33)
Oil on canvas, 115 × 110·5 cm.

ISBN 0 900874 35 X Cloth
 0 900874 36 8 Paper
Copyright © 1972 The Tate Gallery
Second Impression 1972
Designed and published by the Tate Gallery
Publications Department, Millbank, London SW1P 4RG,
and printed in Great Britain by
Balding & Mansell Ltd., Wisbech, Cambs.

Contents

List of Plates

Foreword

Caspar David Friedrich, the greatest German painter of the Romantic Era, is fast becoming a legend in this country. Ever since fourteen of his paintings were shown at the Council of Europe exhibition 'The Romantic Movement', at the Tate in 1959, he has been attracting increasing attention, and the frequent reproduction of his works in English publications has made him widely known as the creator of some of the most penetrating visualizations of the last two centuries. In view of this interest, it is particularly fitting that the Tate should now hold an exhibition that will for the first time provide a comprehensive account of this great artist's achievement. To accomplish this we have brought together not only major oil paintings from all stages of his career, but also examples of his work as a sepia painter and draughtsman, as well as a fascinating selection of paintings by his followers in Dresden.

Owing to many tragic circumstances, Friedrich's works are now unusually scarce. We therefore feel especially grateful to all those public institutions and private collectors listed at the end of this catalogue whose generosity has enabled us to assemble the largest exhibition of this artist's work ever to be held. Her Majesty Queen Margrethe II, Queen of Denmark has most graciously made available for us one of the rare examples of Friedrich's little-known sepias from his last years. With the exception of the Visitors of the Ashmolean Museum, Oxford, the only owners of works by Friedrich in this country, all the loans have come from abroad, extending through Austria, Czechoslovakia, Denmark, the German Democratic Republic, the German Federal Republic, Norway, and Switzerland. Without the unstinting support of the Gemäldegalerie Dresden and the Nationalgalerie Berlin (West), both of whom have lent us the finest examples from their unequalled collections of paintings by Friedrich, this exhibition would not have been possible. Amongst the many other lenders we would also like to record our particular gratitude to Dr Georg Schäfer; the Nasjonalgalleriet, Oslo; the Wallraf-Richartz Museum, Cologne; the Niedersachsisches Landesmuseum, Hanover; the Kunsthalle, Hamburg; and the Museum der Bildenden Künste, Leipzig. The Ministry of Culture of the German Democratic Republic have been especially helpful in assisting us with the invaluable loans made by so many museums in their country. Apart from the museums in Dresden and Leipzig already mentioned, those concerned are: Staatliche Museen, Berlin; Museen der Stadt, Karl-Marx-Stadt; Staatliche Schlösser und Gärten, Potsdam-Sanssouci; Staatliche Museen Heidecksburg, Rudolstadt; Staatliches Museum, Schwerin; and Staatliche Kunstsammlungen, Weimar.

The selection of works for the exhibition has been made by William Vaughan, who was an Assistant Keeper in this gallery until recently when he accepted a

University Lectureship at University College, London. He has also edited the catalogue and written the introduction. The distinguished Friedrich scholar, Dr Helmut Börsch-Supan of the Verwaltung der Staatlichen Schlosser und Gärten, Berlin, has provided catalogue entries based on his shortly to be published oeuvre catalogue. He has also given invaluable assistance and advice at all stages of the exhibition, particularly in tracing many little-known works. Dr Joachim Neidhardt of the Gemäldegalerie, Dresden, has contributed an article on Ernst Ferdinand Oehme, one of Friedrich's most intriguing followers. The architect, Christopher Dean of Castle Park Dean Hook, designed the installation for the exhibition, solving the spatial problems posed by it with great ingenuity.

The translators of the German sections of the catalogue are listed on page 4. We would also like to thank Dr and Mrs George Katkov, Alexander Potts, Dr W. Bach, and Peter J. Gilbert for their help in preparing the final arrangement of the catalogue. In the initial stages of this exhibition Miss Lisa Duncan, who was then a voluntary research assistant at the Tate, provided much valuable assistance in assembling information about Friedrich's work.

SIR NORMAN REID *Director*

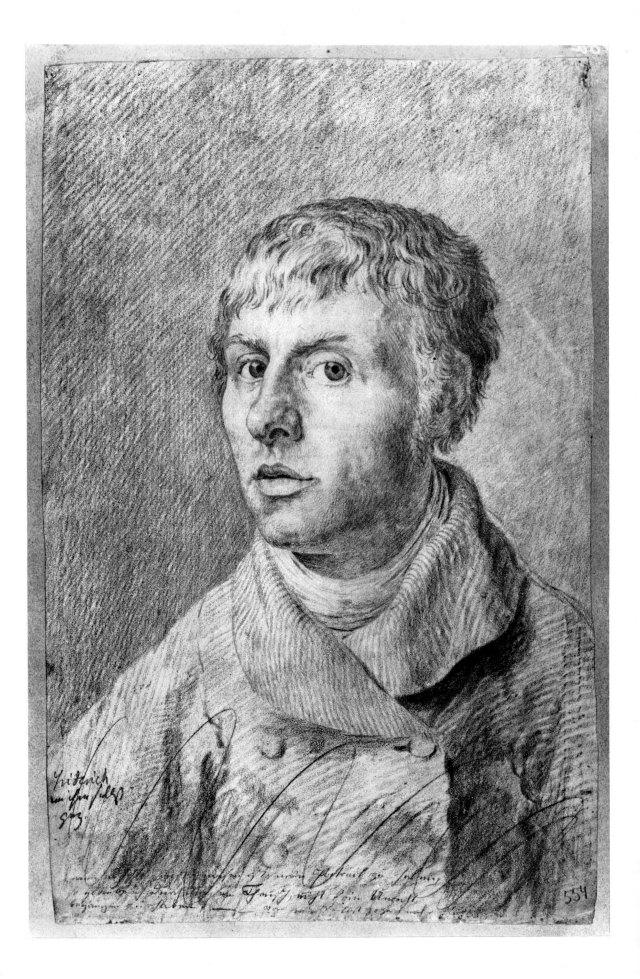

Friderich
von ihm selbst
903

554

WILLIAM VAUGHAN

Caspar David Friedrich

Of all the German painters of the Romantic Era, Caspar David Friedrich is undoubtedly the one whose art is the most compelling and immediate. His striking imagery, radical sense of design and, above all, intensive awareness of the varying moods of nature have made his art reach far beyond any local interest.

However, the very directness of his appeal has also brought its complications; for when, as is frequently the case, they appear outside their context, the resulting strangeness is often felt to be one of their inherent qualities. Yet while Friedrich certainly wished to convey a sense of the mystery of nature, he did not deliberately create enigmas. Like most other artists with a visionary sensibility, his intentions were explicit, and his ideas and aspirations grew directly out of the world in which he lived.

To give an immediate characterization of this milieu for an English audience is not easy. It will probably mean little at first to say that Friedrich was born in 1774 in the Pomeranian harbour town of Greifswald and that he spent most of his working life in Dresden, where he died in 1840. It is, perhaps, better to begin with temporal analogies, and point out that his earliest works date from the time of the French Revolution, and that he died a few years after the young Queen Victoria had ascended the English throne. The near contemporary of Turner (b.1775) and Constable (b.1776), he belonged, in fact, to that distinguished generation of European painters who created a new awareness of nature and made landscape painting one of the most fertile genres of the nineteenth century.

When considering Friedrich's art in this light it is perhaps inevitable that one will soon think of comparisons and contrasts with the landscapes of his great English contemporaries. It was certainly in such terms that he was described in his lifetime by the English traveller and connoisseur, Mrs Anna Jameson, when publishing her recollections of a recent visit to Germany in 1834. In her list of contemporary German Artists she referred to the painter as follows:

> 'Friedrich of Dresden; One of the most *poetical* of the German landscape painters. He is rather a mannerist in colour, like Turner, but in the opposite excess: His genius revels in gloom, as that of Turner revels in light.'[1]

Having visited Dresden in 1833, Mrs Jameson may well have had in mind those later oil paintings like 'The Large Enclosure' (*No. 100*) in which the artist created a pervasive sense of evening light through harmonies of pale blue, violet, and gold. Her view of him as a melancholy mannerist, however, brings out a general difficulty in responding to his work felt by those accustomed to a more descriptive tradition of landscape. For despite the strong awareness of nature that can be sensed in his pictures these are, for the most part, far from being direct

'Self-Portrait'
(No. 4)
Royal Museum of Fine Arts, Copenhagen

9

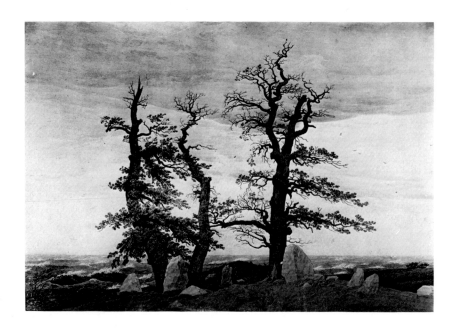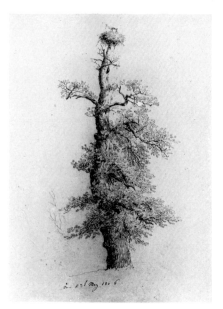

i. 'Dolmen by the Sea' Sepia, 1806 *Kunstsammlungen zu Weimar, Schlossmuseum*

ii. 'Oak with Stork's Nest' *(No. 27)*

records of natural phenomena. Indeed, his disregard for topography could be such that in one picture he placed the perfectly recognizable Pomeranian abbey of Eldena in the midst of the Riesengebirge – the equivalent of depicting Fountains Abbey in the Scottish Highlands. Similarly, one can find from studying his sketches that even works with the greatest appearance of actuality are quite likely to have been built up from a collection of motifs taken from very different situations over a considerable number of years. The 'Village Landscape in the Morning Light' *(No. 66)* of 1822, for example, may lead one to suppose one is looking at an actual part of nature, yet it combines several completely dissimilar regions of Germany, including mountains from the Riesengebirge and oaks from Pomerania. Indeed, the dominating tree, which may have originally caught his attention through the nesting storks on top of it *(No. 27)* had previously done service, at a slightly different angle, in a sepia painted seventeen years previously *(Ill. i)*.

To think of Friedrich's restricted vocabulary as evidence of a lack of concern for nature, however, would be to do him a great injustice. From his surviving sketchbooks *(No. 28)* one can see that he was an avid and exacting student of the countryside, and his concern for the minutiae of nature is fully conveyed in his finished pictures. In being moved from the sketchbook to the canvas his images become transformed but lose none of their individuality.

Friedrich's 'mannerism', in fact, like that of Turner, was the outcome of a search for deeper meanings within the appearance of nature. Yet despite this similarity their methods of conveying such intentions were fundamentally different. Where Turner created a dramatic narrative, Friedrich approached his subject with introspection. In 'Hannibal Crossing the Alps' *(Ill. iii)* for example, Turner used an alpine scene to show man in active conflict with the elements. In 'The Watzmann', *(No. 77)* on the other hand, Friedrich conveyed through the silent sublimity of a mountain an allegory on transience and eternity. While Turner's landscape forms a characteristic vortex, providing a setting within which the drama of man and his struggle with the forces of nature is enacted, Friedrich built his meaning out of the spatial structure itself. The diagonals that ascend from the clumps of grass and flowers in the foreground to the distant mountain peaks move

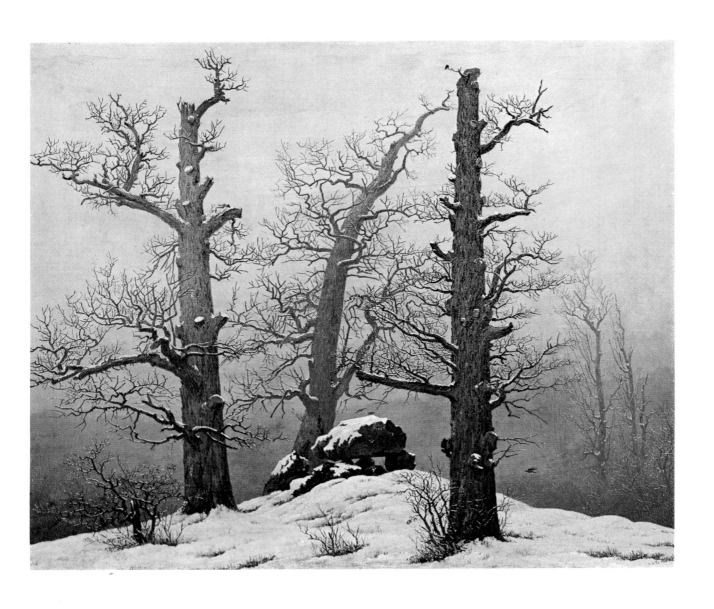

Dolmen in the Snow *c.* 1807 (No. 31)
Oil on canvas, 61·5 × 80 cm.

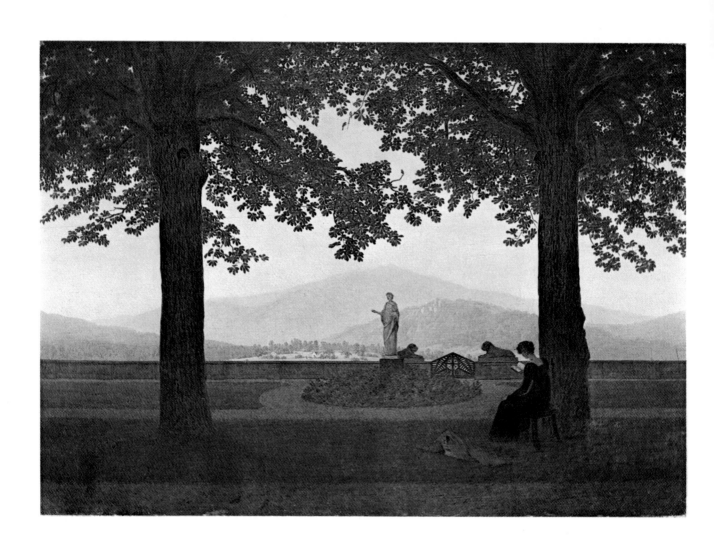

Garden Terrace 1811 (No. 42)
Oil on canvas, 53·5 × 70 cm.

across the central area of vision, compressing rather than opening out the space. Furthermore, the main motifs on each plane have been brought into close proximity with each other along a central vertical axis. Thus, while each area is distinguished qualitatively through differences in atmospheric rendering, the spatial recession has become ambiguous and formal analogies between separate images are stressed. Through such dualities Friedrich endowed each of the central motifs with an obsessiveness that intimates their symbolic meaning. In this case there is a gradual crescendo from the transient mortality of the flowers and dead trees to the eternity of the snow-capped peaks. This new approach to pure landscape imagery was Friedrich's most radical achievement. From the time of the Renaissance it had been accepted that landscape could only be made to convey a definite meaning by peopling it with a human event. Now Friedrich had made the landscape elements themselves the protagonists.

It is not, perhaps, surprising if this way of looking at nature seems to epitomize all that Ruskin condemned in his concept of the 'Pathetic Fallacy', for Friedrich's ideas were formed in the milieu of those German 'transcendentalists' who had originally aroused the English critic's ire. Living in Dresden during the first decade of the nineteenth century Friedrich could hardly have been unaware of the ideas of such Romantic writers and critics as Tieck, Novalis, and the Schlegel brothers. Under the inspiration of Kant, Schiller, and the earlier mystic, Boehme, these enthusiasts had brought new dimensions to the emotive awareness of nature that had spread throughout Europe in the late eighteenth century through the influence of Rousseau and the English nature poets. This later generation's concern lay not just in the appreciation of divine creation manifesting itself in nature, but also in the sense of awareness itself. Through the experience of beauty, which transcended analysis, one could intimate the existence of a suprasensuous reality. In these terms beauty became the indication of a universal totality beyond our comprehension, what August Wilhelm Schlegel called 'A symbolical representation of the infinite.'[2] Similarly they recognized that this response was not just passive appreciation but a creative action, a means by which the individual could

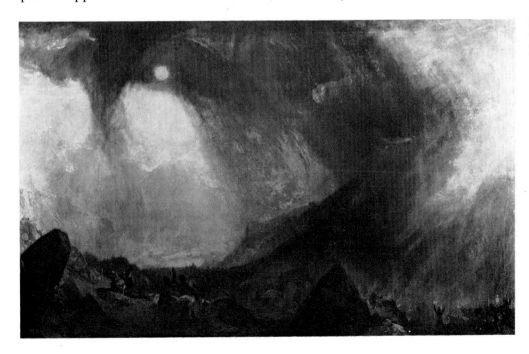

iii. J. M. W. Turner
'Snowstorm: Hannibal and his Army Crossing the Alps'
1812 *Tate Gallery*

bring his own soul into communication with the universal spirit. The reaction that was most personal embodied at the same time the deepest response to that which lay beyond.

It has often been emphasized how Friedrich's own statements seem to reflect such ideas.[3] He understood very well the paradox that that which is perceived of the outer world is at the same time a reformulation through a personal act of conception, and believed that it was through the expression of the internal vision by external means that the artist could achieve a truly spiritual communication. 'The artist should not only paint what he sees before him, but also what he sees within him' *(p. 103)*, he stated in a criticism of those painters who seemed to copy no more than the outward appearance of nature. His own method of using landscape imagery – the creation of a vocabulary of symbols whose meaning was suggested or extended through subtle spatial and tonal relationships – seems by comparison to be almost an exposition of the Nature-philosophy of Schelling. For in his seminal essay 'Concerning the Relationship of the Fine Arts to Nature' (1807), an investigation of the response of the pictorial artist before nature, this friend of the Schlegels distinguished the copying of outward appearance from the creation of form through an awareness of the inner spirit that enlivens all existence.

'The artist must follow the spirit of Nature working at the core of things,' he remarked 'and speak through form and shape as by symbols only.'[4]

It is presumably no accident that two of Friedrich's close associates during the period when he was forming his mature style – the theorists Christian August Semler and Gotthilf Heinrich Schubert *(p. 104)* – should have been investigating the expression of spiritual awareness through the use of nature symbolism in the visual arts. It was Semler, indeed, who edited Friedrich's description of the 'Cross in the Mountains' *(p. 104)*; while Schubert, who had been a pupil of Schelling in 1800, made use of Friedrich's work to illustrate concepts in his lectures on the 'dark side of natural science' *(p. 105)*.

While these theorists could hardly have provided him with the pictorial means for discovering emotive symbols in the imagery of nature, they do seem to have influenced his approach towards pictorial conception. In one of his 'observations' *(p. 103)* he advised the artist to

'Close your bodily eye so that you may see your picture first with the spiritual eye. Then bring to the light of day that which you have seen in the darkness, so that it may react upon others from the outside inwards.'

His own method of transcribing the 'inner vision' has similarities to that of Blake. His friend and biographer Carus *(p. 94)* describes how Friedrich, before beginning a picture, would wait until it 'stood lifelike before his mind' and how he would immediately sketch it on the bare canvas, first in chalk and pencil, then more definitely in pen and ink, and proceed, without further preliminaries, with the underpainting *(p. 108)*. He was also fond of telling visitors how his images, and even his method of achieving luminosity in his pictures, was revealed to him in dreams *(p. 108)*. Such accounts are almost certainly dramatizations; one knows how much he used sketches from nature for individual forms. Nevertheless, there are significantly few compositional studies to be found amongst his drawings – and those that do exist may well be records of completed paintings *(No. 101)*.

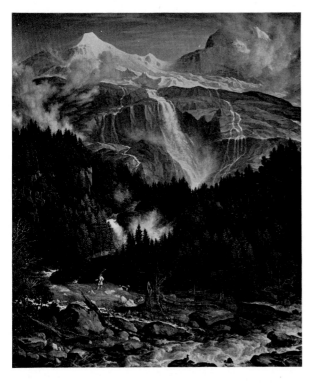

iv. J. A. Koch 'The Schmadribach Waterfall' 1821-2, *Munich, Bayerische Staatsgemäldesammlungen.*

Furthermore, one can often detect beneath the oil paint in his works the thin pen outlines that Carus described; while most of his paintings reveal throughout a sparse and precise treatment – as though they were describing something already fully conceived.

Friedrich's economy of means, however, was not simply the consequence of his visionary approach: it was also a characteristic of his generation. It is a distinction that separates his art, for example, from the richly-worked visions of the younger English painter, Samuel Palmer. Friedrich's linearity and precision, like that of Blake, reflects the Neo-classical emphasis on pure form that achieved its most radical manifestation throughout Europe around 1800. His exacting sense of spatial relationships, flattening of forms, and exploration of rectilinear symmetry, while unique in pure landscape, can be compared to the methods of Flaxman, Blake, Ingres, and his fellow Pomeranian, Philipp Otto Runge. At the same time, this analytic approach seems to be an heir to those great classical landscape painters of the seventeenth century; in particular Poussin, an artist who was once more becoming immensely influential in this period.

Nevertheless, if Friedrich's precision and sense of arrangement have many associations with a classical tradition, his use of them is quite distinctive. In searching for spiritual resonances within nature he did not strive after the creation of an ordered universe but rather the intuition of specific moods. He dismissed the panoramic 'universal pictures' (Weltraumbilder) of Joseph Anton Koch, the principal German classical landscape painter then working in Rome, as a 'boastful striving after abundance' *(Ill. iv).* Considering landscape imagery in terms of meaning, he saw the creation of opposing planes and coulisses, and the contrasting of different types of lines and colours as the setting up of contradictions of expression *(p. 103).* When the critic Ramdohr attacked 'The Cross in the Mountains' *(No. 33)* for lacking these attributes of classical landscape Friedrich retorted:

'Friedrich is an absolute opponent of such contrasts. He finds it insane to speak through contradictions . . . In his opinion every truthful work of art must express a definite feeling, must move the spirit of the spectator either to joy or to sadness, to melancholy or to light-heartedness – rather than try to unite all sensations, as though mixed together with a twirling stick.'[5]

It is such overpowering moods that are built up through Friedrich's expressive directness. The elimination of introductory foreground motifs brings one into contact with the central imagery while their obsessiveness becomes enhanced by the pervasive atmosphere. Significantly his subjects are shown most frequently at times when they are undergoing transformation – before sunrise or in twilight; in mists, or under fallen snow.

Just as Friedrich's pictures combine ambiguous spatial constructions and light effects with direct imagery, so their intentions, while expressed evocatively, are by no means inexplicit. The creation of symbols draws us into an intimation of that which lies beyond our comprehension, yet Friedrich believed, like the Schlegels and Schelling, that such mysteries were embodied in the traditions of religion. As can be seen from the programme that he drew up for 'The Cross in the Mountains' *(p. 104)* he was able to respond to nature in terms of Christian metaphors. Reflecting the departing rays of the sun onto an already darkened earth the cross becomes, quite literally, the means by which the unknowable divinity can be presented to us as a sensuous experience.

The description of 'The Cross in the Mountains' was prepared by Friedrich in response to Ramdohr's criticism of the picture's obscurity. Such direct reports by the artist of his intentions in other works are rare, yet many contemporary accounts show how readily his meanings could be uncovered by sympathetic observers *(p. 105)*. Nor, perhaps, are they so difficult to read. Unlike Blake, Friedrich built up no complex private mythology. He communicated his inner vision with the vocabulary of an outer world. His symbols grew out of readily-made associations (often traditional ones), such as the transience of ruins, the eternity of evergreens, and the 'new light' of Christ in the darkened world, the sickle moon. In many cases, such as the 'Winter Landscapes' of Dortmund and Schwerin *(Nos. 39, 40)*, it is the separation of groups or pairs of paintings that has in the past obscured their meanings.

It is important to draw attention to the religious beliefs that lay behind Friedrich's approach to landscape, since without them a highly significant dimension becomes obscured. For while he may often depict subjects that seem to be imbued with melancholy and gloom, their message is one of contemplation rather than despair. Graves, funerals and ruins point to a more peaceful life beyond, one that will be sensed by those who dwell upon the implications of mortal transience. He himself expressed these intentions in a typically aphoristic verse.

Warum, die Frag' ist oft zur mir ergangen,
Wählst du zum Gegenstand der Malerei
So oft den Tod, Vergänglichkeit und Grab?
Um ewig einst zu leben
Muss man sich oft dem Tod ergeben.

(Why, the question is often put to me, do you choose so often as a subject for

painting death, transience, and the grave? In order to live one day eternally, one must submit oneself to death many times.)[6]

Above all, Friedrich's submission to death was a process of resignation, and even when he depicted his own funeral, it was to point to the greater consolations in eternity.[7] There is little in his work of the more familiar Romantic conflict between a longing for the peace of death and a passionate desire to experience life to the full. Friedrich's spiritual outlook remained rooted in the strict and simple Protestantism of North Germany, and it is notable that, despite his intense sensibility before nature, there is an almost total lack of eroticism in his art.

II

The definiteness of Friedrich's manner and opinions has often led to the belief that his art underwent little change or development. Only in recent years has the peculiarly difficult task of dating his finished works been sufficiently mastered to enable one to see how, far from being isolated from his times, he was continuously reacting to pictorial and ideological developments in the world around him.[8] Unlike Runge, Friedrich unfortunately left no account of the crucial stages by which his vision developed. However, by considering the environment in which he lived, in particular that of his youth in North Germany and the years in Dresden before 1808 – when his first major picture, 'The Cross in the Mountains' *(No. 33)* was painted – it is possible to gain an intimation of the experience that led Friedrich to move from eighteenth century pre-Romantic landscapes of sentiment to the creation of powerful visionary symbols.

The view of Friedrich as a withdrawn and uncompromising artist already existed in his own lifetime. Certainly his singular appearance and unbending manner did everything to emphasize to his contemporaries the harsher side of his art and character. Already his first biographer, Carus, talked of Friedrich's 'strange, always dark, and often hard disposition.'[9] On the other hand, Carus did not meet Friedrich until 1817 and his reminiscences were probably most strongly coloured by his knowledge of the artist towards the end of his life, when he was sick and embittered. Furthermore, Carus' own views on art *(p. 94)* did not allow him a full insight into Friedrich's inner world. While borrowing much of Friedrich's imagery his greatest admiration was for Friedrich's 'concentration of the effect of light'[10], and in his own work there is a conspicuous lack of spiritual intensity. He certainly seems to have been unresponsive to the underlying indication of salvation that ran through Friedrich's art, for he quoted with approval the assessment made by the French sculptor, David D'Angers, in 1834.

'Voilà un homme qui a découvert la tragédie du Paysage.'[11]

While Friedrich's best-known self portrait *(No. 36)* might well seem to corroborate D'Angers' remark, many of his closer acquaintances were able to see through this rather forbidding exterior to a more responsive nature. Gotthilf Heinrich Schubert talked of his moments of sociability and good humour, and the painter, Louise Seidler, wrote that despite his 'forceful expression'

'anyone who has looked but once into his pure eyes must also have tasted through the often bitter shell the sweet kernel in his deeds and pictures.'[12]

Similarly, the Russian poet Zhukovski *(p. 107)* was able to grasp his straightforwardness and the sincerity of his art. After meeting him in 1821 he wrote,

'The outstanding feature of his face is its candidness; such is also his character . . . nor is there any affectation in his pictures; On the contrary, they please us by their precision, each of them awakening a memory in our mind.'

This candidness can also be felt in Friedrich's own writings *(p. 103)*, and if many of his judgements seem harsh, it must be remembered that they come from a time when his own art had become unfashionable and he was suffering from comparisons with younger and more naturalistic painters, particularly those of the Düsseldorf school. His concern for other people and the strength of his affections is more apparent in his correspondence, particularly in that to his family.

It is to this family milieu, too, that one can trace many of the dominating features of Friedrich's art; for despite living most of his working life in Dresden, Friedrich's relationship to his homeland remained of the utmost importance to him. Carus attributed his melancholy to a tragic event of his youth: At the age of thirteen Friedrich witnessed the death of his favourite brother, Christopher, who perished while trying to save him from drowning. However, although this might have induced a sense of guilt which increased a natural tendency towards melancholy, his obsession with mortality and salvation were also common features of the pietism of North German Protestantism. Coming from an established artisan family in a small harbour town on the Baltic coastlands of Pomerania, Friedrich had been brought up from his earliest youth in an atmosphere of religious asceticism. Appropriately, his earliest known works are decorated moral texts *(No. 1)*.

Even Friedrich's use of landscape to express this morality reflects his North German origins. In the late eighteenth century the worship of divinity in nature, common to pre-Romanticism throughout Europe, had become widely influential in Germany through the writings of such English nature poets as Thompson, Gray, and Macpherson, the inventor of 'Ossian'. While inspiring such important writers as Claudius, Herder, and Klopstock, this movement was championed in Pomerania by the minor poet, Ludwig Theobul Kosegarten. An avid translator of English literature, including Gray's 'Elegy in a Country Churchyard',[13] this protestant pastor produced idylls and theoretical treatises that brought to the current enthusiasm for nature worship and melancholy sentiments the mystic fatalism of an indigenous pietism. In a truly protestant tradition he emphasized the direct contact with God, and indicated that it was in nature, which he considered to have been 'Christ's Bible',[14] that the message of salvation could be read.

The relationship between these views and those of Friedrich has often been stressed.[15] Nor are personal connections hard to establish. Kosegarten, for a time the schoolmaster of Philipp Otto Runge in the nearby town of Wolgast, was a close friend of Friedrich's first art teacher, the Greifswald university drawing master Johann Gottfried Quistorp. As early as 1777, indeed, Kosegarten had dedicated his early collection of poems 'Melancholien' to Quistorp, and the frontispiece of this volume shows an etching by the Greifswald artist that combine emotive figures and landscape imagery in a way that seems to prefigure the designs

that Friedrich had made into woodcuts around 1802–3 *(Ill. v ; Nos. 21–3)*. Kose-garten himself was one of the earliest collectors of Friedrich's art, and may even have been the instigator of the scheme for using a landscape as an altarpiece that led to the conception of the 'Cross in the Mountains' *(No. 33)*. He is certainly known to have discussed with Friedrich the possibility of painting an altarpiece for the seashore chapel in Vitte on Rügen – a commission that eventually went to Runge.[16]

While Kosegarten is the most likely person to have brought Friedrich into contact with an eschatological interpretation of nature, he could have been even more directly influential in the development of some of Friedrich's most recur-rent nature images. For, inspired by 'Ossian' and books on Scottish travels,[17] Kosegarten came to see in the elemental and primeval landscape of the large island of Rügen that lies off the Pomeranian coastland a setting for the protagonists of a nordic heroic past. While the large dolmens on the island (still commonly known as 'Hünengräber' – 'Giant's graves') were believed to be the memorials of such heroes, the abundant weather-beaten oaks could also be interpreted as symbols of Teutonic manhood. Indeed, Carus, when visiting North Germany in 1819 re-corded a local traditional practice whereby each man, on reaching maturity, would plant an oak.[18] Friedrich, who made frequent visits to Rügen, habitually used such motifs in his compositions throughout his life *(Nos. 31, 109)*. Nor were contemporaries unaware of Friedrich's relationship to the literary reappraisal of this part of Germany. The writer Heinrich von Kleist, for example, when review-ing Friedrich's 'Monk by the Sea' *(Ill. xii)* spoke of its 'ossianic or Kosegarten-like effect'.[19]

Despite his obsession with a semi-mythical, prehistorical past, Kosegarten was no revivalist. For the modern man, deprived of such elemental existence, memories of this age could awake spiritual longing; but his own path to salvation must lie elsewhere, guided by Christianity, which kept alive the light of spirituality in a darkened world. For the 'Priest of Nature',[20] however, christianity was an empirical rather than a traditional belief. Unlike the Romantics of a later generation, the Middle Ages were for Kosegarten hardly more relevant as a direct model for modern man than heroic antiquity; and this was certainly a viewpoint that Friedrich to a large extent shared. Apart from a brief enthusiasm for Neo-gothicism during the era of the patriotic 'Wars of Liberation' he remained strongly antagonistic towards the mediaevalizing movement. In later years he became the relentless opponent of the 'Nazarenes' and their followers – those German artists like Overbeck and Pforr who had taken their own route towards regaining a lost spirituality by reverting to the styles of Italian and German artists before the high Renaissance.

'What pleases us about the older pictures is, above all, their pious simplicity.' He wrote around 1830, 'However, we do not want to become simple, as many have done, and imitate their faults, but rather become pious and imitate their virtues.' *(p. 103)*

Similarly, Friedrich's concept of the Gothic had more in common with that of the eighteenth-century creators of park landscapes than the revivalists of the nine-teenth. His terrestrial Gothic buildings, most frequently based on the abbey of Eldena that lay three miles away from his home town *(No. 6)*, are always shown in

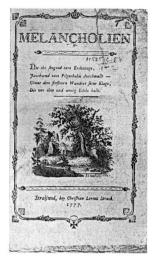

v. Frontispiece to 'Melancholien' by L. T. Kosegarten, 1777. Engraving by J. G. Quistorp

ruins – monuments to a past spirituality and reminders of the incompleteness of earthly existence *(No. 85)*. When Gothic edifices do appear intact they are represented as misty visions that lie beyond the tangible *(No. 40)*. Nor does he fail to make associations between the Gothic and nature. The pre-revivalist myth that related the origin of the Gothic arch to the crossing of two tree branches is referred to in one of the Weimar sepias of 1805 *(No. 25)*. More generally, Friedrich associated the two states of Gothic buildings with different types of trees; the ruined building with the wintry deciduous tree *(No. 85)* and the visionary building with the evergreen *(No. 38)*. In the frame of the 'Cross in the Mountains' *(No. 33)* the arched palms suggest a more complex series of associations between nature, the Gothic arch, and the blessing of God spanning the universe.

Although Friedrich's imagery extended beyond his native Pomerania it was almost always towards landscapes whose extreme character or poignant light effects emphasized a sense of longing that could be transformed into a spiritual metaphor. Significantly, the most important subjects for Friedrich further south were those mountains, particularly the Harzgebirge and Riesengebirge which, like Rügen, were peculiarly elemental and had strong legendary associations. The northern aspiration that for the Nazarenes, in such works as Pforr's 'Sulamith and Maria', grew into a yearning for the paradisal south became for Friedrich directed towards a contemplation of the spirituality that could be felt in the extremities of nature. Indeed, in 1817 he refused to visit Rome for fear that the experience of a richer landscape might destroy his spiritual asceticism. Like his collaborator, Semler, he remained firm in the belief that 'the gloomy and meagre nature of the north is best suited to the representation of religious ideas'.[21]

III

If Friedrich's spiritual approach to landscape was inspired by his Pomeranian homeland, it had little to offer him in his education as a painter. From his first drawing master Quistorp, with whom he studied in Greifswald from 1790 to 1794 he would, perhaps, have gained little beyond the rudiments of technique. For despite Quistorp's connections with Kosegarten his own accomplishment as an artist was limited *(Ill. v)*. Friedrich's few remaining works from this period show how Quistorp encouraged him to draw from academic copy books. He may also have taken lessons in etching, for he was later to dedicate one of his works in this medium to his Greifswald master.[22] However, even this technique was to prove of little value to him beyond his early years *(No. 18)*.

No doubt it was on Quistorp's advice that Friedrich went in 1794 to continue his studies in Copenhagen. The academy there was at that time the most distinguished art school in northern Europe and apart from Friedrich, such major artists as Jacob Asmus Carstens and Runge studied in it. For two years Friedrich attended the freehand drawing class, where he copied engravings of old masters. This was followed by two years study from the antique, while between January and the summer of 1798 he worked in the life class and may also have experimented with oil painting.[23]

Greifswald in Moonlight 1816–17 (No. 49)
Oil on canvas, 22·5 × 30·5 cm.

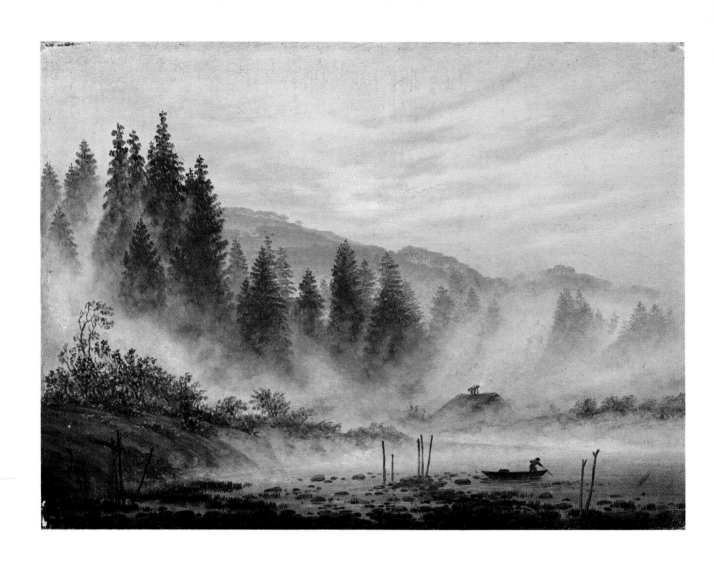

Morning *c*.1821 (No. 60)
Oil on canvas, 22×30·7 cm.

Friedrich's formal education at this time would have been based on the human form. His early figure drawings, some of which are of historical and literary subjects *(Nos. 3, 5)*, show the influence of Nicolai Abilgaard – the leading historical painter in Copenhagen – whose elongated expressive forms depicting classical and Nordic legends bear similarities to those of his former acquaintance in Rome, Henry Fuseli. While these drawings may suggest that Friedrich considered at one time becoming an historical artist, they also show how little natural ability he had for dramatic composition. It is significant that even before he had designed any of the surviving compositions he should already have succeeded in painting, in 1797, a highly accomplished series of watercolour landscapes based on the countryside around Copenhagen *(No. 2)*. At the academy he had been taught by two of the most important Danish artists then working in landscape, Christian Lorentsen and Jens Juel. Lorentsen was principally an exponent of the late eighteenth century dramatic landscape that can be found in France and England in the works of Claude Joseph Vernet and Phillip de Loutherbourg. Although Friedrich is known to have executed some stormy landscapes[24] the dramatic depiction of nature was to play no more of a central role in his oeuvre than did his dramatic figure compositions. A more profound influence was probably the silent, sublime, Norwegian landscapes of the recently deceased Erik Pauelsen. Although essentially topographical, these records of a journey through Norway in 1788 depict the landscape with a freshness and directness which in many ways prefigures Friedrich's own mountain subjects. Significantly, Friedrich is reported by Dahl to have coloured prints after Pauelsen's Norwegian drawings to supplement his income in Copenhagen.[25]

However, there is little of the sublime in Friedrich's Copenhagen watercolours. Both their picturesque compositions and modified rococo manner show closer affinities with the landscapes of Jens Juel. Juel, who had achieved international fame as a portraitist, had turned increasingly during the 1780s and 1790s to the depiction of local Danish scenery. Like his portraits, these pastoral themes express the gentler and more contemplative side of eighteenth-century nature sentiment. His imitation of the English genre of outdoor portraiture may have provided the basis for his landscapes of distinctive sentiment, but he was also able to bring the interpretation of mood to pure landscape. In such pictures as 'North Light' *(Ill. vi)* there is a sensibility for atmosphere that seems to lie half way between the late landscapes of Gainsborough and the pervasive mood in Friedrich's later domestic scenes like 'The Evening Star' *(No. 97)*.

Like those of Gainsborough, the landscapes of Juel and the early watercolours of Friedrich show a generalized approach to nature. During these years Friedrich made studies after Juel's stylized treatment of the foliage of trees that conformed more to compositional requirements than to observed phenomena.[26] Just as such picturesque arrangements show an affinity with the current vogue for the landscape garden, so there is a similar tendency to include within them the monuments, temples, ruins, and grottoes that were placed in park landscapes to awaken senti-ments and trains of thought. Indeed, one finds discreetly concealed within many of these early works of Friedrich the sentient images – crosses, monuments, and ruins – that were to dominate his mature compositions.

To a generation conversant with the conventions of the landscape garden these early pictures may have been suggestive in a way that is difficult to grasp today.

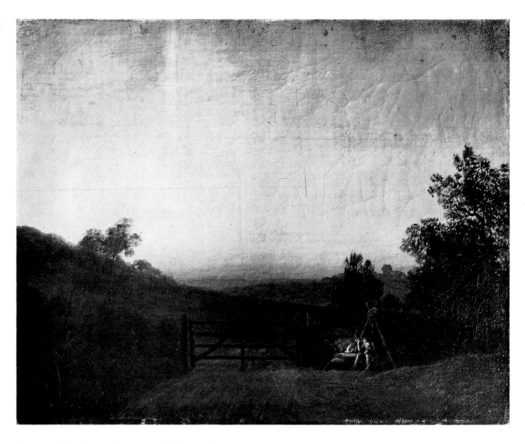

It was in fact the complaint of such connoisseurs as Goethe, Schildener, and
Ramdohr that Friedrich's later paintings had become exaggerated and tasteless
through transforming the evocation of a mood into the elaboration of an allegory.
Nevertheless, this was only one aspect of the direction in which Friedrich's art
developed; for while becoming more overtly imagistic, they also became more direct in
their representation of nature. The generalizing compositions of Juel were replaced
by a detailed and intensive study of individual forms, plants, branches, leaves and
rocks – bringing with it an intimate understanding of the phenomena of nature
that led not, as Ramdohr suggested, to the appearance of a collection of minerals
but rather to a deepened spiritual mood.[27]

This transformation, however, did not begin to take place before Friedrich
moved to Dresden in 1798. The thriving artistic milieu and magnificent art gallery
of the 'German Florence' would in itself have been an inducement for an aspirant
artist, and the progression from Copenhagen to Dresden was by no means
uncommon for northern artists at this time. It was a course taken by, amongst
others, Runge, Kersting, Dahl, and Fearnley.

For Friedrich the contemporary reputation of the landscape painters in Dresden
around 1800 would have been especially important. Following the lead of the mid-
eighteenth century artist, Christian Wilhelm Ernst Dietrich, the landscapists
Johann Christian Klengel and Adrian Zingg, had reinvigorated the realist tradition
of seventeenth-century Dutch painting – one of the schools of art that was as it
happens also particularly well represented in the Dresden Gallery. Friedrich
himself is known to have made copies of works by Zingg,[28] and it may well have
been under his influence that he began to make detailed records of the minutiae of
nature. Already his sketchbooks of 1799 and 1800 are full of carefully drawn

studies of nature made in the neighbourhood of Dresden.

But although these systematic studies represent a move away from the more generalizing forms of Juel, Friedrich's method of recording natural phenomena still revealed the impact of his formal training in Copenhagen. For in these pen drawings the careful outline style favoured by neo-classical artists for grasping the essential form of the human body has become applied to the depiction of nature. Pure outline was, indeed, to remain the means by which he sketched out the compositions of his paintings throughout his life, and while common enough around 1800 it became a curiosity remarked upon by many of his acquaintances in later years. In comparing this manner to the silhouettes of Greek vase paintings, his younger friend, the painter Dahl *(p. 96)* was, perhaps unwittingly, correctly describing its classical origins.[29] On the other hand, Carus' more fanciful supposition that Friedrich's use of outline had been inspired by the broad coastal regions of Pomerania and the intersections of the flat horizon of the sea with the profiles of the chalk cliffs[30] comes nearer perhaps to explaining its continued presence in his works; for it was by this precise method that he was able to construct the careful balancing and correlation of forms on which his language of metaphors depended.

Despite his continued compositional use of outline, its limitations as a sketching technique gradually became evident to him. Around 1800 his studies from nature became augmented increasingly by the addition of washes *(No. 7)*, while his growing interest in texture and volume led him, after 1806, to turn almost exclusively to the use of pencil *(No. 27)*. It is, perhaps, also indicative of a change of direction that he should in his topographical works have begun to supplement his use of water-colour with the more solid and opaque technique of gouache *(No. 17)*.

Friedrich's development as a view painter may also have been inspired by financial considerations. For despite enrolling at the Dresden Academy – where he continued his life studies – he was also now having to make his own living. Not only did he offer his services as a private tutor, but was even driven at times to acting as a local guide.[31]

In any case, by taking up sepia painting for such works, Friedrich was subscribing to a current vogue. The popularity of this technique can be related to the neo-classical emphasis on form and outline. Its principal exponent in Dresden, Crescentius Joseph Johann Seydelmann (1750–1829) specialized almost exclusively, in fact, in the reinterpretation of famous oil paintings in terms of line and tone. For Friedrich the manner was in many ways an extension of his current sketching method in which he used pen outline and wash. However, the greater emphasis that sepia allowed in the modulation of tonalities was to lead him to develop a control of the gradations of light that was to become one of the most outstanding features in his later works in oils.

Friedrich's neatness and care soon made him a master at sepia painting. During a large part of 1801 and 1802 he spent a prolonged period in his homeland, and while making some final experiments with figure composition *(Nos. 10–12)* he also undertook extensive tours through Rügen and Pomerania, producing studies that were to become the basis for sepias *(No. 9)*. Many of these were exhibited at the Dresden Academy *(No. 26)* where both their skill and their subject matter brought him a growing reputation. In 1805 he achieved an unexpected success when Goethe awarded him a prize for two sepias exhibited at Weimar *(Nos. 24, 25)*.

These sepias 'Summer Landscape with a Dead Oak' and 'Procession at Dawn' were not, as it happens, Nordic views. On the other hand, they reflected the equally topical religious preoccupations of the Dresden Romantics. The mystic spirituality that first began to emerge in Dresden around 1798 had by 1805 become widespread in literary and artistic circles and had led to a revaluation of the more emotive aspects of conventional religion that brought, amongst other things, many conversions to Catholicism. In the 'Procession at Dawn' even the emphatically Protestant Friedrich can be found depicting a Catholic ceremony. Goethe, who had recently lost two of his proteges, the Riepenhausen brothers, to the mediaeval Catholic group, responded to the subject matter in Friedrich's sepias in his review in the *Jenaisches Literaturblatt* with caution.[32] Nevertheless, the religious iconography was as yet still displayed within a sufficiently conventional landscape composition for him to be able to appreciate Friedrich's skill both as a designer and as an observer of nature. For some time, indeed, relationships between the poet and the painter remained cordial. Visits were exchanged between them in 1810 and 1811. Only in 1816, when Friedrich refused to assist in Goethe's scheme for studying clouds – saying that this would be the 'end of landscape painting'[33] – did the poet come to realize that Friedrich's vision, with its emphasis on a psychic response before nature, was essentially different from his desire to achieve an objective understanding of the organic forces that determine natural phenomena. A year after this rebuff Friedrich was listed in the famous review in *Kunst und Alterthum* 'New-German Religious-Patriotic art', amongst those whose 'religious-mysticism' had led to the diversion of contemporary art away from good taste and wholesome beauty.[34]

The religious allegories in the Weimar sepias may not have fallen outside accepted conventions of taste; within three years of their successful reception, however, the innovations in Friedrich's 'The Cross in the Mountains' were to be striking enough to goad the critic, Ramdohr, into launching a detailed, comprehensive attack on Friedrich's art and ideas *(p. 104)*. The transformation was aesthetic rather than iconographic, for although the decision to use a landscape painting for an altarpiece (albeit for a private chapel) was a bold one, the theme itself was not fundamentally different from that of the 'Procession at Dawn'. In both, the wayside cross is used as a focus on an allegory which links Christian salvation with the workings of God in nature.

Ramdohr's critique of the 'Cross in the Mountains' shows an acute awareness of the implications of the change from discreet to overt imagery. His first two objections to the subject – that it was a distortion of the appearance of nature and that it attempted the impossible by trying to make landscape allegorical – were, in fact, closely related. As Ramdohr pointed out, allegorical works are those that suggest ulterior meanings by presenting recognizable forms in unexpected configurations. Whereas he saw this as being permissible in figure painting, since such associations do not interfere with the truthful depiction of each object, he considered such practice inadmissible in landscape, since in nature the interrelationship of objects in itself forms part of their actual description. While he was perfectly aware that all landscapes were composed, the crucial distinction between the methods of Friedrich and those of his heroes, Ruysdael, Poussin and Claude, lay in the way the earlier masters arranged their forms to bring out these inter-relationships of nature – the reflection and diffusion of light as it falls on the

earth, the treatment of atmospherics and, above all, the elaboration of forms to present a coherent spatial recession from the spectator to the distant horizon. While the obscuring of these relationships in Friedrich's work are not of the crude kind to which Ramdohr referred 'the earth on top and the sky below, the trees leaved with brickwork'[35] they do, as has already been seen, create ambiguities in our understanding of the positioning of objects. The dissociation of the spectator from the immediate foreground leaves no indication of the position from which the scene is viewed – Ramdohr calculated that one would have to be suspended in mid-air to gain such a view of a mountain top. Thus our eye finds no fixed point to arrest it before reaching the cross, an image that blocks the central area of recession and creates a direct qualitative contrast with the sky behind.

In retrospect it is perhaps too easy to think of the paintings by Friedrich that preceded this bold image as being preparations for it. One can at least see, however, how Friedrich had previously explored the more conventional methods of creating landscapes of meaning. Apart from his early 'park' landscapes he had also experimented with the human drama within the landscape. During his 1801–2 visit to Pomerania he had created a number of designs which show emotive human figures in a landscape setting – a familiar genre of pre-Romanticism which can be found in England in such works as Wright of Derby's 'Sir Brooke Boothby' (Tate Gallery) and which also appears in the etchings of Quistorp *(Ill. iv)*. However, in such works it is the landscape itself that tends to become reduced to an attribute, in many ways comparable to Friedrich's contemporaneous allegorical portrait 'Old Woman with an Hour Glass and Bible *(No. 16)*. In the later Weimar sepias the figures have been placed within a coherent landscape, falling more into the convention of the historical landscape.

Despite the radical nature of Friedrich's final synthesis, it was, in fact, through the exploration of traditional associations between the life of man and the cycles of nature that he created his first strikingly evocative imagery. The archetypal theme of the 'Times of Year' as an allegory on the life of man was first designed as a sepia cycle by Friedrich in 1803 *(Ill. vii, viii)*. In later life he was to return to the theme frequently both in oils and sepias *(Nos. 78–85)*. As can be seen from the description of the original cycle by Schubert *(p. 105)*, Friedrich fully exploited this traditional theme to develop a subject in which the imagery of landscape plays the leading role. Yet, perhaps, even more significant than this transformation is the way in which the images themselves are adapted from the evocative landscapes of the great masters of the seventeenth century.

The revival of interest in these painters was an integral part of the deepening response to landscape throughout Europe. For Friedrich, as for Constable and Turner, such artists had created an awareness of nature that the landscapes of sentiment of later painters like Vernet, de Loutherbourg, and Juel had never achieved. It was a measure of Friedrich's standing that he appeared to many of his contemporaries as the heir to Everdingen, Ruysdael, and Claude.[36]

While the turbulent Nordic waterfalls of Everdingen have more in common with Lorentzen than Friedrich, both Ruysdael and Claude prefigure his silent, pervasive mood and evocative landscape imagery. In view of this it is, perhaps, more than a coincidence that the two most compelling compositions of the original cycle of the 'Times of Year' – 'Summer' *(Ill. vii)* and 'Winter' *(Ill. viii)* – can be associated with two of the works by these masters hanging in the Dresden Picture

vii

viii

vii. 'Summer' Sepia, 1803
formerly Ehlers collection

viii. 'Winter' Sepia, 1803
formerly Ehlers collection

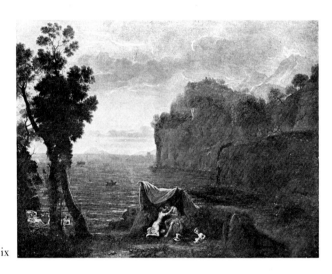

ix

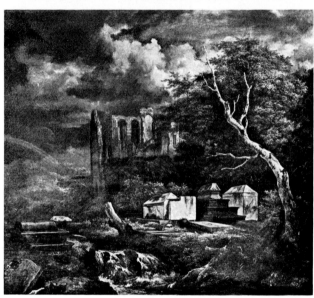

x

ix. Claude Lorraine 'Acis
and Galatea' *Staatliche
Kunstsammlungen, Dresden*

x. Jacob van Ruysdael 'The
Cemetery' *Staatliche
Kunstsammlungen, Dresden*

Gallery. The lovers in a bower, the entwined trees above them, and the pair of doves in the foreground found in 'Summer' also appear in Claude's 'Acis and Galatea' *(Ill. ix)*. Similarly, the ruin, graveyard, and prominent barren tree of 'Winter' are foreshadowed in Ruysdael's 'Cemetery' *(Ill. x)*. There may even have been an overt reference to these works – Claude's 'Southern' landscape providing the prototype for the age of earthly fulfilment, and Ruysdael's 'Northern' landscape for the intimations of a spiritual life beyond the grave.

However, as Ramdohr was the first to point out, such works by Claude and Ruysdael were suggestive rather than explicit. Friedrich's overt allegory, on the other hand, was for the critic yet one further example of the pervasive influence of the Dresden Romantics, of

'That mysticism, that is now insinuating itself everywhere and that comes whafting towards us like a narcotic vapour from art and science, from philosophy and religion'.[37]

Although most of the painters who succumbed to the 'narcotic vapour' created, like the Riepenhausen brothers, mediaevalizing pictures, Friedrich was not quite alone in his investigation of a mystical landscape. At the same time that he had been designing his 'Times of Year' his fellow-Pomeranian, Runge – who, through his

friendship with Tieck, had even closer associations with the Dresden Romantics – had begun creating his own symbolic cycle, 'The Times of Day'. In these works, which were for Runge examples of 'landscape', allegorical figures and elements of nature were to be brought together in a series of frontal hieratic images. While Runge was unable to finish the large paintings that he intended to create on this theme before his death in 1810 he had, prior to leaving Dresden in 1803, designed a series of outlines in which the iconography that he was later to develop was already suggested *(Ill. xi)*. In these outlines, which were issued as engravings in 1805, the cryptic forms seem almost to be an embodiment of the new language of symbols for which the Romantics had called; the simple 'hieroglyph' that contained a hidden meaning.

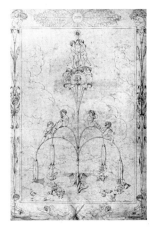

xi. Philipp Otto Runge 'Morning' Pen, 1803 *Kunsthalle, Hamburg*

Echoes of Runge's mythology are rare in Friedrich's works. His interest lay further in the direction of pure landscape than Runge's combination of natural forms with allegorical figures. However, while having little relationship to Friedrich's own cycle of nature, the hieratic character of Runge's 'Times of Day' seems in many ways to prefigure the conception of the 'Cross in the Mountains'. Through the adoption of a strict frontal symmetry, Runge had transposed the concept of the altarpiece to the portrayal of spirituality in nature. The formal, static quality of these images makes one read their attributes in anticipation of a secondary meaning. At the same time, Runge does not present them as a mere inventory of signs. A fine sensibility for balance enlivens the composition and despite the symmetrical format there are no mirror images in the main design. Instead there is a juxtaposition of variant forms that stimulates our sense of analogy. Only in the frame is absolute symmetry observed. Here, however, the reading is in terms of pure symbols, a sequence of Christian attributes that underline the message of the central theme. In Friedrich's altarpiece, too, a hieratic symmetry alien to conventional landscape painting is used to present an overt analogy between the processes of nature, the destiny of man, and the Christian religion. Like Runge's work, there is also a clear distinction between the subtle balancing of forms in the picture itself and the rigid symmetry of the grouped symbols on the frame. However, perhaps these similarities should not be over-emphasized, since the traditional prototypes themselves were available. Runge himself, like so many of his contemporaries, had been deeply moved by the visionary qualities that he saw in Raphael's hieratic 'Sistine Madonna', and this painting, the crown of the collection in the Dresden Gallery, would have been equally accessible for Friedrich.

The formality of 'The Cross in the Mountains' was almost certainly a response to the religious nature of the commission. Indeed, a description of a lost sepia of 1805, the same year in which the Weimar sepias were painted, suggests that Friedrich may well have devised this radical composition for such purposes at a time when he was still creating anecdotal subjects in a very different style *(No. 33, note 3)*. However, during 1806–8, when he was in the process of turning this design into a full-scale altar, this new format began to affect all types of work that he produced. As Börsch-Supan has suggested[38] a trip to Rügen in 1806 may have accelerated this change, since he seems at this time to have made studies from nature in which a symmetrical design and the direct association of foreground image and background is explored. At the same time, sepia became replaced by oil painting, showing a new confidence in the style that he was evolving.

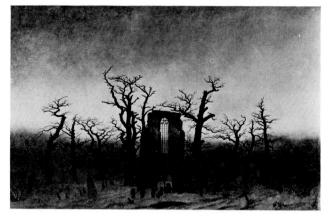

xii. 'Monk by the Sea' 1809
Staatliche Schlösser und
Gärten, Schloss
Charlottenburg, Berlin

xiii. 'Abbey in the Oakwood',
1810 *Staatliche Schlösser*
und Gärten, Schloss
Charlottenburg, Berlin

The silhouetting of foreground image against an intangible background was to remain the decisive feature in Friedrich's paintings for nearly a decade. However, his designs during this period were rarely repetitive. For by compressing spatial relationships he had emphasized an awareness of horizontal and vertical axes that could lead to infinitely varied balances. In some cases the balance was created through an absolute symmetry, as in the Stuttgart 'Cross in the Forest' *(No. 41)* and the Düsseldorf 'Cross in the Forest' where the head of Christ is placed at the point of intersection of the orthogonals. Elsewhere, as in the Dortmund 'Winter Landscape' *(No. 40)*, the symmetry was created through the balancing of a foreground against a 'visionary' form in the background – in this case a completed Gothic building. Often the differing compositions seem to be related to the iconography of the pictures. Those in which a visionary intimation of the life beyond appear are, on the whole, those in which a symmetrical balance is established, while the terrestrial compositions have more informal arrangements. This is certainly the case when one compares the Dortmund 'Winter Landscape' to its earthly counterpart in Schwerin *(No. 39)*.

These points were emphasized dramatically in the two major pictures which he exhibited with great notoriety at Berlin in 1810 and which he set to work to paint immediately after 'The Cross in the Mountains'. In one of these 'The Monk by the Sea' *(Ill. xii)*, Friedrich created what is perhaps the most radical and memorable of all his images. The compressing and simplification of forms found in the 'Cross in the Mountains' has been carried further here to create a landscape of startling bareness, in which a solitary monk holds his head in his hands in a gesture of silent contemplation. As before, the different areas of the painting are decisively separated from each other, so that the monk appears to be surrounded by the uncompromising elements of earth, sea, and sky. The unbroken line of the horizon, below which the monk is placed, suggests even more strongly the endlessness of nature and the limitations and smallness of man within it. When this work was exhibited, its originality created amazement and confusion. The writer, Heinrich von Kleist *(p. 106)*, who did not pretend to understand it, produced by directly recording his impressions the greatest tribute to its modernity.

'Since in its uniformity and boundlessness it has no other foreground than the frame, when one looks at it, it is as if one's eyelids had been cut away.'

However, despite its revolutionary appearance, this picture should not be interpreted out of context. Contemporaries reacted most strongly to the loneliness of

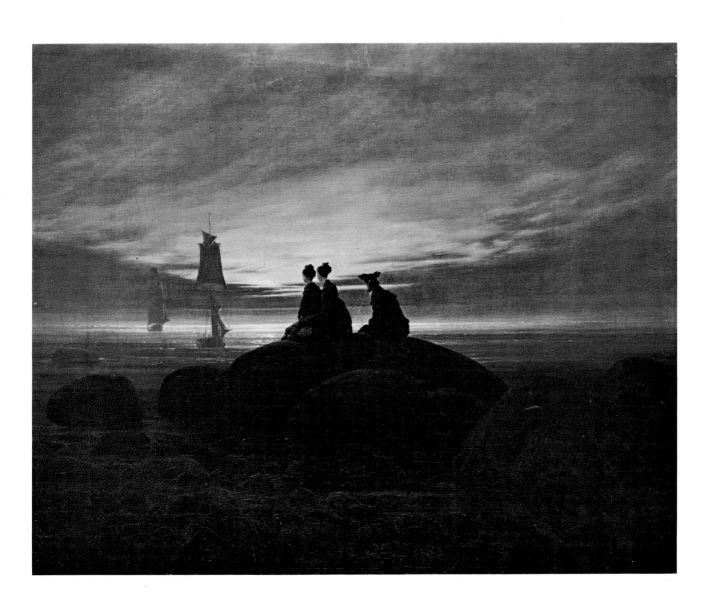

Moonrise over the Sea 1822 (No. 67)
Oil on canvas, 55×71 cm.

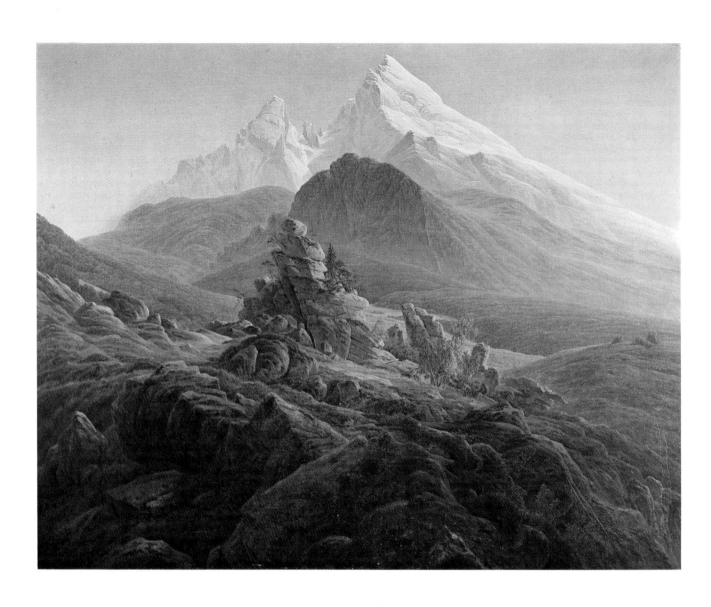

The Watzmann 1824–25 (No. 77)
Oil on canvas, 133×170 cm.

the figure, the helplessness of man. Nevertheless, the gesture of the monk, which may well be a portrait of Friedrich himself, is one of contemplation rather than despair. A representative of the spiritual man, he finds the solution to his loneliness in the pendant, the 'Abbey in the Oakwood' (*Ill. xiii*) in which the burial scene shows him being led to a higher sphere, intimated by the sickle moon in the sky.

As with the Dormund and Schwerin pair, the 'Spiritual' landscape, the 'Abbey in the Oakwoods' is symmetrical, while the monk, despite its compositional innovations, is not.

While these works show Friedrich had now been able to create an emotive symbolism out of the imagery of landscape, the change is also reflected in his approach to the figures within them. The dramatic presentation of his earlier forms has been replaced by a direct, emotive response to nature. Such figures as the monk in the 'Monk by the Sea' or the cripple in the Schwerin 'Winter Landscape' are not involved in a self-determining gesture like the woman in 'Melancholy' *(No. 21)*, but peer instead into the landscape which we ourselves see. The drama that they are experiencing thus becomes also part of our own experience, throwing the emphasis once again upon the landscape. From this time the figures that Friedrich used habitually turn towards the landscape — a motif that he was greatly to expand in later years. Even when they still act out a drama, this is now brought into contact with a much more immediate sense of nature. In the last major picture of his early period, the 'Morning in the Riesengebirge' *(No. 38)*, the rather melodramatic incident of the woman helping the man up towards the cross, is cast in a new mould both by the play of horizontal and vertical axes around the cross and the horizon, and by the immediacy of the effect of the rising sun dispersing the mist lying on the mountains, the outcome of his own experiences in the Riesengebirge.

IV

With the exhibition of this range of large-scale masterpieces at Dresden, Berlin, and Weimar between 1808 and 1812, Friedrich had moved out of relative obscurity into a position, if not of fame, at least of notability. Admired by Goethe and patronized both by the Prussian monarchy and the Grand Duke of Weimar his reputation seemed secure. Yet, the same movement that had brought him to public notice was also to be the cause of his later obscurity. After 1812 royal patronage ceased. While this might be a reflection of the strained circumstances in Germany during the Napoleonic invasions, it is noticeable that after the Wars of Liberation, when such mystical Romanticism was no longer in vogue, this patronage was not resumed.

It was, in fact, the Wars of Liberation that precipitated both the crisis and conclusion of Friedrich's early manner. Friedrich was himself, as is known from H. Schubert's account, deeply concerned with the contemporary political situation *(p. 104)*, and it was such interests that seem to have brought him into association with the 'second generation' of Dresden Romantics, the circle around Kleist and Müller's 'Phoebus' magazine *(p. 106)*. Throughout the wars Friedrich remained a

sympathetic supporter of the movement of pan-Germanic patriotism whose objective was not merely the expulsion of the French, but also the creation of a liberal German state. Within this movement, which was widely supported by artists and writers throughout Germany, the revival of interest in mediaevalism common throughout Europe took on a highly specific direction. It became a symbol for the unification of Germany, focusing on a fanciful Utopian vision of the Holy Roman Empire during the late Middle Ages. Not only were old German paintings enthusiastically collected, but Gothic, then thought to have been of German origin, changed from an antiquarian interest to a living style. It was in this climate that the Boiserée brothers of Cologne, who created the most distinguished collection of early German and Flemish art, were able to initiate the rebuilding of Cologne Cathedral according to the original plans. In the period following the Wars of Liberation, Gothic became established once more in church architecture, and many of the monuments erected to celebrate the victory were replete with mediaeval associations. Yet Germany itself became neither unified nor liberal. The rulers whose power was consolidated after the Congress of Vienna (1814–15), and who were in many cases those, like the King of Bavaria, who had previously benefited from Napoleon's presence in Germany to achieve the status of monarch, gradually brought into their countries increasingly reactionary regimes. Even the liberalism of Prussia was tempered with authoritarianism, and many of the previous 'Freiheitskrieger' – freedom fighters – including Friedrich's friends Görres and Arndt, were persecuted or driven into exile. Meanwhile, mediaevalism in the visual arts became associated with political and religious conservatism.

Friedrich, who remained a democrat throughout his life, had shared the enthusiasm of the patriots before 1814. As early as 1806 he is known to have designed a painting with patriotic connotations showing an eagle hovering above a misty sea, riding the storm.[39] In March 1814, he contributed two subjects to the exhibition held in Dresden to celebrate the liberation from the French, in which he applied his landscape iconography of ancient graves, trees, and winter to suggest a specifically patriotic message *(No. 43)*. The movement too, while engaging him in a more terrestrial redemption, also brought about an interest in more tangible creations. During this period he made a large number of designs for war memorials and monuments *(Nos. 44, 45)* combining armour, weapons, and gothicizing constructions in the current mode that was also used for such schemes by the Prussian State architect Schinkel.

Perhaps even more surprising than these designs is the momentary interest that Friedrich took in architecture at this time, preparing designs in collaboration with his brother Christian for the restoration of the Marienkirche in Stralsund *(No. 53)*. These designs, in which verticality and sparseness are emphasized, display a style of neo-gothicism that is far from archeological exactitude. However, it must be remembered that, in proportions at least, this form of neo-gothicism is not simply a response to a still-prevailing neo-classical taste, but also reflects the peculiar sparseness and economy of the North German 'Backstein' gothic, the style in which the most recurrent images used by Friedrich in his paintings, the Abbey of Eldena, the Marienkirche in Greifswald, and the walls of Neubrandenburg, were built.

Few of Friedrich's designs were executed, and this may have aggravated a disillusionment with the present political situation and even the employment of

Gothic as a living style. As early as 1814, however, he had written to his friend the patriot Ernst Moritz Arndt, when they were planning a memorial for their friend Scharnhorst, who had died in the Battle of Leipzig, that he doubted if any such monuments to patriots could be erected 'as long as we remain the minions of the monarchs'.[40] His own epitaph on the patriotic movement 'Ulrich von Hutten's Grave' (*No. 72*) seems to have abandoned all hope of terrestrial liberation. Painted in 1823, the three hundredth anniversary of the death of the patriot Ulrich von Hutten, it shows a man in the mediaevalizing costume of the 'Freiheitskrieger' in a Gothic ruin, looking at a monument to Hutten. On the sides of the monument are the names of prominent figures in the wars of liberation since exiled by the Prussian government. On the walls behind is a statue of Faith with her head broken off.

V

The painting 'Ulrich von Hutten's Grave' demonstrates how Friedrich continued in later life to use landscape symbolically. Nevertheless, in the period following the Napoleonic wars his style underwent considerable changes. The use of the motif of direct contrast between an image and an undefined space behind was becoming modified through more complex rhythms, in particular the creation of elaborate framing devices in the foreground, as in the 'Two Men contemplating the Moon' *(No. 58)*, and the extension of space towards the background. It may well be that this interest in new spatial structures was related to his architectural interests. As Eimer has pointed out, such pictures as the 'Monastery Graveyard' *(Ill. 15)* show both an invented building – something unprecedented in his art before, when he always depended on ruins he had sketched – and a tectonic sense in the broad disposition of the trees. At the same time motifs of views of city spires, through gates and from balconies, became more frequent *(No. 51)* and he developed a fascination with the complex spatial arrangements of high-masted sailing ships. After his visit to Greifswald in 1815 he produced a series of harbour pictures in which these masts were often brought into direct association with the spires of churches, creating analogies similar to those he had previously used for Gothic edifices and trees.

However, these architectural interests were part of a much more basic change in Friedrich's art which shows a movement away from the esoteric atmosphere of his earlier work towards an actual and more contemporary world. During the 1820s this tendency was to increase. As can be seen, for example, by comparing the 'View in the Elbe Valley' of circa 1807 *(No. 32)* with the 'Village Landscape' of 1822 *(No. 66)* the movement towards a more elaborated space seen after 1815 has now been completed. In the place of enigmatic silhouettes rising against a distant background, the horizon of vision becomes raised, and the central image is elaborated within a system of rising diagonals. Often, as in 'Moonrise over the Sea' *(No. 67)* and the 'Watzmann' *(No. 77)*, these diagonals move across the central line of vision, so that while the spatial development is quite different from his earlier style, the emphasis on the picture plane and the rectilinear relationships

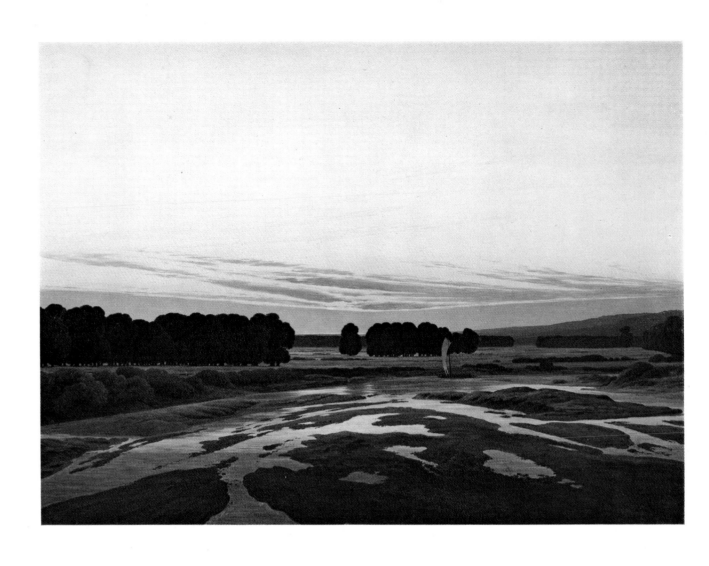

The Large Enclosure near Dresden 1832 (No. 100)
Oil on canvas, 73·5 × 102·5 cm.

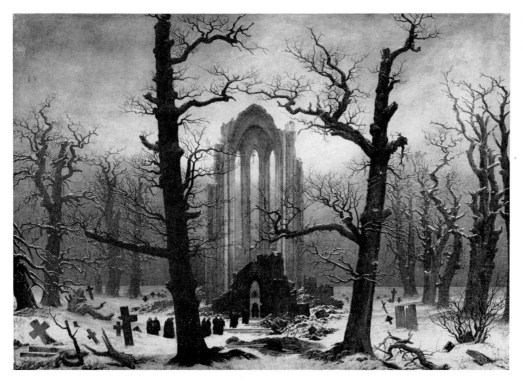

remains. The dramatic tonal and atmospheric contrasts become replaced by fresher colours, the use of bright greens, yellow, and pale blue. His treatment of form, too, becomes less mannered. In the place of attenuated towering images the masses are more broadly treated – a change that can be seen, for example, by comparing the treatment of the fir trees in 'The "Chasseur" in the Woods' *(No. 43)* with those in 'Early Snow' *(No. 92)*.

Just as Friedrich took a growing interest in architectonic structures after 1815, so in the 1820s his imagery shows a significant move towards modernity. The repertoire of hermits, soldiers, wanderers and peasants virtually disappear while figures in contemporary dress predominate. His metaphors on transience, too, become less contrived. In the place of misty atmospherics and visionary edifices are such images as ships at sea. Crosses, for once, become rare, and even ruins appear less esoteric. In the painting in Berlin *(No. 76)* the Abbey of Eldena appears, for once, as it actually looked when Friedrich sketched it, with the small huts that later generations had thrown up against the foot of the decaying edifice.

In many ways these transformations are reflected in a change of life. Although Carus remarked that Friedrich's marriage to the young Dresden girl Caroline Bommer in 1818 brought about little alteration in his style of living the new-found domesticity does seem to have emphasized new resonances in his imagery. The motif of the figure looking into the landscape, which Friedrich had already made his own during his early years as an oil painter *(No. 39)*, now became extended in his repertoire, throwing greater emphasis upon the response of the figures themselves. In his 'Woman at the Window' *(No. 65)* the theme of the view through the window which had been treated by him earlier in terms of a pure allegory of forms *(Ill. xvi)* becomes transformed by the presence of his wife. Her timid curiosity as she looks, leaning slightly to one side, into the future, brings an affecting humanity to a frontal scheme. On his journey to Greifswald to introduce his new wife to his Pomeranian relatives he experienced his familiar Baltic themes for

once in the company of more conventional sightseers, and in subsequent years he was often to return to the theme of groups of figures looking at nature, in which their differing gestures and positions reveal different depths of response and understanding of the scene before them *(Nos. 58, 67)*. In one of his last works, the 'Stages of Life' *(No. 102)* this motif culminates in a theme of mortality being developed in terms of a complex interplay of personal relationships.

The main influence behind these pictorial changes seems to have been the new friends he made at this time. Although now in his forties, he did not disdain to respond to a younger generation of artists who had gathered in Dresden. Already in 1811 he had become the close friend of Georg Kersting, an artist whose domestic interiors may have inspired such works as 'Woman at the Window' *(Nos. 65, 113)*.

From Carus, whom he met in 1817, he had perhaps a little to learn in terms of vision. However, as with a number of his pupils, he did occasionally make use of Carus' motifs for his own works.

The most important of these artists of the younger generation for Friedrich was undoubtedly Dahl *(p. 96)*. This Norwegian artist, fourteen years younger than Friedrich, first came to Dresden in 1818. Already while studying in Copenhagen he had been moving under the influence of Eckersberg towards a new freshness of manner, and his interest in the direct experience before nature was to lead, as it had done with Constable, to the making of *plein air* oil studies of skies. Although Dahl was himself deeply drawn towards the subjective truth of Friedrich's

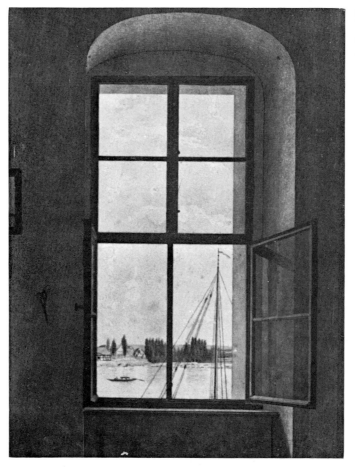

xvi. 'View through a Window'
Wash, 1806
*Kunsthistorisches Museum,
Neue Galerie, Vienna*

experience of nature *(p. 108)* and often made use of Friedrich's imagery he showed little desire in his own works to synthesize phenomenal appearance through a more internal vision.

Despite their different outlooks, Dahl and Friedrich became closely associated. After a visit to Italy where, like Turner and Corot, he discovered a new sensibility for breadth and tonality, Dahl returned to Dresden. From 1823, having, like Friedrich, married a Dresden girl, he shared a house with the older artist on the banks of the Elbe. Significantly it is in these years that Friedrich's colours become brighter and his paint becomes applied more freely and with more impasto. Despite his former remarks to Goethe, Friedrich, under the influence of Dahl, even made a number of dated oil sketches of clouds *(No. 73)*. He also took a renewed interest in topography, and considered painting a series of water colours for a book of engraved views of Rügen *(No. 75)*. If this scheme may have been primarily a commercial undertaking he was nevertheless at this time prepared to abandon his normal practice of synthesizing compositions and use complete sketches as the basis for an oil painting, notably in the 'Landscape with Dyke and Mills' *(Nos. 8, 71)*. Perhaps it was through Dahl, too, that he renewed his acquaintance with traditional intimist landscape painting. Such works as the 'Morning' of the Hanover cycle 'The Times of Day' *(No. 60)* seems, in the figures in boats, to echo the river scenes of Van Goyen, while the 'Village Landscape' *(No. 66)* is a reworking of the traditional theme of the pastorâle.

The early 1820s was a period of great productivity for Friedrich, and while painting a large number of small paintings he also continued to exhibit works of a large format like the 'Watzmann'. The difference between these works and early mountain subjects like the 'Morning in the Riesengebirge' reveals strikingly the way in which the more subtle elaboration of space in his works of the 1820s led in the large works to a reworking of the frontal image. Many of the works in this format, which frequently depict extremities of nature that Friedrich himself had never experienced, may have been deliberate formulations of a nordic landscape on the grand scale. The first of his polar paintings, a genre in which he created the masterpiece in Hamburg *(Ill. xvii)*, was apparently painted to form a pendant to a picture by Martin von Rohden, a German artist settled in Rome, which represented an Italian idyllic scene as an 'earthly paradise'. Similarly, it has recently been suggested[41] that the 'Watzmann' itself may have been painted by Friedrich to form a contrasting interpretation to a work sent to the Dresden academy from Rome by the young Dresden artist Ludwig Richter in 1824 *(p. 109)*. In his compression of planes and rigorous linear organization Friedrich certainly builds up a sublime and powerful image with an authority quite alien to the domesticity of Richter's treatment.

VI

However, Friedrich was hardly in a position to stem the tide of naturalists, mediaevalists, and Roman landscape painters that seemed to grow around him in increasing profusion in his later years. His large landscapes of the 1820s, while

admired by a few, were fast becoming out of date. To his other troubles was added ill health. In 1825-6 he suffered a severe illness, the first of the lapses of strength that were to lead to his stroke in 1835. For a time his ability to work was restricted, and he returned to painting in sepia, often reworking themes from his earlier years, like the 'Times of Year' *(Nos. 78–85)*. Although he was able to return to oil painting, he seems to have been permanently shaken by the experience and this, together with his fading popularity, led to the development of a persecution complex. He became increasingly mistrustful, and even suspected his blameless wife of unfaithfulness. Terrestrial paganism became a preoccupation, and in these years he returned to themes of cemeteries, snow, and ruins. It was in this frame of mind, too, that he wrote his 'Observations on a Collection of Pictures' *(p. 102)* in which he sets against his own concept of spiritual empathy with the divine in nature stringent criticisms of the contemporary world. In painting, the art of the mediaeval revivalists appeared as false piety, the imitation of the form rather than the spirit of religious art. Similarly the naturalists, with their skilful simulation of the appearance of nature seemed to herald an age of soulless material-ism. In the same spirit he viewed with horror the effects of the industrial revolu-tion spreading from England to Germany. Reviewing a work in the new English technique of steel engraving he concluded that it had been carried out 'either by an Englishman or a machine'.

Yet despite the growing bitterness of mood, it is in the 1830s that he produced some of his most lyrical works. Paintings like 'The Large Enclosure near Dresden' *(No. 100)* and 'The Stages of Life' *(No. 102)* use the liberation of colour that he experienced in the 1820s to create a heightened awareness of atmosphere. The fascination with scenes of twilight and sunrise has now become expressed with a

xvii. 'Arctic Shipwreck' 1824
Kunsthalle, Hamburg

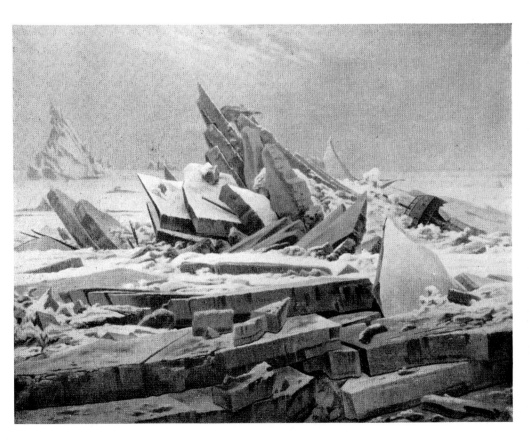

40

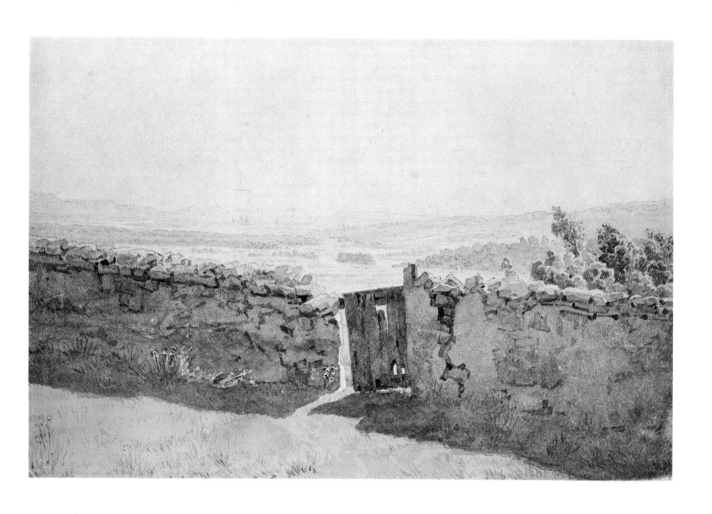

Landscape with Crumbling Wall 1837 (No. 111)
Pencil and Watercolour, 12·2 × 18·5 cm.

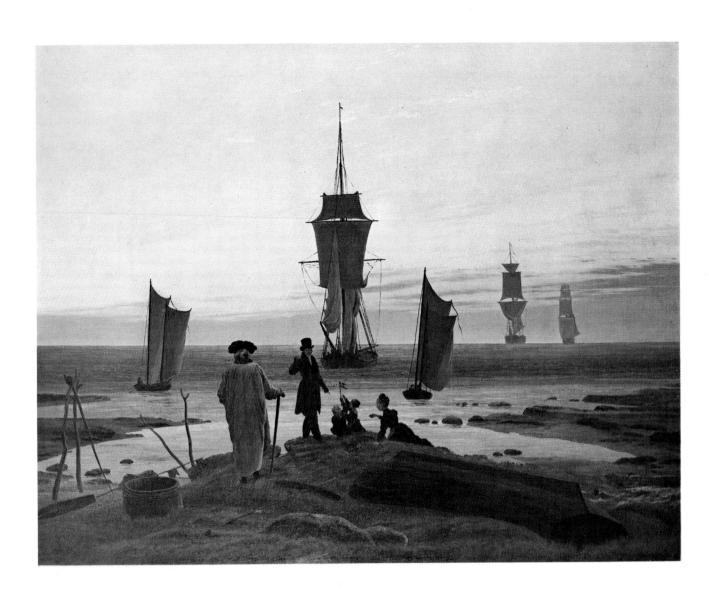

The Stages of Life 1835 (No. 102)
Oil on canvas, 72·5 × 94 cm.

new refinement in colour ranges of blue, silver, orange, and yellow. The paradoxical unification of internal and external vision in these works appears complete. They are at the same time masterpieces of colour symbolism and the naturalistic rendering of light. Perhaps it is significant that he should at this time have become preoccupied with the interplay of differing light effects, combining in such works as the 'Evening on the Baltic' *(No. 98)* and the 'Solitary House in a Pine Wood' *(No. 105)* the effects of natural and artificial illumination. Indeed, colour, reflection, and light all become dominating sources of imagery. In 'The Large Enclosure' the heavens are reflected in and illuminate the water on the earth, while the white sail drifts towards a vista of blue and gold partly concealed by darkened trees. At the same time the striking curvature of the foreground and the sky show how he was still capable of arriving at totally unique designs for subjects that moved him deeply.

In such poignant images the persisting allegories on transience seem to have become deeply personal. Yet even here the fatalism of Friedrich is the predominating characteristic. In 'The Stages of Life' the man in the cloak and stick walking towards the harbour is Friedrich himself, yet the gestures of the other figures, which include Friedrich's wife and children are curiously unmoved. The man nearest the harbour, the most enigmatic figure of all, beckons Friedrich forward and points to the children, his curious expression and gestures apparently indicating an inevitable and irreversible process.

Meanwhile Friedrich's physical condition deteriorated. After his stroke in 1835 his powers were seriously limited. Despite a partial recovery he was only able to paint a little in oils, and those that he executed showed a weakened hand *(No. 105.)* Once more he returned to working in sepia and watercolour, but while many of these contain old images, the shadow of death can be felt even more strongly in them. In a startling series of sepias he showed huge birds waiting in graveyards as symbols of death *(No. 107)*. Though haunting in the way that they loom against the horizon, they express the fear of mystery rather than of horror. Often they are linked with the symbol of Christian salvation, the sickle moon which, as in 'The Stages of Life' rises behind the figures. By this time Friedrich was an almost totally forgotten figure. Incapable after 1838 of executing more than the smallest pictures he lived in great poverty, increasingly dependent for the support of himself and his family on the charity of friends. Visitors like Zhukovsky who met him in these years recorded sadly his diminished powers. His death in May 1840 caused little reaction in artistic circles, although his friend Carus published an appreciation of him in the 'Kunstblatt'. A year previously, Mrs Jameson had already removed his name from the list of German artists in the second edition of 'Visits and Sketches at home and abroad'.

During the remainder of the nineteenth century, Friedrich's art was remembered no more than occasionally as a curiosity, and it was only in the 1890s with the researches of the Norwegian art historian Andreas Aubert, that his art began to re-emerge.[42] From this time he excited increasing attention amongst artists and scholars in Germany, and his imagery found many echoes in the development of a symbolic landscape by such northern European artists as Munch, Hodler and Klee. Yet despite the significance of his symbolism and sense of presence his art had been reborn in a changed world. In the place of Friedrich's steadfastness and simple faith were more complex and confusing spiritual tensions. Such works as

Munch's 'The Lonely Ones' *(Ill. xviii)* seem to be associated with the imagery of Friedrich. Like the earlier artist's Baltic coast scenes, two figures stand on a bare shore staring out into the sea. Yet there is no sky for them to look at, and no divinity to be found in the surrounding water; instead they find reflected back upon themselves their own isolation.

It is difficult to imagine what Friedrich would have made of such transformations of his ideas. Yet perhaps he would have accepted the judgement for, with characteristic fatalism he appears to have resigned himself to leaving posterity to make the final assessment on his art.

> 'I am not so weak as to submit to the demands of the age when they go against my convictions. I spin a cocoon around myself; let others do the same. I shall leave it to time to show what will come of it: A brilliant butterfly or a maggot.'[43]

xviii 'Two People' (The Lonely Ones)
Edvard Munch
1899

HANS JOACHIM NEIDHARDT

Ernst Ferdinand Oehme and Caspar David Friedrich

'E. F. Oehme, one of the younger artists in Friedrich's circle, is known by name, but few of his works are known.' This comment was made by Paul Ortwin Rave in 1925 on the acquisition of two of Oehme's paintings, 'Scharfenberg Castle by Night' and 'The Wetterhorn', by the National Gallery in Berlin.[44] Up until now lack of knowledge of the works of this important painter of the German Romantic Period has been the reason for his being disregarded or misrepresented in previous Histories of Art.

The dilemma faced by all those artists who were pupils of Friedrich, or who temporarily came under his influence, was the difficulty of asserting themselves in the face of the solitary greatness and marked individuality of his own outstanding work, for Friedrich's paintings were to such a high degree an expression of subjective feelings that his pupils avoided straightforward imitation. The only members of his circle to achieve artistic acclaim were those whose period of dependence on his art was a passing phase in their quest for their own identity. So we have the paradoxical situation whereby Friedrich's best pupils are not those who followed him most faithfully, but those who came to terms with his style by integrating it with their own work. Among these gifted artists, like August Heinrich and Carl Gustav Carus, Ernst Ferdinand Oehme may be mentioned.

In 1819 Oehme, then aged 22, went to the Dresden Academy, shortly after Christian Dahl had moved down from the North to reside in the town. Oehme became a private pupil of Dahl and at the same time probably made the acquaintance of Dahl's friend, Caspar David Friedrich. Oehme was so attracted by Friedrich's paintings that he took them as his models.

Even the titles of two works, now lost, exhibited at the Academy Exhibition in 1820 – 'Moonrise after a Thunderstorm' and 'Tombstone at Dusk' – show signs of Friedrich's influence. But the best impression of the extent to which Friedrich had influenced Oehme is probably conveyed by his 'Cathedral in Winter', completed in 1821 *(No. 124)*.

The Gothic facade, viewed through a high-pointed arcade, reminds one of Meissen Cathedral. One can assume that Oehme was inspired by Friedrich's 'Monastery Graveyard in the Snow', shown at the Academy Exhibition in 1819 *(Ill. xv)*[45]. From this he took the symbolically most important motif of the open Gothic church portal, revealing the High Altar approached by monks in black habits. The principle, whereby one's view is directed from the foreground to the centre of action in the background by means of a dual framework, has also been used. In Oehme's painting the two dark oak trees of the Monastery Graveyard have been changed into the sharp geometric shapes of the Gothic columns, through

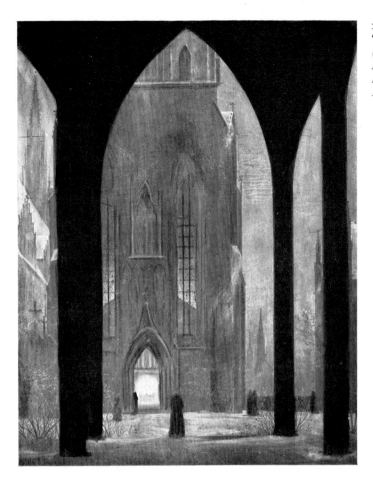

xix. Ernst Ferdinand Oehme,
'Cathedral in Winter' 1819
*(No. 120) Staatliche
Kunstsammlungen,
Dresden, Gemäldegalerie,
Neue Meister.*

which one can see a completely intact building instead of a church in ruins.[46] So, compared with Friedrich's work, Oehme's painting takes on a completely different emphasis. The church appears here not as the ephemeral work of man ravaged by the passage of time, but as a solid fortress, beaten by winter storms but resistant to time's onslaughts.

Even if a number of motifs in the painting have been borrowed from Friedrich, one must give Oehme credit for his more independent use of colour. The fascinating effect of the picture is achieved by the contrast between cold and warm tones. The candles burning on the High Altar are the only source of warm light, shading off towards the top of the picture and illuminating the two high windows on the facade from the inside. The light shining forth from the cross, lightening the darkness, as a study of an optical phenomenon and at the same time conceived at a higher symbolic level, is Oehme's own idea. In this picture the young artist has already gone farther than simply imitating Friedrich. The latter's Romantic experience of nature stands in contrast here with a cultural experience, the image of the Mediaeval Church as a centre of life, symbolically expressed in the unique language of the Dresden Early Romantics.[47]

In 1822, when Oehme went to Rome on a grant from the Saxon Crown Prince Friedrich August, he half-heartedly adopted the Classical-Heroic style of the landscapes of Joseph Anton Koch. The sentimentally poetic way in which he too tried to depict the southern landscape incurred the old master's wrath. Like Friedrich, Oehme was inclined to melancholy. He was, as his friend Ludwig Richter describes him, 'a night bird which was happiest flitting to and fro at dusk

and at night'. He goes on, 'Oehme adapted himself to prevailing ideas, as far as he could, and painted some gay Italian landscapes, in which he went little beyond true to life representation of nature. Later on his best works were always mood pictures in a quite individual, highly poetic style. One could call him the Lenau of the painters'.[48]

His experience of the South and acquaintance with Koch's ideal landscapes enriched his art through the new possibilities it presented, but, as Ludwig Richter says, it did not cause him to change course. In 1825, when he had returned to Dresden, he continued to work on melancholy, patriotic themes like 'Mountain Folk at Prayer before Daybreak' (1826), 'Scharfenberg Castle at Night' (1827) and 'Procession in the Mist' (1828). But if he takes an Italian theme like the 'Moonlit Night on the Gulf of Salerno' (1826), a consequence of his southern studies, it becomes 'romanticized' in the manner of Novalis and comes surprisingly close to Friedrich's seascapes.[49] In the 'Procession in the Mist' *(No. 125)* Oehme is again quite clearly indebted to Friedrich. The procession of monks moving in pairs from the left foreground towards the background of the picture is again taken from Friedrich's 'Monastery Graveyard in the Snow'. The Romantic transformation of the scene is however achieved by means of the mist, which makes the trees in the centre appear hazy and ghost-like and seems to swallow the head of the procession.[50] In no other picture does Oehme come closer to Friedrich's conception of a sharply defined, clear-cut foreground standing in contrast with a vast, immeasurable, misty background. Towards the top of the picture the mist begins to clear; here it is bright and the sky is blue. In contrast to Friedrich's practice, the procession of monks links the two planes without destroying the tension between them. That 'symbolic destruction of time and space' (Friedrich Schlegel), which is so characteristic of Friedrich's works, occurs here again in Oehme's

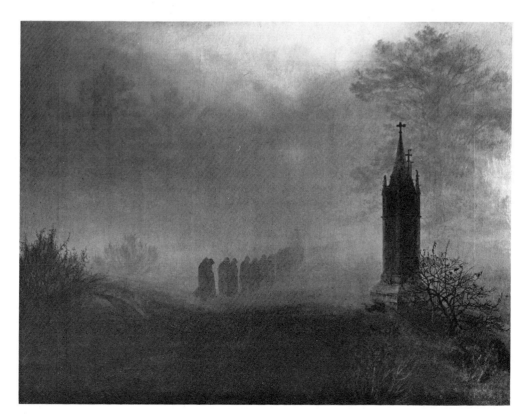

xx. Ernst Ferdinand Oehme, 'Procession in the Mist' 1828 *(No. 125) Staatliche Kunstsammlungen, Dresden, Gemäldegalerie, Neue Meister.*

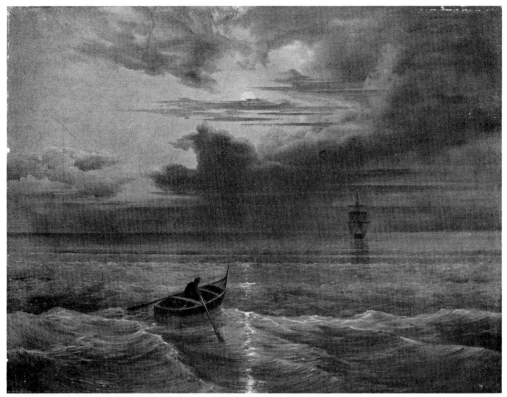

xxi. Ernst Ferdinand Oehme,
'Moonlight Night on the
Gulf of Salerno' (1826)
*Staatliche Kunstsammlungen,
Dresden, Gemäldegalerie
(Pillnitz)*.

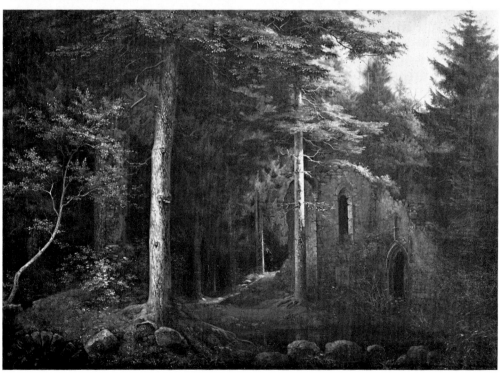

xxii. Ernst Ferdinand Oehme,
'Ruin of a Gothic Church
in a Wood' (1841) *Saamlung
Georg Schäfer, Schweinfurt*.

painting. His contemporaries were already interpreting the picture as a symbolic representation of earthly existence.[51] But in the early thirties, when the Romantic movement was on the wane, not only Friedrich, but Oehme too, began to sense the change in public opinion. During a discussion at the Leipzig Art Exhibition in 1837 his paintings 'Churchyard in Stormy Rain' and 'Priesnitz at Dusk' were condemned as 'scenic vampirism' and rejected as being behind the times. The 'grave-hungry vampire of the palette' is recommended to paint 'gay scenes, fresh green trees and blue mountains'.[52] This warning given to the Early Romantic Oehme was justified but applicable to only one aspect of his art. For from the beginning of the thirties Oehme inclined more and more towards Biedermeier Realism and had successfully developed those sides of his work which leaned towards Johann Christian Dahl and Ludwig Richter, with the result that he was able to make an independent contribution to landscape painting of the period. So in the 'Ruin of a Gothic Church in a Wood' (1841) there is still an echo of the spirit of his master, who died in 1840, but in concept and pictorial treatment it no longer shows a trace of Friedrich. The poetic, almost magical atmosphere is similar to that of Richter's painting 'Genoveva Alone in the Wood' (Hamburg Kunsthalle), which originated in the same year. The ruin, which has lost its symbolic significance, arouses no nostalgic thoughts of the past but has a more friendly, enchanted atmosphere. It has become part of nature. With the finely observed effects of sunlight falling on the darkness of the wood, this work by the mature artist clearly displays a graphically realistic approach.

In place of Friedrich's sweeping views, true to his conception of the vastness and infinity of nature, there appear more closely observed motifs, idyllic views of nature in the manner of Adalbert Stifter, in the subdued style of Biedermeier Realism. As a reflection of the increasing commercial and industrial growth in the thirties the bourgeoisie began to turn away from the ideas, dreams and fantasies of the Romantic Period and to lean towards a well-defined, even if limited, view of reality. Oehme's paintings form part of this development, and show how the strict, spiritual art of Caspar David Friedrich underwent an interesting modification in the spirit of Late Romantic and Realist trends.

NOTES AND REFERENCES

1. A. Jameson, *Visits and Sketches at Home and Abroad*, London, 1834, Vol. II, p. 144.
2. A. W. Schlegel, *Vorlesungen über Söhone Literatur und Kunst*, Stuttgart, 1884, I, p. 19.
3. Hinz (Lit. *95*) p. 251.
4. F. W. J. Schelling, *Über das Verhältnis der bildenden Künste zu der Natur* (Sämmtliche Werke, VII), Stuttgart, 1860, p. 292.
5. Hinz (Lit. *95*) p. 158-9.
6. Hinz (Lit. *95*) p. 82.
7. 'Mein Begräbnis', Exh, *Dresden Academy*, 1804 (206).
8. The technique of associating signed and dated studies with finished paintings first pioneered by Von Einem (Lit. *43*) has been used increasingly to provide *termini ante quem* for a large number of Friedrich's works (Lit. *92*). Börsch-Supan's stylistic analysis (Lit. *74*) has provided an account of the development of Friedrich's art which has been the basis of the arrangement of this exhibition.
9. Hinz (Lit. *95*) p. 200.
10. Hinz (Lit. *95*) p. 202.
11. Hinz (Lit. *95*) p. 200.
12. Hinz (Lit. *95*) p. 233.

13. c.f. T. Gray *Elegy written in a Country Churchyard, with versions in Greek, Latin, German, Italian and French*, London, 1839.

14. To Kosegarten, *Rhapsodien*, II, Leipzig, 1794, p. 147.

15. c.f. Sumowski (Lit. *100*), pp. 11-12.

16. 'Petrus auf dem Meer' 1806/7, Kunsthalle Hamburg Inv. No. 1007 (c.f. *No. 32*).

17. In 1802, Kosegarten published a translation of T. Garnett's *Observations on a Tour through the Highlands*.

18. C. G. Carus, *Reise nach der Insel Rügen auf Caspar David Friedrich's Spuren*, Dresden, 1941, p. 8.

19. Hinz (Lit. *95*) p. 222.

20. Daniel Runge 'An Kosegarten'. c.f. Sumowski (Lit. *100*) p. 12.

21. Journal des Luxus und der Moden, XXIII, 1808, p. 182ff (Lit. *100*) p. 25.

22. Dated 25 November 1799. c.f. O. Schmitt, 'C. D. Friedrich's Radierung mit der Widmung an Quistorp', Balt. Studien N.F. XLII, 1940, p. 212.

23. c.f. Sumowski (Lit. *100*) p. 47-8.

24. Schmitt (Lit. *40*).

25. Dahl's report to the Dresden Academy.

26. c.f. Sumowski (Lit. *100*) repr. 45, 46. In the 'Berlin' sketchbook No. 22 there is a study of the trees after Juel's study for the 'Tronchin' portrait.

27. Hinz (Lit. *95*) p. 140.

28. Dated 1799. Ashmolean Museum, Oxford. c.f. *Kunstausstellung* Kühl, Dresden 1928, No. 39. (Information kindly provided by Dr Carl-Wolfgang Schümann.)

29. c.f. Lit *17* p. 198.

30. Carus 'Reise nach Rügen' (c.f. note 18) p. 23.

31. c.f. Sumowski (Lit. *100*) p. 58.

32. Goethe, Artemis Ausgabe, 1954, vol XIII, pp. 452-4.

33. Hinz (Lit. *95*) p. 256.

34. Goethe, Artemis Ausgabe, 1954, vol. XIII, pp. 722-3.

35. Hinz (Lit. *95*) p. 153.

36. c.f. Sumowski (Lit. *100*) p. 36.

37. Hinz (Lit. *95*) p. 156.

38. Lit. *74*.

39. G. H. Schubert *Lebenserinnerungen*, Erlangen, 1855, II, p. 182.

40. Hinz (Lit. *95*) p. 25.

41. c.f. Lit. *101*.

42. Lit. *16*.

43. L. Eitner, *Neoclassicism and Romanticism*, New Jersey, 1970, vol. II, p. 56.

44. P. O. Rave, *Neuerwerbungen der Nationalgalerie*, in Der Kunstwanderer, 1924/5, p. 388.

45. W. Sumowski, *Caspar-David-Friedrich-Studien*, Wiesbaden 1970, p. 83.

46. Carl Gustav Carus took the same theme for a sketch 'View of a Gothic Cathedral' (through a Gothic window), (1832), chalk, 23·7 × 24·2 cm, Folkwang Museum, Essen.
E. Ruhmer, *Der Dom – eine romantische Vision,* in Die Kunst und das schöne Heim, 59, 1960/61, pp. 86-91, Plate 7.

47. On the few occasions that Friedrich depicts intact churches in his pictures they are either of secondary importance to the landscape or (as in G. Eimer's series *Vision der Kirche I bis IV*) are conceived as de-materialized phenomena, attainable only in thoughts, dreams and wishes. G. Eimer, *Caspar David Friedrich und die Gotik,* Hamburg 1963, Plates 7-10.

48. Ludwig Richter, *Lebenserinnerungen eines deutschen Malers,* edited by Erich Marx, Leipzig 1944, p. 232.

49. 'This little picture, portraying a calm night at sea, embodies the sweetness and peace of sleep itself, apparently world-wide. The sea breathes in the gentle swell and the moon shines softly through a light, cloudy mist. A wakeful monk rows alone across the sea, where a large ship lies at anchor in the far distance. This solitary figure, huddled in his cloak, set against the vast, immeasurable sea, appears to have a mystical and dreamlike element, which gives the painting its own distinctive charm.' 'Artistisches Notizenblatt', No. 19, October 1826. Article entitled *'Blicke auf die Ausstellung der Königlichen Sächsischen Akademie der Künste in Dresden, 1826,* p. 73.

50. On mists and iconology in the Romantic Period, c.f. Sumowski (lit. 100), pp. 91-92.

51. 'The heavy morning mist, through which one can see the chapel [!] and trees and the funeral procession of the monks disappearing into the mist, just like the end of our earthly existence, whose colourless gloom is illuminated only by the homely cross of our faith.' C. A. Böttiger in Artistisches Notizenblatt zur Dresdner Abendzeitung, 18.1828, p. 70.

52. Paris H. (i.e. Jeanette von Haza), *'Erste Eindrücke eines Laien auf der ersten Leipziger Kunstausstellung 1837',* Leipzig 1838, pp. 51-52.

HELMUT BÖRSCH-SUPAN

Catalogue

These catalogue entries are abridged versions of interpretations of Friedrich's pictures contained in a catalogue raisonné which is still in manuscript form, and which will appear in 1973. This catalogue raisonné, which includes Friedrich's paintings, finished drawings, and prints, utilizes the papers left behind by the Friedrich scholar, Karl Wilhelm Jähnig, who died in 1961.

The limited size of this exhibition catalogue does not allow any extensive substantiation of the interpretation of the pictures proposed here. If one is to decipher Friedrich's pictorial symbolism, one has to look at his entire oeuvre. Similarly, detailed justification for the dating has had to be omitted, and it has only been possible to indicate the use of studies from nature in a few individual cases.

Dimensions are given in centimetres, height before width. Numbers shown under the heading 'Lit:' refer to the Bibliography on page 98.

On account of last minute decisions relating to their condition Nos. 24 and 25 have not been included in the exhibition.

I

Early Work, 1789-1807

From the period before Friedrich attended the Copenhagen Academy (1794–1798), only a few drawings and two tentative attempts at etching have survived. The impact made on him by his stay in Copenhagen can be observed in a group of watercoloured pen drawings done in a style which still derives from the late Rococo tradition *(No. 2)*. They depict scenes from the area around Copenhagen, and already show signs of an attempt to convey allegories through the medium of such motifs.

In 1798, Friedrich went to live in Dresden. The following years were characterized by an intensive searching in a variety of directions. The works he executed – studies from nature, views and composed landscapes, portraits and figure compositions – were partly illustrative in character, and partly symbolic, and expressed an idea by means of atmosphere and landscape attributes. Three such drawings were executed as woodcuts by Friedrich's brother, Christian, about 1803–4. Under the influence of Dresden artists like Philipp Veith, Johann Christian Klengel, and Adrian Zingg, Friedrich's drawing became more disciplined and systematic. A stay on the Baltic Sea in 1801–1802 brought about a clarification of Friedrich's organization of space, and awoke his feeling for broad expanses. He subsequently did a number of large sepia drawings which established his reputation as a painter. A later stay on the Baltic Sea in 1806 resulted in further advances in this process of clarification of pictorial form. Foreground and background now came to signify different levels of reality in a religious sense, and the more prominent elements of the landscape were introduced into this space and so ordered that they could both be observed with clarity and carry crucial significance for the meaning of the picture.

1 **A Page of Writing** Schriftblatt
Pen and watercolour, 20·2 × 31·8 cm.
Inscribed: 'C. D. Friedrich d.lt April Greifswald d
1 April 1789'
Lit: *92* No. 5
Kunsthalle, Hamburg

Pages of writing with devotional texts like this one are the earliest known works by Friedrich. Those that have come down to us are dated 1 October 1788, 1 November 1788, 1 January 1789, 1 March 1789, and 1 April 1789.[1] It is most likely that Friedrich wrote them out to serve as a kind of motto for each new month.

2 **Landscape with Pavilion** Landschaft mit Pavillon
Pen, wash, and watercolour, 16·7 × 21·6 cm.
Lit: *74* p.65; *92* No. 330; *100* p.54, 158, 160, 182
Kunsthalle, Hamburg

The building shown is a house near Klampenburg, north of Copenhagen. Stylistically, this work belongs with several other watercolours, dated 1797, which depict park scenes from the surroundings of Copenhagen.[2] Though these works seem to be simple views, they nevertheless have an allegorical significance.

3 **Tragic Scene on the Seashore** Trauerszene am Strand
Pen and sepia, 18·7 × 23·7 cm.
Inscribed: 'den 26 Mai: 1799 invent'
Lit: *74* p.65; *92* No. 18; *100* p.7, 49, 166, 182
Städtische Kunsthalle, Mannheim

This comes from a sketchbook which is now in the Berlin Nationalgalerie. It is the companion piece to a drawing which depicts a young sailor bidding farewell to his father.[3] In the scene represented here, the family is evidently mourning the loss of their son who has died at sea. The ivy which links the cross and the gravestone symbolizes the hope of resurrection. In Friedrich's work, a stunted willow signifies both death and resurrection because of the way in which it always brings forth new shoots. Despite a certain awkwardness of drawing, this is a significant composition, for it provides evidence of an attempt to develop a system of symbolic motifs together with the formal values such a system demands.

4 **Self-Portrait** Selbstbildnis [repr. p.8]
Black chalk, 42 × 27·6 cm.
Lit: *30 ; 60* p.16, 119; *92* No. 250; *100* p.46, 48, 51, 183
Royal Museum of Fine Arts, Copenhagen

A gift from Friedrich to his friend Johann Ludwig Gebhard Lund, a fellow student at the Copenhagen Academy, this work comes from the latter's bequest to the Copenhagen Department of Prints and Drawings. It is described by Friedrich in a letter of 5 November 1800, that is preserved in the Royal Library, Copenhagen. This portrait, with its almost confessional appearance, seems to have been a token of friendship. The general conception of the picture suggests the influence of the Dresden portrait painter Anton Graff (1736–1813).

5 **A Scene from Schiller's 'die Räuber'** Szene aus Schillers 'Räubern'
Pen and sepia, 20·3 × 26·3 cm.
Lit: *92* No. 208; *100* p.49, 166, 183
Museum der Stadt, Greifswald

About 1800–1801. A depiction of the moment in Act 5, Scene 7 when Amalia says to Karl Moor – who is surrounded by brigands – 'You're certainly a master of murder. Draw your sword, and I'll be happy.' Friedrich had been working on illustrations to 'die Räuber' as early as 1799. The style of drawing, and the proportions of the figures show the influence of his Copenhagen teacher Nicolai Abildgaard.

6

 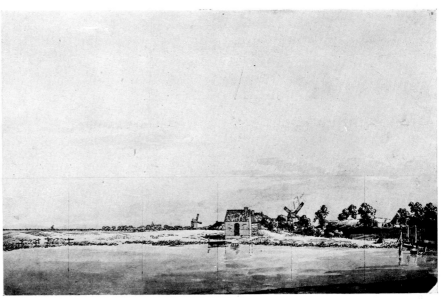

6 **The Ruin at Eldena** Ruine Eldena [repr. p.53]
Pen and wash, 17·5 × 33·5 cm.
Inscribed: 'den 5 Mai 1801'
Lit: *34* p.169; *51* p.69; *62* p.13; *92* No. 260; *100* p.140,
160, 163, 183, 194
Staatsgalerie, Graphische Sammlung, Stuttgart

A view taken from the south-west, of the east end of the
Cistercian Abbey near Greifswald. This study from nature
was used later for two watercolours and a sepia drawing.[4]
Friedrich made a number of drawings of this ruin from
various sides. He often used this motif as a symbol of an
outmoded form of religious belief and the transitory nature
of earthly life (cf. *Nos. 76, 82* and *85*).

7 **Studies of Plants** Pflanzenstudien
Pen, pencil, and wash, 37 × 23·7 cm.
Inscribed: 'den 19 May 1801, Sonne', 'den 20ᵗ May
1810 Sonne', 'den 10ᵗ Juni 1801'
Lit: *92* No. 259
Nasjonalgalleriet, Oslo

On the reverse side, there are more studies of plants and trees
dated the 5th and 15th May, 1801. The sheet belongs to a
sketchbook which Friedrich used during his stay on the
Baltic Sea in 1801–1802 (cf. *Nos. 8, 9* and *13*). Friedrich
made studies of plants like these with a view to working them
up later and incorporating them in finished works.

8 **Landscape with three Windmills** Landschaft mit
drei Windmühlen
Pen and wash, 23·7 × 37·2 cm., squared
Lit: *92* No. 267; *100* p.76, 184
Nasjonalgalleriet, Oslo

On the reverse side there are a series of studies dated
13.6.1801. It belongs to the same sketchbook as *Nos. 7, 9*
and *13*. This study from nature was probably made on the
Island of Rügen. It forms the basis of the painting *No. 69.*

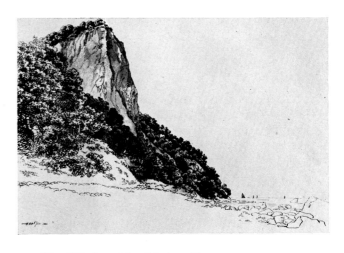

9 **The Königstuhl** Königstuhl
Pen and pencil, 23·8 × 36·6 cm.
Inscribed: '20. Juni 1801'
Lit: *40* p.429; *51* p.74; *92* No. 275; *100* p.115, 148,
185, 208
Museum der bildenden Künste, Leipzig

The Königstuhl is a part of the chalk cliffs on the north
coast of the Island of Rügen. Friedrich sketched a number of
views of these cliffs. Afterwards – particularly between 1803
and 1807 – he took to executing sepia drawings from them
(cf. *No. 26*). From the same sketchbook as *Nos. 7, 8* and *13*.

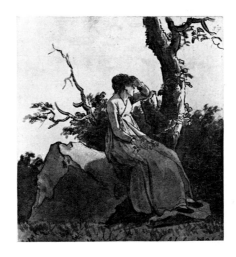
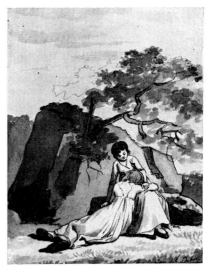

II, 10, 12

10 **Woman sitting on a Rock** Auf einem Felsen sitzende Frau
Pen, wash, and sepia, 18·6 × 12 cm.
Inscribed: '5ᵗ October 1801'
Lit: *50* p.268; *52* No. 37; *92* No. 298; *100* p.136
Staatliche Kunstsammlungen, Kupferstich-Kabinett Dresden

From the so-called Mannheim sketchbook which is now dispersed. Like *Nos. 11* and *12*, this belongs to a group of drawings done during the years 1801–02, in which Friedrich used figures and a few landscape motifs to make allegorical statements. Judging from the direction in which the light is falling, and the position of the woman's left hand, she is watching the setting sun – thus alluding to the expectation of death which is suggested by the dead branch. The rock symbolizes faith. The ivy (cf. *Nos. 3, 11* and *33*) is a traditional symbol of the hope of resurrection. This drawing was used for the woodcut *No. 21*.

11 **Two Girls under a Tree** Zwei Mädchen unter einem Baum
Pen, wash, and sepia, 18·6 × 11·9 cm.
Inscribed: 'den 6ᵗ October 1801'
Lit: *52* No. 40; *92* No. 303; *100* p.136
Staatliche Kunstsammlungen, Kupferstich-Kabinett, Dresden

From the dispersed Mannheim sketchbook (cf. *No. 10*). The two girls in front of the dead tree symbolize fear of death and sorrow over the transitory nature of life. On the other hand, the ivy and the church in the background suggest the hope of resurrection and the consolation found in religion. On the lower part of the sheet there are some pen studies.

12 **Two Girls in front of a Rock** Zwei Mädchen vor einem Felsblock
Pen, wash, and sepia, 18·5 × 11·9 cm.
Inscribed: 'den 7ᵗ October 1801'
Lit: *52* No. 40; *92* No. 303; *100* p.136

Staatliche Kunstsammlungen, Kupferstich-Kabinett, Dresden

Compared with the drawing done the day before with the same two models *(No. 11)*, any religious allegory on the relationship between the tragic and the consoling is much less in evidence. The rock stands for the security found in Christian belief (cf. *Nos. 10, 31, 32, 38, 40*).

(detail)

13 **Dolmen near Gützkow** Hünengrab bei Gützkow
Pencil, 22·3 × 36·2 cm.
Inscribed: '19ᵗ Marz 1802'
Lit: *45* p.290; *92* No. 269; *94* p.63ff
Wallraf-Richartz Museum, Cologne

This page, which is used on both sides, comes from the same sketchbook as *Nos. 7, 8* and *9*. Gützkow is near Neubrandenburg (cf. *No. 50*). Both sketches of the dolmen were used on several occasions for paintings and sepia drawings (cf. *Nos. 31* and *109*).

14 **Christian Friedrich** Christian Friedrich
Black chalk, 23·7 × 18·6 cm.
Lit: *51* p.35, 65; *92* No. 71; *100* p.46, 81, 176
Sammlung Winterstein, Munich

Christian Friedrich (1779-1843), the younger brother of the
painter, was a cabinet maker in Greifswald. He executed the
woodcuts *Nos. 21-23*. This portrait belongs to a group of
portrait drawings of the painter's relatives which he carried
out during his stay in Pomerania in 1801-1802 (cf. *Nos. 15*
and *16*).

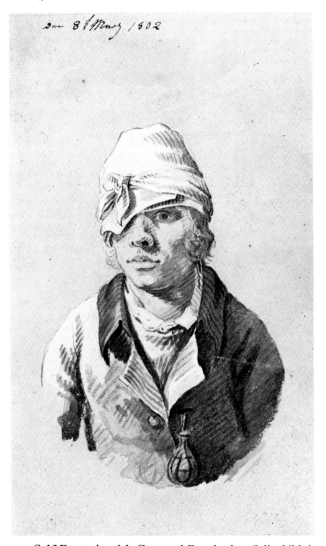

15 **Self-Portrait with Cap and Eyeshade** Selbstbildnis
mit Mütze und Visierklappe
Pencil and wash, 17·5 × 10·7 cm.
Inscribed: 'den 8ᵗ März 1802'
Lit: *92* No. 314, *100* p.136
Kunsthalle, Hamburg

Probably from the Mannheim sketchbook (cf. *Nos. 10-12*).
Compared to the portraits *Nos. 14* and *16*, this drawing looks
much more like a study. With uncharacteristic informality
Friedrich has depicted himself here as a sketcher in a cap and
eyeshade with a small bottle containing wash or water
fastened to his buttonhole.

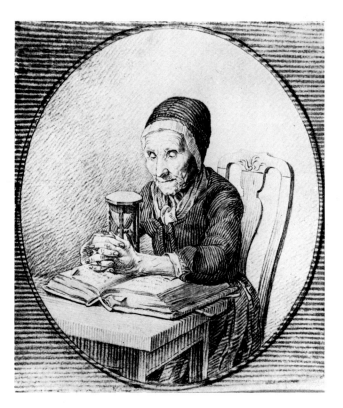

16 **Old Woman with an Hourglass and Bible** Alte
Frau mit Sanduhr und Bibel
Black chalk, 35·6 × 31·1 cm.
Lit: *38* p.96; *51* p.65; *60* p.48, 119; *61* p.365; *74* p.68;
92 No. 75; *100* p.51, 176
Städtische Kunsthalle, Mannheim

Described, according to one tradition, as 'an aged relation in
her 102nd year'. A preparatory study was made on 24.5.1802.[5]
In contrast to *No. 14*, this drawing represents a type rather
than an individual – an old person, living in faith, awaiting
death. The composition is reminiscent of Dutch prototypes,
in particular works by Gerard Dou.

17 **An Inlet on the Island of Rügen** Meeresbucht auf
Rügen
Gouache, 13 × 20·7 cm.
Lit: *43* p.12; *71* p.522; *74* p.75; *92* No.406; *100* p.34,
67, 68, 103, 149, 184, 217
Schlossmuseum, Kunstsammlungen zu Weimar

This gouache, which dates from around 1802, belonged
together with four similar Rügen landscapes to Friedrich's
friend, the Greifswald lawyer and connoisseur Carl
Schildener. A view without symbolic content, it remains
within the late eighteenth century tradition of topographical
landscape.

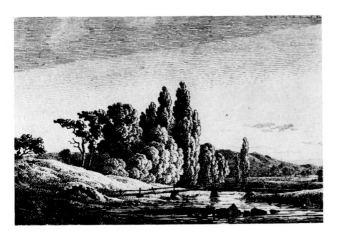

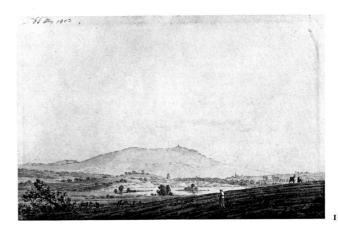

19

18 **Footbridge with Cross** Steg mit Brückenkreuz
Etching, 8·8×14·2 cm. (picture size)
Inscribed in mirror image: 'vom 20ᵗ November bis
zum 22ᵗ'
Lit: *100* p.110
Albertina, Vienna

Friedrich made 18 etchings in the period before 1804. He
seemed to have been experimenting with the technique of
etching, and only a few impressions of each plate exist. Most
of the etchings are allegorical landscapes, like the one here
which dates from 1802. By means of a cross – a symbol often
used in Friedrich's work – the bridge is made to allude to the
Christian religion. As such, it becomes an image of the
crossing over from this life to the hereafter, indicated here

by an open expanse of countryside under a clear sky. Poplars
often appear in Friedrich's work as symbols of death (cf.
Nos. 51, 65 and *97*).

19 **Landscape with River** Landschaft mit Fluss
Pen and wash, 11·4×18 cm.
Inscribed: 'den 6ᵗ May 1803'
Visitors of the Ashmolean Museum, University of Oxford

This drawing, like *No. 20*, comes from a sketchbook which
has now been dispersed. A number of other sheets from this
sketchbook are known.[6] These are all essentially pictorial in
character and there is little suggestion of allegorical content.
It is not clear whether this is a Bohemian or Saxon landscape.

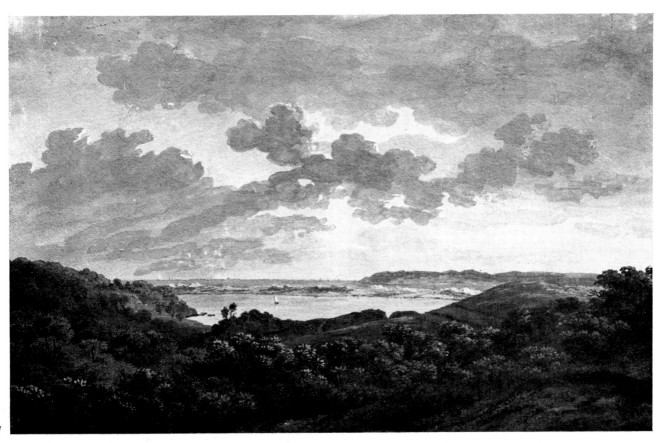

17

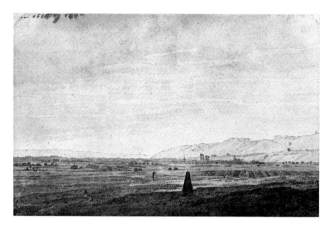

20 Landscape with Obelisk Landschaft mit Obelisk
Pen and wash, 12·9 × 20·2 cm.
Inscribed: 'den 25ᵗ May 1803'
Visitors of the Ashmolean Museum, University of Oxford
Cf. *No. 19*. The obelisk is probably a milestone which, as a
sign on the path of life, represents a momento mori. Friedrich
used the same motif elsewhere to suggest this meaning
(cf. *No. 81*).

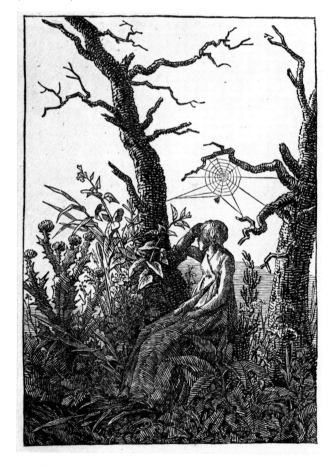

21 The Woman with the Cobweb Die Frau mit dem
Spinnennetz
Woodcut, 17·1 × 12 cm.
Lit: *21* p.299ff; *50* p.261ff; *73* p.132ff; *74* p.93; *100*
p.136ff

The actual woodcut was executed by Friedrich's brother
Christian (cf. *No. 14*) in about 1803–1804. Together with
Nos. 22 and *23*, it may well have been intended as an illus-
tration for a book which was never published – woodcuts at
this time were usually carried out as illustrations for books,
and hardly ever as single prints. The idea already implicit in
No. 10 has been developed further here. The thistle is a
traditional symbol associated with melancholy (cf. *No. 72*),
while the other plants indicate the fleeting transience of
life. The cobweb may be an allegory on art, displaying its
fragile beauty against the background of the transcendent.

22 The Woman at the Precipice Die Frau am
Abgrund
Woodcut, 16·9 × 11·9 cm.
Lit: *21* p.229ff; *74* p.93; *100* p.136ff
Exh. *Dresden Academy*, 1804 (240–242)
*Staatliche Kunstsammlungen, Kupferstich-Kabinett,
Dresden*
Executed by Friedrich's brother Christian in about 1803-
1804 (cf. *No. 21*). The woman at the precipice represents a
person at the end of life (cf. *Nos. 58* and *103*). The two
stages of destiny are suggested by the two fir trees. The
upright tree, which has taken root in the rocks, represents
the life of the believer, and the fallen one to the left, his

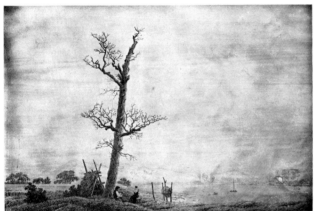

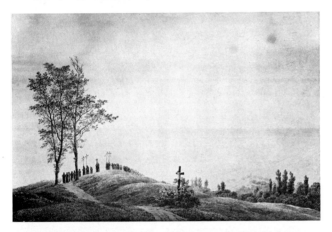

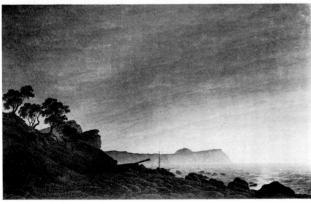

death. The dead tree with the raven is also a symbol of death (cf. *No. 43*). The mountains in the distance denote the life hereafter, and the snake in the foreground, the evil in the terrestrial world.

23 **Boy sleeping on a Grave** Knabe, auf einem Grab schlafend
Woodcut, 7·7×11·3 cm.
Lit: *21* p.229ff; *74* p.93; *100* p.136ff
Exh. *Dresden Academy*, 1804 (240–242)
Staatliche Kunstsammlungen, Kupferstich-Kabinett Dresden

Executed by Friedrich's brother Christian in about 1803-1804 (cf. *No. 21*). Friedrich plays here on traditional associations between sleep and the premonition of death. The butterfly is a symbol of the soul. The grass makes a reference to the fleeting and transitory nature of life.

24 **Summer Landscape with a dead Oak Tree**
Sommerlandschaft mit abgestorbener Eiche
Pencil and sepia, 40·5×62 cm.
Lit: *60* p.20, *64* 98, 107, 120; *71* p.453ff, 484; *74* p.61, 87; *92* No. 367; *100* p.144
Schlossmuseum, Kunstsammlungen zu Weimar

Together with its companion piece *No. 25*, this work was exhibited at the 7th Weimar Exhibition in 1805 and awarded a prize by the Weimar 'Friends of Art' (Goethe and Heinrich Meyer).[7] The two people in the foreground looking out at the far shore indicate a sense of longing for the life hereafter. The ripe field of corn shows the life which has run its course. The leafless oak tree and the rack for drying hay (which makes one think of a straw hut – cf. *No. 29*) are also allusions to death. Like *Nos. 25* and *26*, this work is an example of those large and carefully executed sepia drawings which first made Friedrich's reputation.

25 **Procession at Dawn** Prozession bei Sonnenaufgang
Pen and sepia, 40·5×63 cm.
Lit: *60* p.98, 107; *71* p.453, 454, 484; *74* p.61, 75; *92* No. 366; *100* p.110, 144, 145
Schlossmuseum, Kunstsammlungen zu Weimar

This is a companion piece to *No. 24*. It is probably intended to depict a Corpus Christi procession. The way in which the monstrance is set against the sun leads to an association between the sun and Christ. The path leads up to the crucifix as if to an altar. The two tall trees on the left form a kind of portal. By these means Friedrich illustrates a conception of nature as the church of God.

26 **View of Arkona with Rising Moon** Blick auf Arkona mit aufgehendem Mond
Pencil and sepia, 60·9×100 cm.
Lit: *100* p.148, 189
Exh. *Dresden Academy*, 1806 (200)
Albertina, Vienna

A study from nature dated 22.6.1801[8] has been used for this

subject – one often repeated by Friedrich. Cape Arkona forms the northernmost tip of the Island of Rügen, where there was a temple to the heathen god Svantevit until the 12th century. The ship lying on the shore is a symbol of the life which has ended. The stony shore represents the domain of the worldly. The rising moon is an image of Christ (cf. *Nos. 46, 49, 51, 54, 55* and *58*). About 1806.

27 **Oak Tree with Stork's Nest** Eiche mit Storchennest
Pencil, 28·6 × 20·5 cm. [repr. p.10]
Inscribed: 'dem 23 May 1806'
Lit: *43* p.16, 112; *64* p.50; *92* Nos. 380
Kunsthalle, Hamburg

A study from nature done in the area around Neubrandenburg. It was used in several finished works, including *No. 66.* Many similar studies of oak trees are known dating from the years 1804, 1806 and 1809. From about 1806 onwards, Friedrich normally used pencil for his studies from nature. Sometimes watercolour was added as well.

28 **Sketchbook** Skizzenbuch
Twenty-four pages, each drawn on one side
Pencil, 36·6 × 24 cm.
Lit: *92,* Nos. 461–484
Nasjonalgalleriet, Oslo

The drawings, almost exclusively studies of trees, were all made between 13 April and 13 June 1807. Studies from this sketchbook were used for three of the fir trees and three of the small pines in the 'Cross in the Mountains' *(No. 33).* Sketchbooks like this one, as well as a number of individual sheets constituted the store of studies to which Friedrich continuously turned when carrying out his compositions. According to the inventory of 1843, Friedrich had fourteen such books, making a total of 326 pages, in his possession at the time of his death. Six of these are still intact. This one comes from Dahl's collection.

NOTES

[1] 1.10, 1.11.1788, 1.1.1789 are in the Städtisches Museum, Greifswald; 1.1.1789 is in Kiel, Stiftung Pommern (*92*; Nos. 1–4).

[2] cf. *Emilienkilde*, pen and watercolour, 21·8 × 16·7 cm., dated on reverse 5.5.1797. Kunsthalle, Hamburg inv. 1916/147 (*92*; No. 33).

[3] 'Uferszene', dated 16.5.1799. Kunsthalle Mannheim inv. Nr. 438 (*92*; No. 117. *100*; repr. 23).

[4] *Eldena bei Mond und Feuerbeleuchtung*, sepia, formerly private collection, Würzburg (*47* repr. 4); *Eldena mit Segelboot*, dated on reverse January 1814, watercolour. Department of Prints and Drawings, Copenhagen (*62* repr. 4); *Ruine Eldena mit Flechtzaun*, watercolour, Pushkin Museum, Moscow (*100* repr. 363).

[5] Now lost. Formerly (1906) in the possession of Harald Friedrich, Hanover.

[6] Above all in the Kunsthalle, Mannheim and the Kunsthalle, Hamburg.

[7] Between 1799 and 1805 Goethe and Heinrich Meyer, the Swiss artist who assisted him with his didactic projects for the fine arts, held an annual competition at Weimar. In this a subject, invariably a classical theme, was set, and the works submitted received detailed criticism from Goethe. The competitions attracted widespread attention, and many artists of the younger generation, like Runge and Cornelius, made contributions, usually without success. The award to Friedrich in the last of these competitions was all the more surprising as the works he contributed to the Weimar Exhibition were not on the theme set by Goethe, a subject from the story of Hercules (cf. W. Scheidig, 'Goethes Preisaufgaben für bildende Künste, 1799–1805', Weimar, 1958).

[8] Kupferstich-Kabinett, Dresden (*40* repr. 6; *92* No. 276).

II

First Oil Paintings (1807-1812)

In 1807 Friedrich began to paint in oil, possibly as a result of the commission for the 'Tetschen Altar' *(No. 33)* (cf. *p. 104*). Oil paintings now took the place of large sepia drawings. The paintings were exclusively allegorical in character. Representations of the passage of time – seasons of the year, times of day, ages of man, and stages in the evolution of religion – became the predominant themes and were often treated in pairs or cycles of pictures. The first of Friedrich's major works was the 'Tetschen Altar'. It was followed soon after by his two largest pictures to date, 'Monk by the Sea' *(Ill. xii)* and 'Abbey in the Oak Wood' *(Ill. xiii)*. It was in these that Friedrich expressed his artistic and religious ideas with greatest clarity. The composition and the colouring came to depend on the idea being expressed. The result was an increasing abstraction of pictorial structure and manner of painting. Despite his use of new motifs – the result of journeys made in the Riesengebirge in 1810 and the Harz Mountains in 1811 – Friedrich was not able to prevent a certain stagnation in his artistic development setting in after 1812. The oppression and widespread material poverty which came in the wake of the Napoleonic invasions may well have been contributing factors.

29 **Seashore with Fisherman** Meerestrand mit Fischer
Oil on canvas, 34·5 × 51 cm.
Lit: *51* p.70; *57* p.76; *74* p.80ff; *83* p.266; *87* p.66; *100* p.23, 75, 91ff, 100, 152, 190, 194
Kunsthistorisches Museum, Neue Galerie, Vienna

A companion piece to *No. 30*. Executed in 1807, it is one of Friedrich's first oil paintings.[1] The colouring is similar to such gouache view paintings as *No. 17*. The painstaking way in which the paint is applied – partly glazed, and partly as if drawn on – is related to the technique of Friedrich's sepias. The fisherman with his tackle indicates the active life. The narrow shore set against the infinite sea represents the limitations of the terrestrial world. The rack for drying hay (cf. *No. 24*) and the small stream which, after a short course, flows into the sea, can be seen likewise as images of the transience of life.

30 **Mist** Nebel
Oil on canvas, 34·5 × 52 cm.
Lit: *57* p.70; *74* p.80, 81; *100* p.6, 75, 91ff, 100, 190, 194
Kunsthistorisches Museum, Neue Galerie, Vienna

Companion piece to *No. 29*, and executed at the same time. A rowing boat brings passengers to a ship lying at anchor, the outline of which melts into the mist. While *No. 29* is concerned with earthly existence, this scene is to be interpreted as an allegory on death (cf. *No. 55*). The mist represents the enigma of death. The light which penetrates the mist is an expression of hope.[2]

31 **Dolmen in the Snow** Hünengrab im Schnee
Oil on canvas, 61·5 × 80 cm [repr. p.11]
Lit: *18* No. 509; *13* p.76; *16* p.292; *28* p.138, 202; *34* p.181, 435, 112, 455, 290; *51* p.59, 75; *60* p.55, 81; *74* p.47ff; *94* p.63; *100* p.54, 100ff, 105, 193
Staatliche Kunstsammlungen, Gemäldegalerie Neue Meister Dresden

Executed around 1807. Originally in the possession of Carl Schildener (see *No. 17*) and after 1845, owned by Dahl (cf. *p. 96*). Presumably a companion piece to *No. 32*. The study from nature *No. 13* has been used for the dolmen. The old decrepit oak trees stand for a pagan and heroic conception

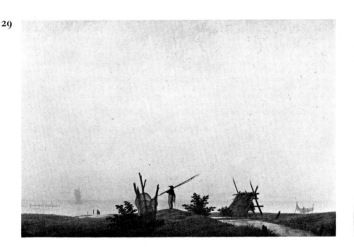

29

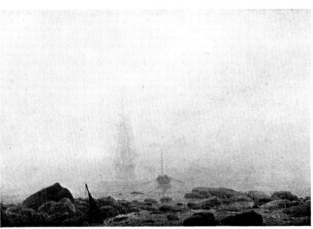

30

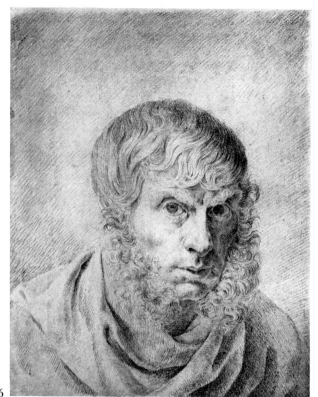

36

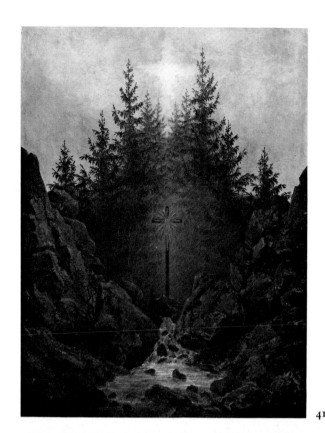

41

32

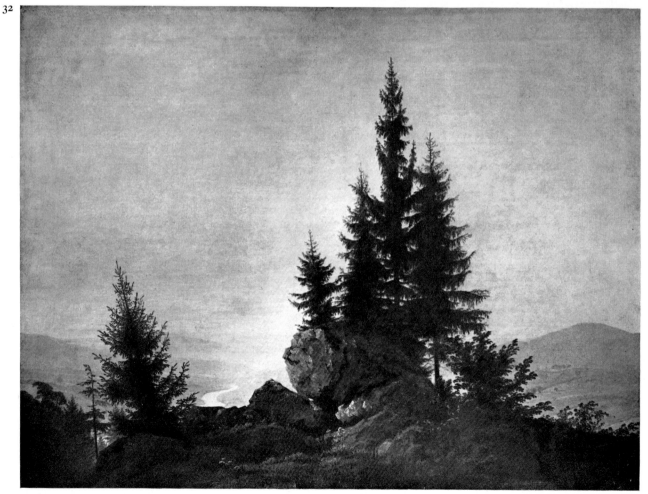

62

of life. The winter, the dusk, the dolmen, and the raven are all used in association with them as signs of death.

32 View over the Elbe Valley Ausblick in das Elbtal
Oil on canvas, 61·5 × 80 cm.
Lit: *33* p.366ff; *57* p.86; *74* p.83; *100* p.90, 202
Staatliche Kunstsammlungen, Gemäldegalerie Neue Meister, Dresden

About 1807. Presumably a companion piece to *No. 31*. The foreground stands for the terrestrial world, the river valley beyond for paradise, and the chasm which separates the two, for death. In contrast to the bare oak trees in *No. 31*, the fir trees symbolize the Christian. The rock indicates the faith which gives him support (cf. *No. 33*). The theme of the changing seasons suggested by the comparison between this work and *No. 31* was frequently used by Friedrich to express a religious interpretation of existence (cf. *78–85*).

33 The Cross in the Mountains (The 'Tetschen Altar') Das Kreuz im Gebirge [repr. frontis]
Oil on canvas, 115 × 110·5 cm., rounded at top
Lit: *3* p.89ff; *4* p.57ff; *5* p.389ff; *6* p.239; *7* p.446ff, 453ff; *10* p.9; *16* p.292; *18* No. 515; *22* p.6, 9; *26* p.267ff, 390ff, 395; *28* p.10, 146, 202; *42* p.171; *43* p.66, 83ff; *49* p.114ff; *57* p.123ff; *60* p.21, 41, 75ff, 109; *61* p.294ff; *74* p.20, 30, 81ff; *78* p.50ff; *100* p.8, 15, 17, 22, 34ff, 72, 111ff, 179, 194, 198, 239
Staatliche Kunstsammlungen, Gemäldegalerie Neue Meister, Dresden

Commissioned early in 1807 by Count Franz Anton von Thun-Hohenstein for his private chapel in Schloss Tetschen, in northern Bohemia, and completed in December 1808. Precedents for the conception of the picture can be found in Friedrich's work as early as 1804.³ The idea of using a landscape as an altarpiece seems to have come from the poet and theologian Gotthard Ludwig Theobul Kosegarten *(see p. 18)* who, in about 1806, considered having Friedrich paint an altarpiece for a chapel on the Island of Rügen. This commission then fell to Runge, who painted Christ walking on the waters (now in the Hamburg Kunsthalle, unfinished).⁴ An interpretation of the Tetschen altarpiece by the artist himself, sent in a letter of 8 February 1809 to the Dresden writer Friedrich August Schulz, was used by C. A. Semler in an article in the *Journal des Luxus und der Moden* in April 1809 *(see p. 104)*. According to these, the setting of the sun represents the passing of the old order of the world before Christ. The golden figure of the Saviour on the crucifix reflects the light of the setting sun onto the earth. The rock symbolizes the steadfastness of faith in Christ. The dark evergreen fir trees are an allegory on the hope of the believer in Christ. The frame was made from a sketch of Friedrich's by the sculptor Karl Gottlob Kühn. Its emblems – as in the picture cycle 'The Times of Day' by Runge *(Ill. xi)* elaborate on the symbolic content of the picture. The beams of light behind the triangle with the Eye of God – symbol of the Trinity – are a variation on the motif of the sun setting behind the rock.

The palm branches, which join together to form an arch, stand for God's satisfaction with mankind. An arch shape is also formed by the symbols of the Eucharist – the ears of corn and the vine branches. The star is the evening star, which, as a result, proclaims both death and resurrection. Friedrich exhibited the picture in his studio at Christmas time in 1808. Both the idea of using a landscape as an altarpiece, and the unusual conception of the landscape itself provoked a vehement critical controversy. F.W.B. Ramdohr, taking a classical point of view, wrote a severe criticism of the picture, which gave rise to replies from Friedrich's friends.

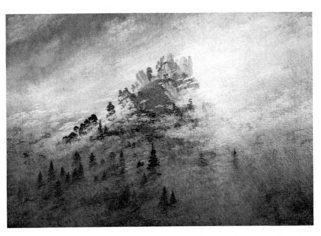

34 Morning Mist in the Mountains Morgennebel im Gebirge
Oil on canvas, 71 × 104 cm.
Lit: *63* p.7ff; *92* p.81; *99* p.40, 208
Staatliches Museum, Heidecksburg, Rudolstadt

Probably executed at the same time as the Tetschen Altarpiece. This work can be identified with a picture described as being in Friedrich's studio in 1808.⁵ The cross on the cliffs is hardly visible; nevertheless, it is made more prominent by a group of small clouds which looks like a halo. In contrast to *No. 30*, where it forms an ethereal background, the mist here shrouds the foreground. In this context it symbolizes the errors of the world, whereas the clear sky beyond is linked together with the cross as a promise of the hereafter.

35 Study of Oaks Sturdie der Eiche [repr. p.65]
Inscribed: '25 April 1809 Eiche' and '26 April 1809'
Pencil: 32 × 35·8 cm.
Lit: *92*, No. 508; *100*, p.74, 179, repr. 262
Staatliche Kunstsammlungen, Kupferstich-Kabinett Dresden

This drawing, which comes from a sketchbook that has now been dispersed, belongs to a group of studies of oaks that Friedrich made in Neubrandenburg during April, May, and June 1809. He made use of these studies in his finished works several times, as for example in *Nos. 39* and *58*.

36 Self-Portrait Selbstbildnis
Black chalk, 23 × 18·2 cm.
Lit: *28* p.194; *43* p.112; *57* p.31, 32; *74* p.97; *77* p.20; *92* No. 709; *100* p.92ff.

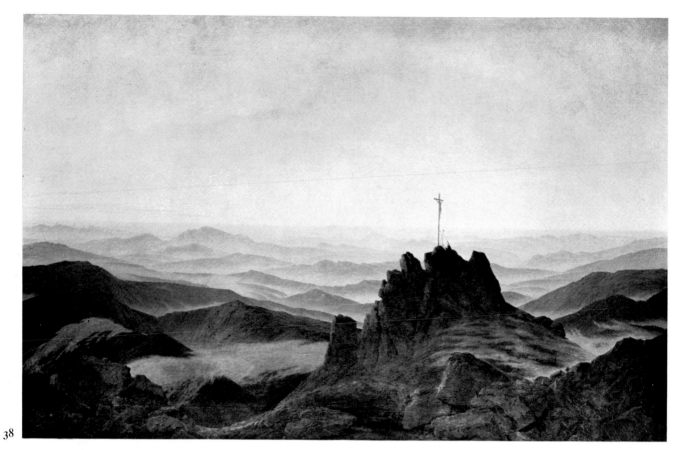

38

Staatliche Museen, Kupferstichkabinett und Sammlung der Zeichnungen, Berlin GDR

Executed around 1810. Once in the possession of Johann Jakob Otto August Rühle von Lilienstern, one of Friedrich's friends who publicly defended the Tetschen Altarpiece. It is comparable to *No. 4*, in its searching and thoughtful expression. The robe, a self-conscious departure from the current fashion, is most likely a monk's costume – at about the same time, Friedrich depicted himself as a monk in the picture 'Monk by the Sea'. There is already some suggestion here of the kind of attitude of protest which was expressed after 1815 in Friedrich's use of figures in 'old-German costume' (cf. *Nos. 50, 56, 58, 72*).[6]

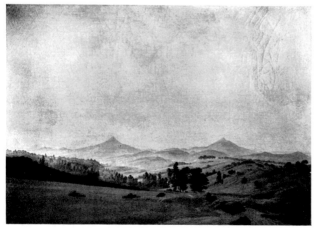

37

37 Bohemian Landscape Böhmische Landschaft
Oil on canvas, 71 × 104 cm.
Lit: *16* p.292; *18* No. 514; *32* p.79; *43* p.99; *57* p.83; *74* p.30ff, 46, 52; *100* p.73, 77
Staatliche Kunstsammlungen, Gemäldegalerie Neue Meister, Dresden

Probably painted about 1810 for Count Franz Anton von Thun-Hohenstein (*No. 33*). Companion piece to an evening landscape in the Staatsgalerie, Stuttgart. The serene, open, and free-rolling countryside is an image of a view of life which is directed towards this world. The path is the path of life. The house with the smoking chimney stands for the security found in human community. The mountains in the distance, which close off the area depicted, represent the transcendent. Serene landscapes like this one, *No. 29* and *No. 66*, were, in fact, used by the artist to form the first part of a religious allegory.

38 Morning in the Riesengebirge Morgen im Riesengebirge
Oil on canvas, 108 × 170 cm.
Lit: *18* No. 582; *22* p.7, 9, 15; *28* p.11, 202, 210; *32* p.88ff; *43* p.66, 113; *57* p.28, 126, 127; *60* p.77, 109; *66* p.138; *74* p.7, 22, 83, 88ff; *87* p.75; *100* p.70, 83, 130, 197
Exh. *Dresden Academy*, 1811 (unnumbered), Weimar, 1811 (unnumbered); *Berlin Academy*, 1812 (582)
Staatliche Schlösser und Gärten, Schloss Charlottenburg, Berlin (West)

Begun in 1810, after a walking tour in the Riesengebirge, and finished in 1811. Acquired in 1812 by King Friedrich Wilhelm III of Prussia. In a contemporary report, it is said that Georg Friedrich Kersting (see *p. 94*) painted the accessory figures.[7] The man, who is Friedrich himself, is being led up to the cross by the woman. The cross, as the only object to break the line of the horizon, connects the near with the distant: thus, as in 'The Cross in the Mountains' *(No. 33)* it comes to represent Christ as the intercessor between heaven and earth. The rising sun, which lies to the left of the composition, counterbalances the cross on the right. When exhibited at Weimar in 1812 the work was shown with a companion piece (now lost) which depicted a waterfall in a mountain landscape in the evening. In the latter picture, one also saw a ship navigating a river in the background, and a man helping a woman to climb over a ravine.[7] In contrast to the 'Morning in the Riesengebirge', this picture symbolized the unrest of earthly existence, and the guidance given by the man in the mastery of the practical life.

This picture is a good example of Friedrich's habit of building up his compositions out of studies from nature. The range of mountains in the background comes from a study dated 11 July 1810. A drawing dated 17 July 1810 has been used for some of the boulders in the middle foreground, while the group of rocks to the right are based on a study dated 7 July 1800. The left part of the prominence on which the cross is erected has been taken from a drawing of 10 August 1799 in a sketchbook in the Nationalgalerie, Berlin, while the steep rocks at its approach are the reverse of a drawing made between 1806 and 1808. Friedrich must certainly have made use of other drawings for the boulders in the foreground. By these means the picture becomes effective both through its exact observation of nature and its free imagination.

39 **Winter Landscape** Winterlandschaft
Oil on canvas, 33×46 cm.
Lit: *43* p.56; *67* p.229ff; *74* p.94; *100* p.26, 74
Exh. *Weimar, 1811, Dresden Academy,* 1812 (424)
Staatliches Museum, Schwerin
Executed in 1811. Companion piece to *No. 40.*[8] Friedrich

used drawing *No. 35* for the two oaks. The man hobbling forward on crutches, who sees an endless snowy wasteland before him, symbolizes the despair of the faithless in the face of death. The dead oak tree stands for the pagan-heroic attitude towards life (cf. *Nos. 24* and *31*); the tree stumps are symbols of death.

40 **Winter Landscape with Church** Winterlandschaft mit Kirche
Oil on canvas, 33×45 cm.
Lit: *43* p.56; *53* p.5ff; *57* p.126; *67* p.229ff; *74* p.26ff, *84*; *79* p.15; *100* p.3, 26, 70, 98, 111, 198, 220
Exh: *Weimar, 1811; Leipzig,* 1814
Schloss Cappenberg Museum für Kunst und Kulturgeschichte der Stadt Dortmund

35

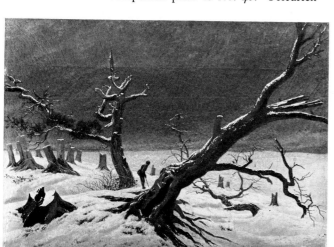

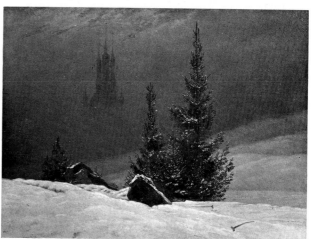

40

Executed in 1811. Companion piece to *No. 39*. The picture suggests the security man finds when he overcomes death through the Christian faith. The man sitting against the rock (symbol of faith) has thrown away his crutches. The fir trees occur again here as the opposite of the oak tree. The visionary apparition of the Gothic church in the distance stands for the promise of an existence in the hereafter (cf. *49*, and *51*).

41 **Cross in the Forest** Kreuz im Walde [repr. p.62]
 Oil on canvas, 42 × 32 cm.
 Lit: *47* ill.44; *50* p.280; *57* p.82; *74* p.84; *79* p.15; *100* p.106, 107, 111, 221
 Staatsgalerie, Stuttgart

In this work there is a noticeable discrepancy between the precisely drawn fir trees and the broadly treated foreground. The manner in which the fir trees are painted is consistent with Friedrich's style during the second decade of the nineteenth century, and the theme is similar to a painting in Düsseldorf, and to two destroyed works, dating from 1813 and 1818. In view of this the original design may well date from circa 1813. However, the sketchiness of the foreground is probably not due, as has previously been suggested, to the work being unfinished. It is more likely that Friedrich repainted this part of the picture in the period following his stroke in 1835 (cf. *p.91*). The cross with the sun above the spring indicates the relationship of the beginning and end of earthly existence with Christ, and the promise of eternal life through Christ. The repetition of the cross in the sky emphasizes this meaning.

NOTES

1 This and *No. 30* were referred to by Christian Semler *(see p.104)* as Friedrich's first oil paintings in 'Klinskys allegorische Zimmerverzierungen und Friedrichs Landschaften in Dresden'. *Journal des Luxus und der Moden,* Weimar, 1808, p.183ff.

2 Both Semler (Note 1) and the reviewer in the *Morgenblatt für gebildete Stände* (2 February 1808, p. 132) emphasized this interpretation (*100* p. 91).

3 cf. a drawing dated 14 November 1804 in a Bremen private collection. A sepia similar in subject and composition to No. 32 was described in detail by Schildener *(see No. 17)* in the Appendix of his translation of Ehrenwärd's *Philosophie der Freien Künste,* 1805, p. 67ff. This sepia is not the same one as the 'Cross in the Mountains' that was exhibited at the Dresden Academy in 1807 and which is now in the Kupferstichkabinett, Berlin (*92* No. 360); for whereas the Berlin sepia, like No. 33, depicts fir trees, the trees in the sepia mentioned by Schildener were deciduous (*100* p. 188).

4 Ph. O. Runge, *Hinterlassene Schriften,* 2 vols, Hamburg 1840–1841, vol. 1, p. 348.

5 *Prometheus,* Vienna 1808, Part 3, p. 21.

6 'Old-German costume' (Alt-deutsch Tracht) was an archaicizing form of dress common amongst the supporters of the Wars of Liberation *(see p. 33).* In post-Napoleonic Germany it lingered on, particularly in student liberal circles. As such it was regarded with suspicion by many régimes and was, in fact, banned in Bavaria.

7 *Journal des Luxus und der Moden,* 1811, p.371.

8 *Journal des Luxus und der Moden,* 1812, p.117.

III

The Wars of Liberation 1813-1815

During the Wars of Liberation (1813-1815), Friedrich only executed a few pictures. In these, he tried to use his earlier religious symbolic language for political allegories directed against Napoleon; it was in a similar spirit that Friedrich's friend, Gerhard von Kügelgen (*p.104*) depicted Napoleon as the Antichrist. After the defeat of France, Friedrich set to work on designs for monuments commemorating the victory. Unruined Gothic buildings, which had appeared in Friedrich's pictures ever since 1811 as symbols of the transcendent (cf. *No. 40*), now also took on a more topical significance as representatives of a national style – at that time the French origins of the Gothic were as yet unrecognized. Friedrich's tectonic sense which, since about 1806, had manifested itself in the composition of his pictures, now led him to try out some architectural designs as well. With the exception of a few funerary monuments, however, none of these projects was ever realized.

42 **Garden Terrace** Gartenterrasse [repr. p.12]
Oil on canvas, 53·5 × 70 cm.
Lit: *1*, 1812, No. 426 or 427; *18* No. 535; *28* p.50, 153; *32* p.77; *43* p.87, 113; *57* p.82; *60* p.63, 107, 121; *74* p.24, 33; *87* p.75; *97* p.400; *100* p.72, 197ff
Exh. *Dresden Academy*, 1811 (426 or 427), *Berlin Academy* 1812 (582).
Staatliche Schlösser und Gärten, Potsdam-Sanssouci

Painted in 1811 and acquired by King Friedrich Wilhelm III of Prussia in 1812. Exhibited in Dresden in 1812 as a companion piece to a work depicting a garden with flowers in bloom and children at play. The way this picture was referred to in a contemporary journal[1] as 'Garden Party in the French Style' may suggest a patriotic meaning, for Friedrich sharply rejected everything French, especially at the time of the Napoleonic Wars. Thus, the shadowed foreground with the girl reading symbolizes natural creation violated by human reason. The statue, as a lifeless form of stone, is likewise a negative symbol. The gate with the pattern of the cross indicates the way out from these surroundings into the open mountain landscape which is bathed in light. The latter, perhaps, is intended as a political vision of the future world of peace.

43 **The 'Chasseur' in the Woods** Der Chasseur im Walde [repr. p.68]
Oil on canvas, 65·7 × 46·7 cm.
Exh: *Dresden Academy*, 1814 (328); *Berlin Academy*, 1814 (59).
Private collection, Bielefeld

Painted in 1813–1814 during the occupation of Dresden by French troops. The subject was described in a contemporary review as follows: 'A raven perching on an old branch sings the death song of a French Chasseur who is wandering alone through the snow-covered evergreen forest.'[2] In a small group of paintings dating from this period, Friedrich gave his religious emblems political overtones. The forest of firs symbolizes here the people sorrowing over their defeat, and preparing for the death of the French soldier. The ravens and the tree stumps are allusions to his fate. The winter stands for present distress.

44 **War Memorial** Kriegerdenkmal
Pen and watercolour, 53 × 36·5 cm.
Lit: *23* p.202; *92* No. 803
Städtische Kunsthalle, Mannheim

Immediately after the Wars of Liberation, Friedrich set to work on some designs for war memorials, evidently without any specific commission in mind. The only works that were ever executed after his drawings were some gravestones in the Dresden cemetery, and a monument in Neubrandenburg to the pastor, Franz Boll (1819).

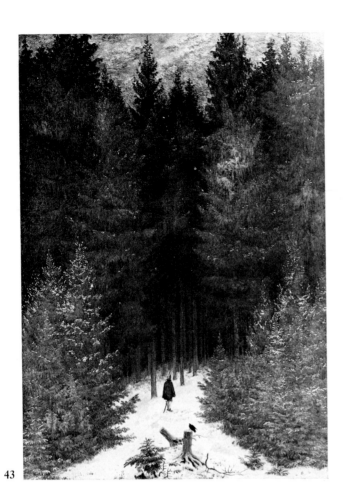

43

45 **Gravestone with a Knight's Helmet** Grabstein mit Ritterhelm
Pen and watercolour, 54·2 x 37 cm.
Lit: *23* p.206; *92* No. 811
Städtische Kunsthalle, Mannheim

Used in the painting *No. 72;* nevertheless, it was probably executed originally as an independent design for a monument around 1815.

NOTES

[1] *Journal des Luxus und der Moden*, 1812, p. 357.
[2] *Vossische Zeitung*, 8 December 1814 (Lit. *22*, p. 17)

IV

New Beginnings
1815-1820

Friedrich abandoned patriotic themes very soon after the war. In 1815, he undertook another journey to his homeland, and his impressions were reflected in the highly important picture 'View of a Harbour' *(No. 48)*. This, together with another major work (the first to show a view from a terrace), was acquired by Friedrich Wilhelm III of Prussia in 1816. Despite this new start, crowned as it was by outward success, Friedrich's artistic activity underwent a crisis in about 1816, a crisis which he himself remarked on the 11 July 1816 in a letter to his friend, Johan Ludwig Gebhard Lund. His work at this time mostly consisted of small sea pieces where the pictorial structure was comparatively informal, the colouring subdued, and the application of the colours sometimes thin and dry. Nevertheless, he developed a new feeling for the effects of light.

The largest work dating from this period was the 'Monastery Graveyard in the Snow', *circa* 1817-1819, which was destroyed in 1945 *(Ill. xv)*. It was a variant of the picture 'Abbey in the Oak Wood' *(Ill. xiii)*. In 1818 Friedrich married Caroline Bommer, and this might have played a part in helping him to overcome the stylistic crisis in which he found himself at the time. In 1818 he travelled to Greifswald and Rügen. A new importance given to the figures in Friedrich's paintings, which in their size at least, are reminiscent of figures in works dating from 1799–1803, might have reflected a change of attitude towards his fellow men, one in which the friendship struck up with Carus in 1817 and Dahl in 1819 could have been instrumental. Upright compositions became more frequent, and some pictures executed after 1818 have a surprising inner drama which could be taken for the expression of a newly won inner freedom.

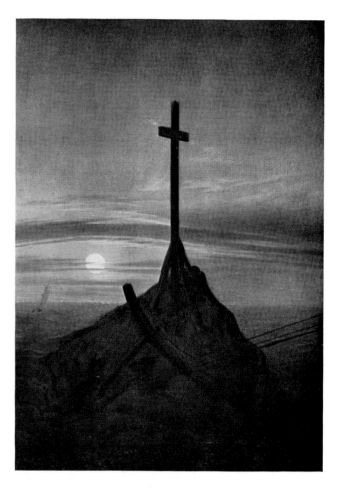

46 **The Cross on Rügen** Das Kreuz auf Rügen
Oil on canvas, 46×33 cm.
Lit: *91* No. 36; *100* p.179ff
Sammlung Georg Schäfer, Schweinfurt

This composition, done in 1815, is known to exist in three different versions. The cross raised up on the rock shows the ship drifting on the troubled waters the way towards dry land (that is, the way to death), while the full moon, a symbol of Christ, illuminates the sea. The anchor suggests the hope of resurrection. The taut cables belong to a ship which is out of sight. The picture was probably painted in remembrance of Emma Körner, who died on the 15 March 1815. Several of Friedrich's pictures are known to have been painted in memory of someone who had died (cf. *No. 51*).

47 **Ship on the High Seas in Full Sail** Schiff auf hoher See mit vollen Segeln
Oil on canvas, 71·5×49·5 cm.
Lit: *28* p.209; *58* p.31; *100* p.88, 219
Städtische Kunstsammlungen, Karl-Marx-Stadt

Painted around 1815. There is a smaller version of this picture in a private collection in Hamburg. The ship is probably intended as a symbol of the Christian religion, the three masts making an allusion to the Trinity. The majestic appearance of the ship, which has no parallel in other works by Friedrich, speaks against an interpretation of it as a symbol

of the fate of the individual soul of the kind seen, for example, in *No. 71*. The Danish flag has presumably been used not so much for national associations as for the Cross represented on it. A comparable motif is the anchor on the prow of the ship.

48 **View of a Harbour** Ansicht eines Hafens
Oil on canvas, 90×71 cm.
Lit: *28* p.117; *43* p.112; *51* p.41ff, 68; *60* p.27, 85, 112, 121; *74* p.12, 51, 58, 90ff; *83* p.249ff, 267; *100* p.81ff
Exh. *Dresden Academy*, 1816, (396); *Berlin Academy*, 1816
Staatliche Schlösser und Gärten, Potsdam-Sanssouci
Acquired by King Friedrich Wilhelm III of Prussia in 1816. A major work of this period, which resulted from a journey to the Baltic Sea in 1815.[1] The harbour, with some ships at anchor and others returning to port as night descends, is an image of the security that lies in death. The crescent of the waxing moon represents Christ.

49 **Greifswald in Moonlight** [repr. p.21]
Greifswald im Mondschein
Oil on canvas, 22·5×30·5 cm.
Lit: *16* p.258; *17* p.196; *18* No. 506; *43* p.115; *51* p.68; *60* p.54, 123; *74* p.42, 50; *75* p.238; *79* p.23; *83* p.250; *100* p.125
Exh: *Dresden Academy*, 1817 (461 or 462)
Nasjonalgalleriet, Oslo
Once in the possession of Carus *(see p. 94)*. Painted in 1816–1817. As in *No. 48* use is made of motifs sketched during Friedrich's journey to the Baltic sea in 1815.[1] The town which appears in silhouette is Friedrich's home town, but its setting has been completely altered, for it has been placed on the far side of a broad expanse of water. Thus the earthly home becomes transformed into a symbol of paradise (cf. *Nos. 50, 74* and *97*). The expanse of water signifies death, and the marshy shore the worldly existence that is threatened by it (cf. *No. 54*).

50 **Neubrandenburg** Neubrandenburg
Oil on canvas, 92·5×72 cm.
Lit: *79* p.24; *100* p.178
Gemäldegalerie der Stiftung Pommern, Kiel
Friedrich considered Neubrandenburg, where both of his parents had been born, to be as much of a home town as Greifswald. Its silhouette in this picture, therefore, has similar eschatological overtones to that of Greifswald in *No. 49*. The two travellers in 'Old-German costume' (cf. *No. 58*) looking towards the setting sun, catch a glimpse of the town that is the destination of their life's journey. Symbols of death can be found in both the dolmens (cf. *No. 31*) and the flying storks which, as migrating birds, are portents of approaching winter. The range of mountains, a motif taken from the area around Dresden, is an imaginative addition that underlines the significance of the background as a transcendent sphere.

47

48

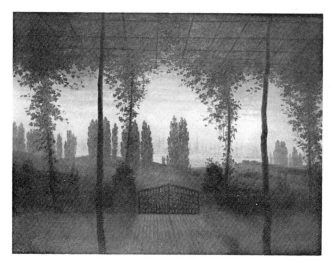

51 **Picture in Remembrance of Johann Emanuel Bremer** Gedächtnisbild für Johann Emanuel Bremer
Oil on canvas, 43·5 × 57 cm.
Lit: *97* p.399ff; *100* p.97
Staatliche Schlösser und Gärten, Schloss Charlottenburg, Berlin (West)

Can be dated about 1817, since the Berlin doctor, Johann Emanuel Bremer, died on the 6 November 1816. The name 'Bremer' can be read on the garden gate. The colouring, and some of the individual motifs are similar to *No. 49*. The area which leads through the opening from foreground to background symbolizes the transition from life to death and to an existence beyond the grave. The poplar trees are symbols of death (cf. *Nos. 18* and *65*), and the full moon stands for Christ. The use of the gate to allude to death is found again later in *Nos. 90* and *111*.

52 **The Cathedral** Die Kathedrale
Oil on canvas, 152·5 × 70·5 cm., arched at the top
Lit: *81* p370ff; *91* p.105; *100* p.105
Sammlung Georg Schäfer, Schweinfurt

Probably painted around 1818. The cathedral is a fanciful alteration and enlargement of the church of St. Mary of Stralsund. Friedrich had been working on the restoration of the interior of this church since 1817–1818 *(see No. 53)*. The church here is a transcendent apparition, as in *No. 40*.

53 **Fittings for the Choir of St. Mary Stralsund** Ausstattung des Chores von St. Marien in Stralsund
Pen and watercolour, 58 × 41·1 cm. [repr. p.72]
Lit: *98* p.150ff
Germanisches Nationalmuseum, Nuremburg

One of a large number of designs for the restoration of the interior of the Gothic church of St. Mary Stralsund. Friedrich worked on this project around 1817–1818, but it was never carried out. In addition to the screens shutting off the ambulatory, the altar, and the pulpit, Friedrich also designed here, for reasons of symmetry, a six-sided pedestal with a baldachino for weddings.

52

54 Moonlit Night on the Shore of the Baltic Sea
Mondnacht am Ostseestrand
Oil on canvas, 23 × 31·5 cm.
Lit: *57* p.68; *83* p.255; *91* No. 41; *98* No. 31; *100* p.71, 122
Sammlung Georg Schäfer, Schweinfurt
About 1816–1818. Companion piece to *No. 55*. After his journey to the Baltic Sea in 1815, Friedrich executed a series of small sea pieces, where the allegorical content is, to some extent, hard to determine. The marshy shore with the fishing tackle and small boats symbolizes the uncertainty and difficulty of earthly existence (cf. *No. 49*). The waxing moon, which appears from behind the clouds, symbolizes Christ.

55 Moonlit Night with Ships on the Baltic Sea
Mondnacht mit Schiffen auf der Ostsee
Oil on canvas, 22·5 × 31·5 cm.
Lit: *57* p.68, 376; *83* p.255, 267; *91* No. 42; *99* No. 30; *100* p.71, 87, 122, 154, 205
Sammlung Georg Schäfer, Schweinfurt
About 1816–1818. Companion piece to *No. 54*. An allegory on deliverance through death. The earthly, in the form of dry land, has disappeared. The passengers in the rowing boat are being brought to one of the large ocean-going ships. In contrast to the companion piece, the sky is hardly clouded over, and the moon has become full.

56 Morning Morgen
Oil on canvas, 22 × 30·2 cm.
Lit: *43* p.52; *74* p.34, 89; *83* pp.250–255, 267; *100* pp.122–124
Niedersächsisches Landesmuseum, Hanover
This picture belongs, together with 'Evening' *(No. 57)* to a group which represents the 'Times of Day' as sea pieces. The 'Midday' and 'Night' have disappeared, although they are known from reproductions. In contrast to earlier cycles Friedrich has avoided here any association with the times of year, and has replaced the theme of the ages of man with an allegory on spiritual development that embraces hope, activity, resignation and confidence. The cycle was painted after 1815. Like a number of other contemporary sea pieces of a similar format, they are a consequence of the journey that he made to the Baltic in 1815. The pair in 'Old German Costume' *(No. 36)* on the stern, as well as the invented flag, suggest a political meaning that may well reflect Friedrich's disappointment over the outcome of the wars of liberation. The picture is full of the sense of departure. The anchor, the symbol of christian hope, remains on the shore. The fishing tackle indicates human activity.

57 Evening Abend
Oil on canvas, 22 × 30 cm.
Lit: *43* p.53; *74* p.12; *83* pp.250–255, 267; *100* pp.4, 122, 124
Familie Bührle, Zürich

53

Part of the same cycle as *No. 56*. In this picture the ship is returning to harbour with reefed sails, a symbol of loneliness and resignation after the misfortunes of life. The pair seek comfort in religion, while the anchor gives an intimation of the hope of eternal life.

58 Two Men Contemplating the Moon Zwei Männer in Betrachtung des Mondes
Oil on canvas, 35 × 44 cm.
Lit: *16* p.292; *17* p.254; *18* No. 510; *28* p.54, 135, 202; *42* p.175; *43* p.114; *48* p.163; *60* p.32, 54, 69, 107, 121; *16* p.148; *74* p.58, 94; *100* p.74, 178ff, 204
Staatliche Kunstsammlungen, Gemäldegalerie Neue Meister, Dresden
Acquired by the Dresden Gallery in 1840 from Dahl *(see p. 96)*. Painted in 1819. According to Dahl, the accessory figures represent two of Friedrich's pupils, his brother-in-law Christian Wilhelm Bommer and August Heinrich. However, according to a more convincing account by Wilhelm Wegener they are Friedrich himself (right) and August Heinrich (left)[2]. The figures look out from a stony path (the path of life) at the waxing moon (a symbol of Christ), whose full shape can already be seen in outline. The dying oak tree beside the dolmen on the right is based on drawing *No. 35*.

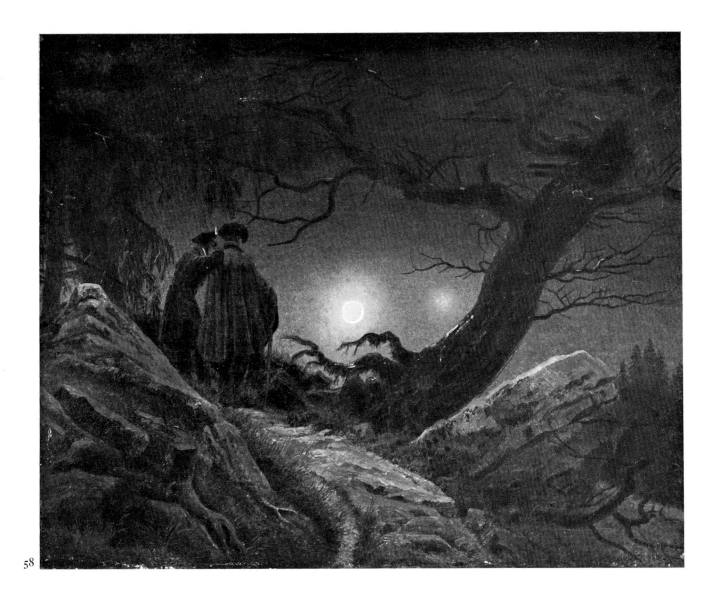

58

56

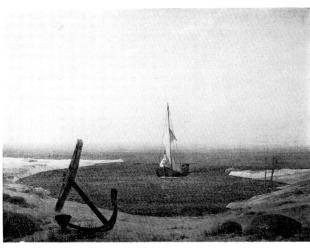

57

59 **Swans in the Rushes** Schwäne im Schilf
Oil on canvas, 35·5 × 44 cm.
Lit: *43* p.70; *60* p.30, 110, 121, 157; *96* p.34; *100*
p.168ff, 207, 212, 233, 242
Exh: *Dresden Academy*, 1820 (545)
Freies Deutsches Hochstift, Goethemuseum, Frankfurt

About 1820. Friedrich, who used this motif several times, alluded to its spiritual intentions in a slightly laconic manner when the Nazarene painter Peter Cornelius visited his studio on 18 April 1820. Showing a picture of two swans in the rushes (probably actually this work) he declared; 'The divine is everywhere, even in a grain of sand. Here I have depicted it for once in the rushes (*Lit. 95,* p.220). Alluding to the way they sing while they are dying, the swans here are portrayed as a symbol of the joyful expectation of death, the path to eternal life. This theme is further referred to by the evening star (cf. *Nos. 33* and *97*). Carus also used the swan motif on several occasions, but the meaning was modified as, for example, in an allegory on the death of Goethe (Goethe Museum, Frankfurt).

NOTES

[1] A sketchbook from this journey, preserved in the Nasjonal-galleriet, Oslo contains several studies of boats that were later used in this work and *No. 49* (*100*, p. 81, repr. 181–3).

[2] cf. Lit. *13*, p. 76. This identification can also be supported by the appearance of the figures. The younger man, who leans on his companion is wearing the typical student's costume of the time, while the upright figure wears the cloak and cap that Friedrich is known to have favoured (cf. *No. 102*). Dahl's statement is contained in a letter to the Dresden Gallery dated 26.9.1840.

V

Second Maturity 1820-1826

In the early 1820s a significant change of attitude towards nature became evident in Friedrich's art, one in which Dahl's influence probably played an important part. Some of the landscapes executed at this time seem to be simple views or direct impressions of nature with only the most discreet references to allegorical meanings. Friedrich began to discover religious sentiments in the chance configurations of landscape.

The colour in Friedrich's work became more lively, and its application more fluid. Sea pieces were less frequent, while all types of inland motifs increased. Friedrich painted new landscapes based on the Riesengebirge and the Harz Mountains, still using studies made in 1810-1811. The renewed interest in mountains even led Friedrich to paint two large Alpine landscapes in 1824 and 1825; subjects for which he used studies by Carl Gustav Carus and August Heinrich *(Lit. 86)*. The depiction of landscapes which he himself had never seen became for Friedrich an intimation of the transcendent. It was in this spirit that he also painted Polar landscapes in the 1820s *(Ill. xvii ; Lit. 85)*. Around 1825 illness led to a decrease in the production of oil paintings. In order to regain his health, Friedrich travelled to the Baltic Sea in 1826. It was to be his last visit to this region. During these years he painted a group of thirty-seven watercolours, which reflect his new outlook on nature. They included views of Rügen, and a series of seven sepias depicting the times of day, the seasons of the year, and the ages of man. In the late 1820s, Friedrich was to continue painting watercolour views.

60–63 **The Times of Day** Die Tageszeiten [repr. p.76] In this cycle the atmosphere of nature is rendered with peculiar suggestiveness and the allegorical content is only conveyed through allusions. Unlike other treatments of the theme (eg. *Nos. 78–85*), the representation of 'Night' is omitted. Acquired by Dr. Friedrich H. Wilhelm Körte of Halberstadt *(Lit. 95 p.55, 248; 100 p.207)*, a frequent patron of Friedrich's during the 1820s.

60 **Morning** Der Morgen [repr. p.22]
Oil on canvas, 22 × 30.7 cm.
Lit: *18* No. 536d; *43* p.53; *57* p.111; *74* p.50; *89* p.158; *100* p.26, 207, 212
Niedersächsisches Landesmuseum, Hanover
Various circumstances suggest that around 1821 Friedrich painted this picture and 'Evening' *(No. 63)* as allegories on active life and religious contemplation (cf. *Nos. 66 and 67)*. *Nos. 61 and 62* would have been added at a slightly later date.

61 **Midday** Der Mittag
Oil on canvas, 21.5 × 30.4 cm.
Lit: *18* No. 536e; *43* p.54; *57* p.111; *74* p.43, 100; *89* p.158; *100* p.207, 212
Niedersächsisches Landesmuseum, Hanover
Cf. *No. 60.* Probably painted in 1822 together with 'Afternoon' *(No. 62)*, to which it is closely related in atmosphere. The path is the path of life. The shepherd is a motif which, in Friedrich's work, expresses community with nature (cf. *No. 66)*. The view-like effect underlines the worldly character of the landscape.

62 **Afternoon** Der Nachmittag
Oil on canvas, 22 × 30.7 cm.
Lit: *18* No. 536ff; *43* p.54, 115; *57* p.111; *74* p.43, 100; *83* p.247; *89* p.158ff; *100* p.76, 78, 207, 212
Niedersächsisches Landesmuseum, Hanover
Cf. *Nos. 60 and 61.* Probably painted in 1822. As in *No. 61*, the informal composition, which is derived in its entirety from a study[1], expresses an affirmative attitude towards nature. Nevertheless, the field of corn set beside the ploughed-up field alludes to the threat of death (cf. *Nos. 24, 68 and 70)*.

63 **Evening** Der Abend
Oil on canvas, 22 × 31 cm.
Lit: *18* No. 536g; *43* p.54; *57* p.112; *74* p.32, 46, 100; *89* p.158ff; *100* p.180, 207, 212
Niedersächsisches Landesmuseum, Hanover
Cf. *No. 60.* In contrast to 'Morning', religious contemplation is represented here (cf. *Nos. 58, 67)*. The path is the path of life. The woods here could be interpreted as a symbol of death, though they also allow through the light of the promise of the life hereafter. The comparatively abstract composition is in keeping with the emphasis on the spiritual content.

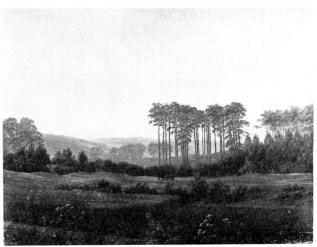

60, 61

62, 63

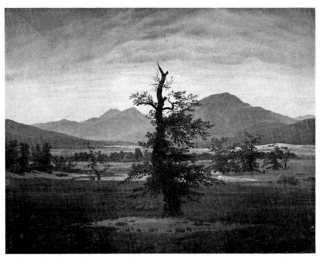

66

64 Ship on the River Elbe in the early Morning Mist
Elbschiff im Frühnebel
Oil on canvas, 22·5 × 31·8 cm.
Lit: *59* p.97; *74* p.43, 104; *100* p.207, 209
Wallraf-Richartz Museum, Cologne

About 1822. A particularly striking example of the kind of
informal landscape which Friedrich did at this time. In a
casual manner, Friedrich introduces motifs that he used
more explicitly elsewhere to convey a symbolic meaning.
Even so, there are indications of an overall religious signi-
ficance. The ship gliding downstream (a symbol of life) is
making towards the mouth of the river, which represents
death. The flowers and the grass likewise suggest transience.
The mist symbolizes the murkiness of life which is dispelled
by the sun, a symbol of God.

65 Woman at the Window Frau am Fenster
Oil on canvas, 44 × 47 cm.
Lit: *18* No. 517; *28* p.22; *43* p.87ff, 114; *57* p.33, 130;
60 p.28, 100; *74* p.103; *100* p.119ff
Exh: *Dresden Academy*, 1822 (LXXXII)
Nationalgalerie, Staatliche Museen Preussischer
Kulturbesitz, Berlin (West)

Painted in 1822, when it was described by the poet La Motte
Fouque who saw it in Friedrich's studio. As is confirmed by a
contemporary review[2], the figure seen from the back repre-
sents Friedrich's wife Caroline, and the room is the studio that
Friedrich used after 1820. The view extends over the river
Elbe to the opposite shore, which symbolizes paradise. The
cross-like shape formed by the supports dividing the window
pane becomes a Christian symbol, and the dark, close interior
represents the terrestrial world. As early as 1806, Friedrich
had used the same kind of composition to suggest this theme
(Ill. xvi).

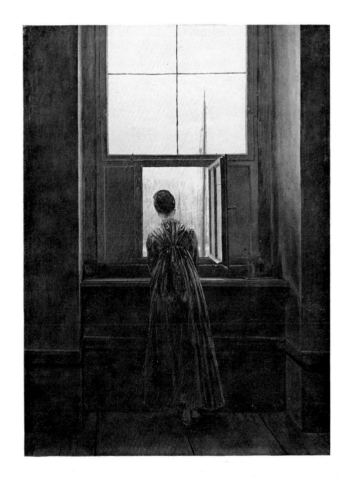

66 Village Landscape in the Morning Light Dorfland-
schaft bei Morgenbeleuchtung
Oil on canvas, 55 × 71 cm.
Lit: *16* p.292; *18* No. 522; *28* p.50, 158ff; *43* p.90; *57*
p.94; *60* p.90, 114, 122; *74* p.15ff, 26, 99; *83* p.266ff; *100*
p.70ff
Nationalgalerie, Staatliche Museen Preussischer
Kulturbesitz, Berlin (West)

Companion piece to *No. 67*. A letter by Friedrich establishes
this work as being painted in 1822.[3] The mountain peak is a
motif from the Riesengebirge. The fresh colouring with its
dominating green, the uninterrupted development of spatial
depth and the fertility of the countryside all give this picture
a life-affirming character (cf. *No. 37*). The shepherd (a
motif which goes back to the pastoral tradition of the 17th
and 18th centuries) illustrates the community of man with
nature (cf. *No. 61*). The oak trees in leaf emphasize the
worldly atmosphere (cf. *Nos. 31* and *39*).

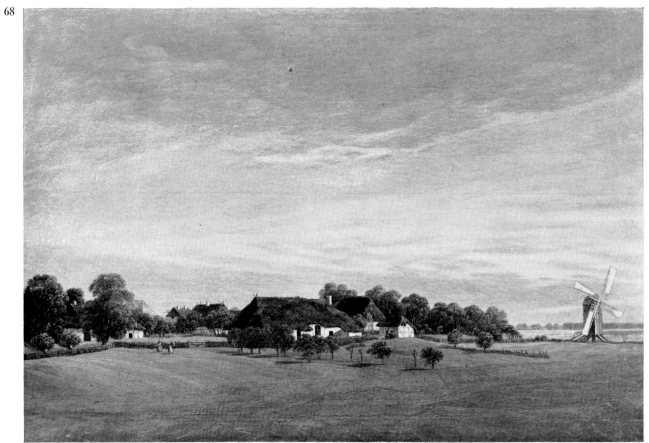

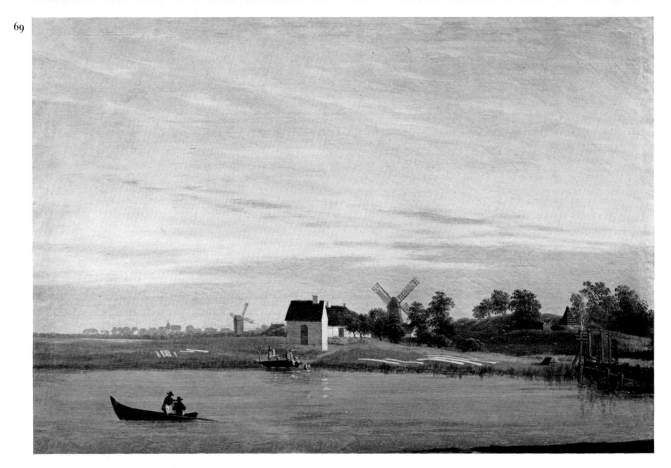

67 Moonrise over the Sea Mondaufgang am Meer
Oil on canvas, 55×71 cm. [repr. p.31]
Lit: *16* p.292; *18* No. 523; *28* p.24, 58, 125, 206; *43*
p.106, 115; *57* p.73; *60* p.61ff, 106, 122; *74* p.20; *83*
p.266; *100* p.70, 130ff, 213
Nationalgalerie, Staatliche Museen Preussischer
Kulturbesitz, Berlin (West)

The figures, evidently townspeople, are sunk in the contem-
plation of the rising moon and the ships. Just as the rocks
become symbols of faith, the home-coming ships represent
the consolation offered by Christ in the face of death. The
strong, abstract composition is in keeping with a spiritualized
conception of nature, which is quite different from that in
No. 66. Evidence provided by Ludwig Richter leads one to
believe that the strange blue-violet is an expression of
melancholy[4].

68 Flat Country Landscape Ländliche ebene Gegend
Oil on canvas, 27·4×41·1 cm.
Lit: *89* p.149ff; *100* p.76
Exh: *Dresden Academy,* 1823 (609)
Staatliche Schlösser und Gärten, Schloss Charlottenburg,
Berlin (West)

Companion piece to *No. 69*. Painted around 1822–1823.
Probably a motif from the Island of Rügen or the area
around Greifswald. This rustic idyll, like *No. 66*, may well be
an allegory on the terrestrial world. The ripe fields of corn in
the distance allude to the threat posed to this life by death
(cf. *Nos. 24, 62* and *70*).

69 Landscape with Windmills Landschaft mit Wind-
mühlen
Oil on canvas, 27·7×41·1 cm.
Lit: *89* p.149ff; *100* p.76
Exh. *Dresden Academy,* 1823 (607)
Staatliche Schlösser und Gärten, Schloss Charlottenburg,
Berlin (West)

Companion piece to *No. 68*. Painted around 1822–1823,
using the study from nature *No. 8*. The view-like effect, and
the veiling of the symbolic content which results from it, is
characteristic of many works from this period (cf. *Nos. 60–64*
and *76*). The river signifies death, the far shore with the
village and the church in the distance, the life hereafter. The
eschatological significance of the background is underlined
by the moored boat on the right, the gate, and the pyramid.
The birch tree next to the pyramid is a symbol of resurrection.

70 Landscape in the Riesengebirge Riesengebirgs-
landschaft
Oil on canvas, 35×48·8 cm.
Lit: *16* p.292; *18* No. 527; *28* p.164; *32* p.81; *43* p.74;
Kunsthalle, Hamburg

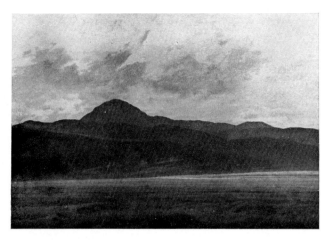

Presumably the view from Bad Warmbrunn onto the foot-
hills of the Riesengebirge. The striking contrast between the
green lowlands and the blue mountains is a symbolic parallel
to the opposition between this world and the next. The
yellow field of corn, lying as it does on the boundary between
the two regions, signifies the life which is close to death
(cf. *Nos. 24, 62* and *68*).

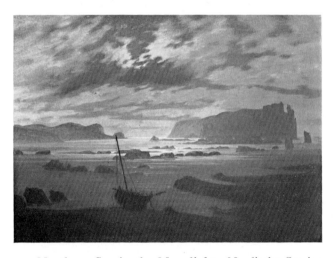

71 Northern Sea in the Moonlight Nordische See im
Mondlight
Oil on canvas, 22×30·5 cm.
Lit: *16* p.292; *28* p.202; *51* p.75; *57* p.70; *60* p.85, 113,
123; *100* p.172, 199
Exh: *Prague Art Exhibition,* 1824 (19c)
Národní Galerie, Prague

About 1823. This work was bought for the 'Gallery of Living
Painters' by Count Eduard Clam-Gallas on 1 May 1824 while
it was on exhibition at Prague. The picture belongs to a
group of works depicting northern landscapes, scenes whose
forbidding grandeur was a symbol of divine majesty for
Friedrich (cf. *Ill. xvii*). The ship drawn up on the shore
signifies the life which has ended (cf. *No. 26*), while the
anchor nearby offers the hope of resurrection.

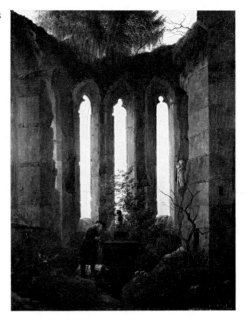

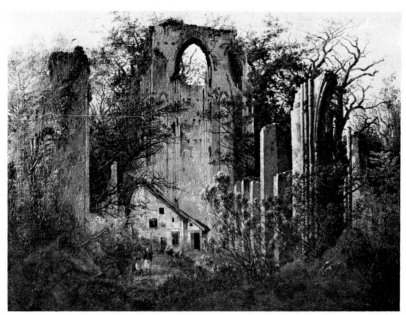

72 **Ulrich von Hutten's Grave** Ulrich von Huttens
Grab
Oil on canvas, 93×73 cm.
Lit: *32* p.75, 91; *43* p.68, 114; *62* p.26, *71* p.522; *74*
p.49; *79* p.23, 35; *100* p.62, 69, 73, 78, 206
Exh: *Dresden Academy*, 1824 (581); *Hamburg* 1826 (49);
Berlin Academy, 1826 (324).
Schlossmuseum, Kunstsammlungen zu Weimar
The inscription 'Hutten' is found on the base of the breast-
plate, for which the study *No. 45* was used, and the inscrip-
tions 'Jahn 1813', 'Arndt 1813', 'Stein 1813' and 'Görres
1821' on the panels of the sarcophagus. Probably done in
1823 as a monument to Ulrich von Hutten: at the same time,
with the names Jahn, Arndt, Stein and Görres, there is a
play upon the contemporary political situation – the hopes
of many liberals who had fought during the war of liberation
had been dashed by the reactionary nature of the govern-
ments who established power in Germany after 1815.
In 1823, ten years after the outbreak of the wars of liberation,
the 300th anniversary of the death of Ulrich von Hutten was

in many people's minds; particularly as Hutten, who had died
in exile in Switzerland, could serve as a symbol of freedom and
national consciousness. Friedrich saw in Hutten's fate a parallel
to that of Görres, who fled to Switzerland before the persecu-
tion of Prussian authoritarianism. Arndt, Jahn and Stein who
all played an essential part in the uprising of 1813, later
suffered – like Görres – from both neglect and persecution.
Typical of Friedrich's attitude is the way in which this
political allegory is tied up with a religious idea. The ruins
of the chapel – modelled on the monastery church on the
Oybin near Zittau – together with the headless statue of
Faith, while elaborating on the sense of mourning, also
signify the end of the religious spirit of the middle ages.
These contrast with the plants which characterize the new
nature piety. The fir tree, as an image of the Christian,
makes reference to the warrior in 'old-German costume' (cf.
No. 58) who is surrounded by symbols of death – the tomb
and the dead tree. The thistle signifies melancholy (cf.
No. 21).

73 **Evening** Abend
Oil on board, 20×27·5 cm.
Inscribed: 'Abend October 1824'
Lit: *57* p.113; *74* p.62; *100* p.69, 174, 239
Städtische Kunsthalle, Mannheim
Two other similar studies from this period are known. They
all show the influence of Dahl, who had been living in the
same house as Friedrich since 1823 *(see pp. 38, 96)*.

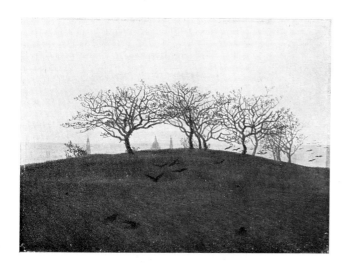

74 Hill and Ploughed Field near Dresden Hügel und Bruchacker bei Dresden
Oil on canvas, 22·2 × 30·4 cm.
Lit: *28* p.34; *43* p.84; *57* p.80; *74* p.42; *100* p.85
Kunsthalle, Hamburg

About 1824. The autumnal mood of this picture, with its bare fruit trees and ravens settling on the harvested and ploughed fields, suggests the approach of death. The spires, which rise in the distance behind the hill, symbolize the heavenly home which lies beyond (cf. *Nos. 49, 50* and *97*).

75 View through a Dip in the Shore onto the Sea
Blick durch eine Ufersenkung auf das Meer
Pencil and watercolour, 24·7 × 36·5 cm.
Lit: *28* p.128; *57* p.76; *60* p.121; *74* p.77ff; *76* p.121; *92* No. *411*; *100* p.161
Staatliche Museen, Kupferstichkabinett und Sammlung der Zeichnungen, Berlin GDR

Painted after a study from nature dated 2 July 1806. Belongs to a series of 37 views of Rügen (mostly lost), which Friedrich apparently carried out in preparation for a set of engravings which were never executed.

76 Ruin at Eldena Ruine Eldena
Oil on canvas, 35 × 49 cm.
Lit: *34* p.183, 190; *43* p.112; *57* p.108; *60* p.82, 111, 122; *62* p.18; *74* p.84; *83* p.260, 268; *89* p.157; *100* p.78, 229ff.
Exh: *Dresden Academy,* 1825 (642)
Nationalgalerie, Staatliche Museen Preussischer Kulturbesitz, Berlin (West)

Painted around 1824–1825. This view of the inside of the west wall of the Eldena ruin was executed after a study from nature, which was also used for the idealized transformation of Eldena in *No. 82.* The house built into the ruins, which was there until 1828, characterizes the poverty of the present when compared with the remains of a grand piece of mediaeval architecture; the latter also stands for an antiquated form of religious belief *(see p. 19).* The spring-like vegetation overrunning the walls suggests the resurrection and an interpretation of nature as the revelation of the divine (cf. *No. 72*).

77 The Watzmann Der Watzmann [repr. p.32]
Oil on canvas, 133 × 170 cm.
Lit: *41* p.220ff; *43* p.115; *57* p.90; *60* p.87ff, 113, 122; *74* p.102ff, 106; *86* p.572; *100* p.77, 111, 157, 172, 218, 219, 227; *100* p.212ff.
Exh: *Dresden Academy,* 1825 (644); *Hamburg* 1826 (47); *Berlin Academy* (321, 22 or 23); *Brunswick* 1932 (66)
Nationalgalerie, Staatliche Museen Preussischer Kulturbesitz, Berlin (West)

As Friedrich had never seen the Alps, he used a watercolour of the Watzmann by August Heinrich for the basic design.[5] Executed around 1824–1825, this important painting is one of Friedrich's largest works. The high mountain is a symbol of God, and the snow on the glacier, which never melts, alludes to His eternal nature. The salient crag in the middle ground (a motif from the Harz Mountains) combines the ideas of faith and death. The fir tree on the rock directly beneath the peak of the Watzmann stands for the believing Christian (cf. *No. 33*); the birch trees are symbols of resurrection (cf. *No. 69*).

78–85 The Cycle of Life Lebensalter-Zyklus

A cycle which combines the themes of the times of day, the seasons of the year, and the ages of man. Whereas earlier variants of this cycle dating from 1803 and circa 1807,[6] were made up of four scenes, in this series, the number has been extended to seven, so that representations of the existence before birth and after death could be included. An allegory on the progress of the spirit through life, is provided by the theme of the transformation of water as it goes through a natural cycle from clouds forming over the sea to the river flowing back into the sea. (For a contemporary description of an earlier version of this cycle see *p. 105*). According to contemporary sources, Friedrich carried out the seven part cycle twice – with variants – in 1826 and 1834.[7] Differences in the style of painting between the group *Nos. 78–80*, and the group *Nos. 81–84*, and the evidence provided by the drawing *No. 85* all indicate that the cycle in the Hamburg Kunsthalle is made up of a mixture of items from the two versions.

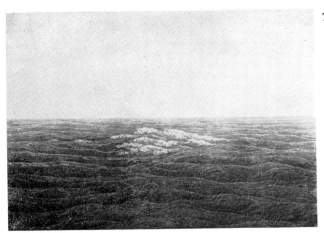

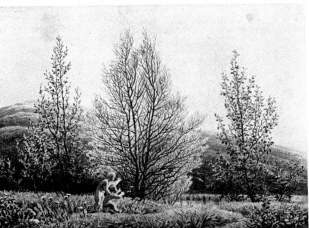

78 **Sea with Rising Sun** Meer mit aufgehender Sonne
 Pencil and sepia, 18·7 × 26·5 cm.
 Lit: *77; 92* No. 288; *100* p.149ff, 232
 Exh. *Dresden Academy*, 1826 (664)
 Kunsthalle, Hamburg
1826. The sea is an image of eternity. The sun stands for God, and the foam on the crests of the waves for the impermanence of existence. The clouds, which are formed over the sea through the influence of the sun, are the source of the rain, and the origin of the river which is depicted in the following works.

79 **Spring** Frühling
 Pencil and sepia, 19·1 × 27·3 cm.
 Lit: *62* p.17ff; *77; 92* No. 349; *100* p.149, 232
 Exh. *Dresden Academy*, 1826 (664)
 Kunsthalle, Hamburg
1826. The two birds, the tree which has not yet sprouted its leaves, and the small stream which is still near its source, are all brought into relationship with the two children, who stretch out their hands towards the butterflies, and thus express their innocent longing for an existence as pure souls.

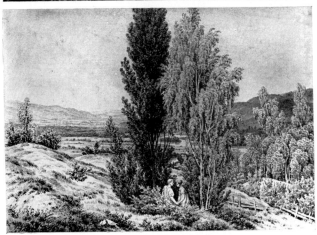

80 **Summer** Sommer
 Pencil and sepia, 19 × 27·1 cm.
 Lit: *77; 92* No. 350; *100* p.150, 232
 Exh. *Dresden Academy*, 1826 (664)
 Kunsthalle, Hamburg
1826. The group of the two lovers is echoed by the cooing doves. The poplar tree is linked to the man, the birch tree to the woman. Thus allusion is being made to death and resurrection as well as to love and marriage (cf. *Nos. 51* and *77*). The two houses symbolize the domestic happiness of marriage. The river, which has grown wider, crosses a cultivated landscape and serves as an image of the interest directed towards earthly existence at this time of life.

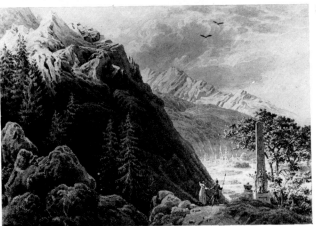

81 **Autumn** Herbst
Pencil and sepia, 19·1 × 27·5 cm.
Lit: *77; 92* No. 351; *96* p.400; *100* p.150, 153, 232
Kunsthalle, Hamburg

Probably 1834. The path of life leads down the hill towards
the town, which is probably a symbol of a political ideal, is set
in contrast with the high mountains, which symbolize the
Divine (cf. *No. 77*). The man, whose patriotic mission is
identified by the coat of arms and the uniform, is making
towards the town past the war monument beside the oak tree,
while the woman, who is associated with the fir trees, chooses
to climb a narrow path leading to the nearest peak, which
has a cross on top of it. Friedrich characterizes here the
differing relationship man and woman have with politics and
religion.

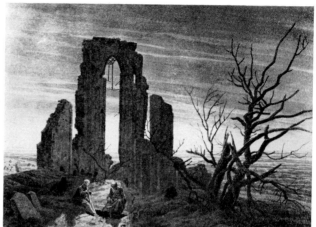

82 **Winter** Winter
Pencil and sepia, 19·2 × 27·5 cm.
Lit: *34* p.186, 190; *43* p.78, 110; *62* p.16ff, *77; 92*
No. 347
Kunsthalle, Hamburg

Probably 1834. The same view of the western end of the ruin
at Eldena, as in *No. 76*, but with considerable changes. For
the lost version of 1820, there exists a traced working drawing
with corrections *(No. 85)*. The aged couple are awaiting
death. The two trees on the right are leafless. The setting sun
appears in the window of the ruined abbey. The sea in the
background into which the river flows is likewise a symbol
of death (cf. *No. 29*).

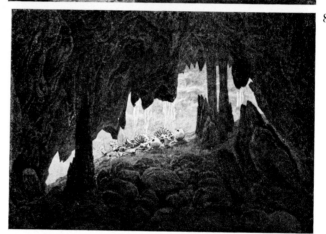

83 **Skeletons in the Stalactite Cave** Skelette in der
Tropfsteinhöhle
Pencil and sepia, 18·8 × 27·5 cm.
Lit: *74* p.10; *77; 92* No. 351
Kunsthalle, Hamburg

Probably 1834. The cave is an image of the grave (cf. *No. 77*).
The moonlight, which shines on the skeletons, symbolizes
Christ. The water is represented here in the form of icicles
hanging over the skeletons.

84 **Angels in Adoration** Engel in Anbetung
Pencil and sepia, 18·5 × 26·7 cm.
Lit: *74* p.42; *77; 92* No. 775; *100* p.218
Kunsthalle, Hamburg

Probably 1834. The resurrected souls of the couple, now
transformed into angels, adore the vision of God, seen here as
light (cf. *No. 52*). The water appears here in the form of
clouds indicating that it has been drawn upwards by the sun.

85 **Winter** Winter
Pencil, 19 × 27·5 cm.
Lit: *43* p.14; *92* No. 346
Kunsthalle, Hamburg

A working drawing, which reproduces two variants of
No. 82, an earlier one in outline which has not been fully
erased, and a later one drawn on top. Neither of these

versions matches *No. 82.* The earlier one is related, in
essential points, to a version dated 1803 destroyed in the last
war *(Ill. viii)*, and the later one probably reproduces the lost
variant of 1826 – the purpose of this drawing with tracing
marks (which is blackened on the reverse side) was probably
to carry over the composition of the 1803 version onto the
1826 one.

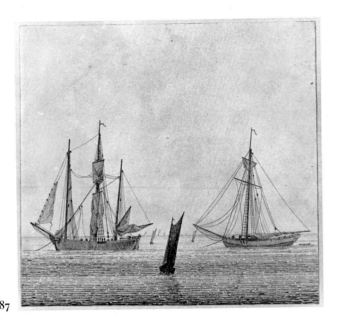

87

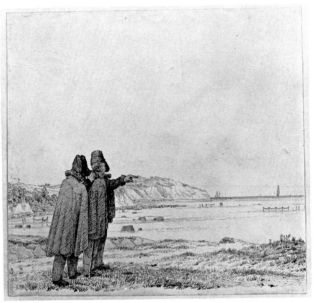

88

86　**The Minstrel's Dream**　Traum des Sängers
Pencil, 72 × 51 cm.
Lit: *43* p.114; *73* p.132ff; *79* p.34; *92* No. 798; *100*
p.62, 85, 87, 105, 206, 213, 218, 224
Kunsthalle, Hamburg

About 1825–1830. A working drawing, with tracing marks,
for a lost work which was most likely a transparency. Friedrich
made four transparencies for the Russian court around 1835.
Three of these are known from descriptions by the artist,[7]
and formed a cycle with allegories on secular, religious, and
heavenly music. The Hamburg composition is probably an
earlier variant of the 'heavenly music'. Sunk in sleep (which is
an anticipation of death) the minstrel listens to the music of
the angels. The flowers here presumably have a heavenly
character.

87　**Sea with Ships**　Meer mit Schiffen
Pen, 16·8 × 18·5 cm.
Lit: *74* p.32, 59; *83* p.265; *92* No. 736; *100* p.157
*Staatliche Kunstsammlungen, Kupferstich-Kabinett,
Dresden*

This work can be assigned to the same period as a similar
drawing which is dated 1826. At this time Friedrich was
suffering from an illness and could only carry out a few
paintings. The ships at anchor with their sails let down
symbolize the dead, while the boat which is approaching the
shore stands for the life which is approaching death.

88　**Two Men on Mönchgut**　Zwei Männer auf Mönchgut
Pen, 17·1 × 18·6 cm.
Lit: *28* p.206; *51* p.54ff, 74; *74* p.59, 87; *92* No. 670;
100 p.157
*Staatliche Kunstsammlungen, Kupferstich-Kabinett,
Dresden*

About 1826 (cf. *No. 87*). The man with the telescope is look-
ing out at the departing ships – presumably to be seen as a
symbol of the transcendent (cf. *No. 30*). Mönchgut is the
south-east peninsula of Rügen.

NOTES

1　Now in the Nasjonalgalleriet, Oslo, Inv. No. GK 58 (*92*,
No. 65; *100*, repr. 177).
2　*Wiener Zeitschrift für Kunst*, 1822, p. 1042.
3　Friedrich's letter to Consul J. H. W. Wagener in the Archive of
the Nationalgalerie, Berlin (West).
4　'Green is fresh and lively, red joyful or splendid, violet
melancholy (as with Friedrich)'. Ludwig Richter *Lebenserin-
nerungen* Frankfurt, 1885, p. 370.
5　Nasjonalgalleriet, Oslo.
6　The cycle of 1803, in the Ehlers collection in Göttingen in
1935, is now destroyed; the cycle of 1807 is only known
through the description of G. H. Schubert (see *p. 105*).
7　Seen by David D'Angers in 1834 (*100*, p. 232, Nos. 343–347).
8　cf. especially Friedrich's letters to Zhukovski 9 February 1830
and 14 October 1835 (*94*, pp. 65–6).

VI

The Late Period, 1827-1835

While Friedrich seemed to recover the full range of his creative powers around 1827, a sombreness of imagination became increasingly evident in his work. Often, a simple subject – single tree, or a group of bushes set against the sky – was all that made up a picture, and many works from this period have something of the quality of a still life about them. Once more the depiction of people became less frequent. It was only with the beginning of the 1830s that Friedrich regained a greater freedom in his choice of subjects, even though the expectation of death became an increasingly dominant theme of his creative work. In the first half of the 1830s, a high proportion of Friedrich's work consisted of mountain landscapes, both from the Riesengebirge which he had depicted earlier, and the mountains of North Bohemia, which he visited in 1828. A group of small night or evening sea pieces can also be assigned to this period. Friedrich's skill as a colourist reached its peak at this time. However, contemporary artistic criticism became less and less sympathetic towards Friedrich. The Düsseldorf school, which included Carl Friedrich Lessing as its principal landscape painter, was now widely popular because of the taste for close and exact observation of nature and it was by this standard that the quality of Friedrich's work was judged.

89 **Cemetery in the Snow** Friedhof im Schnee
Oil on canvas, 30×26 cm. [repr. p.86]
Lit: *16* p.295; *28* p.12, 142; *57* p.101; *60* p.79, 122; *74* p.11; *99* p.69, 118, 125, 128
Museum der bildenden Künste, Leipzig

There is a possibility that the date '1826' on one of the gravestones is not meant to date the picture, but rather to indicate the year of the death of the person in memory of whom the picture was painted. It was evidently done for the Baron Speck von Sternburg, in 1827. Here, the earthly life is represented as a cemetery and, hence, as the realm of death; nevertheless, there is an opening into the background, where the trees, though still in a leafless winter state, give promise of a future spring and resurrection. The blanket of snow, which Friedrich himself described as 'The essence of highest purity, whereby nature prepares itself for a new life'[1] emphasizes these thoughts.

90 **The Churchyard** Der Kirchhof [repr. p.86]
Oil on canvas, 31×25·2 cm.
Lit: *74* p.104
Kunsthalle, Bremen

About 1825–1830. The picture shows the churchyard of Priesnitz near Dresden. The motif is related to *Nos. 42* and *111*. The confined area lying in shadow on this side of the wall is contrasted with the distant landscape on the far side – together with the church, the graveyard illuminated by the sun (a symbol of deliverance through death), and the sky, which is a symbol of eternal life.

91 **Trees and Bushes in the Snow** Bäume und Sträucher im Schnee [repr. p.86]
Oil on canvas, 31×25·5 cm.
Lit: *43* p.116; *57* p.95; *74* p.12, 25; *100* p.85, 125, 220, 243
Exh: Leipzig, 1828
Staatliche Kunstsammlungen, Gemäldegalerie Neue Meister, Dresden

About 1828. Originally exhibited as a companion piece to a picture of fir trees in the snow, which is in a private collection in Bremen. The winter landscape is a symbol of death; the leafless bushes, however, contain an allusion to the coming spring and, hence, to the hope of resurrection. These associations are emphasized by the blanket of snow (cf. *No. 89*).

92 **Early Snow** Frühschnee [repr. p.87]
Oil on canvas, 43·8×34·5 cm.
Lit: *13* p.76; *28* p.100, 208; *42* p.172; *60* p.83ff, 112, 122; *74* p.105; *95* p.32; *100* p.4, 99, 127ff, 209, 214, 221, 237, 242
Exh: *Dresden Academy, 1828 (619)*
Kunsthalle, Hamburg

About 1828. The patriotic programme found in *No. 43* here gives way to a more intimate and religious experience. The path of life disappears into the darkness of the woods (cf. *No. 63*) but the fir trees denote the hope of the Christian in eternity. The snowy winter, as in *Nos. 89* and *91*, is linked with the idea of the spring to come.

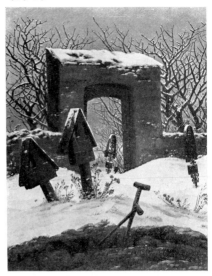

93 Oak Tree in the Snow Eiche im Schnee
 Oil on canvas, 44×34·5 cm.
 Lit: *59* p.97ff; *74* p.29; *100* p.75, 118, 238
 Wallraf-Richartz Museum, Cologne

About 1828–1830. The pool in the foreground, as well as the hazy atmosphere, indicate that the snow is melting and spring is near. Thus, this picture – like *Nos. 89, 91* and *92* – brings together the idea of death and the hope of resurrection. In this context the oak tree is less likely to refer to a pagan past (cf. *31*) than to symbolize the strength of the soul which endures after death. Such an interpretation is supported by the way in which Friedrich has restored the branches of the tree which were shown broken off in the study from nature used for this picture.[2] Thus by comparison with this study, he has made the tree whole.

94 Ships in harbour in the Evening Schiffe im Hafen
 am Abend
 Oil on Canvas, 75·5×88 cm.
 Lit: *74* p.35, 36; *83* p.263; *82* p.75, 76; *97* p.401, 408;
 100 p.126, 127, 220
 Staatliche Kunstsammlung, Gemäldegalerie Neue Meister,
 Dresden

A rowing boat in the foreground bears the inscription 'Max. v. Speck'. This refers to the patron who commissioned this work, Baron Maximilian von Speck und Sternberg, who assembled an important collection of pictures in Lützschena near Leipzig. Both *Nos. 89* and *99* were in this collection. This picture, which was painted in 1828, is a memento mori. The name on the boat identifies it as the 'ship of life' of Max von Speck; it already lies in the harbour, the symbol of death, while the other boats are returning home. The richness of composition in this work distinguishes it from the many other works that Friedrich painted around this theme.

95 The Temple of Juno at Agrigentum Junotempel
 von Agrigent
 Oil on canvas, 53·8×71·6 cm.
 Lit: *95* p.89; *101* p.205ff
 Schloss Cappenburg, Museum für Kunst und
 Kulturgeschichte der Stadt Dortmund

About 1828–1830. The only known picture by Friedrich with an Italian subject. It was probably based on an aquatint by Franz Hegi after Carl Ludwig Frommel. The ruin of the pagan temple, as a symbol of death and decay, is contrasted with the full moon as a symbol of Christ above the boundless sea. Here Friedrich also indicates his critical attitude towards the contemporary enthusiasm for Italy and the kind of view of painting which went with it.

96 The Source of the Elbe Elbquelle
 Pencil and watercolour, 25×34 cm.
 Lit: *32* p.85, 90; *57* p.85; *74* p.61; *92* No. 544; *100* p.164,
 241
 Sammlung Winterstein, Munich

Based upon a study from nature dating from 10.7.1810.[3] Probably belongs to a group of watercolour views of the Riesengebirge, which can be dated about 1828–1830. The figure of the pensive traveller seems to suggest a symbolic content, in which the spring and the mountains would stand for the origin of life (cf. *No. 79*) and the Divine.

97 The Evening Star Der Abendstern
 Oil on canvas, 32·1×45 cm.
 Lit: *74* p.42; *95* p.33; *100* p.85
 Freies Deutsches Hochstift, Goethemuseum, Frankfurt

About 1830–1835. The town in the background is Dresden. The figures might be Friedrich's wife, Caroline, one of his two daughters, and his son, Gustav Adolf, who was born in 1824. Dresden appears here – like Greifswald and Neubrandenburg in *Nos. 49* and *50* – as the divine home, which the boy greets with eager anticipation. The evening star symbolizes the connection between death and resurrection (cf. *No. 33*).

92

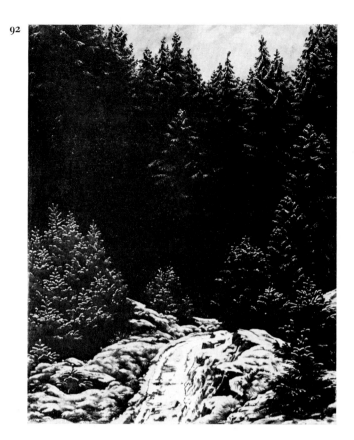

95

97

93

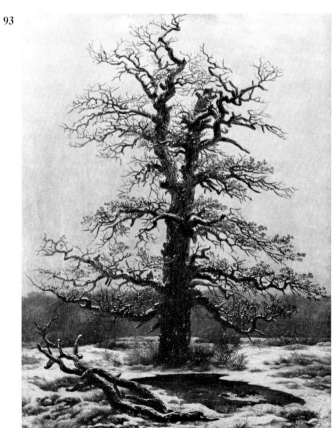

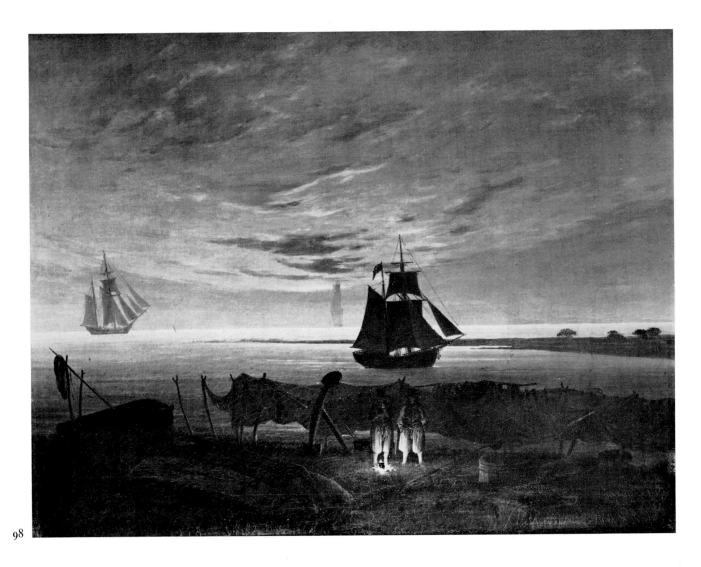

98

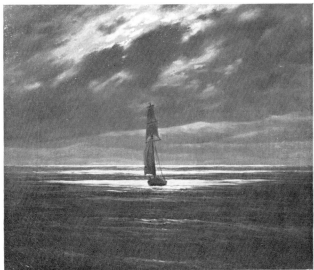

99

98 **Evening on the Baltic Sea** Abend an der Ostee
Oil on canvas, 54×71·5 cm.
Lit: *28* p.128; *43* p.113, 116; *57* p.70; *60* p.38, 113, 122;
74 p.56, 108, 111; *83* p.247, 266; *100* p.48, 72, 123, 174
Exh: *Dresden Academy*, 1831 (651)
*Staatliche Kunstsammlungen,Gemäldegalerie Neue Meister,
Dresden*

Painted about 1831.[4] The contrast between the artificial light
of the fire and the natural light of the moon was an effect
frequently exploited by the highly-popular French eight-
eenth-century painter Carl Joseph Vernet in his night sea
pieces. However, the striking composition, as in many other
works by Friedrich, is used here to suggest religious
overtones.

99 **Sea Piece by Moonlight** Seestück bei Mondschein
Oil on canvas, 25×31 cm.
Lit: *16* p.292; *28* p.128; *57* p.67; *60* p.87, 122; *74* p.43;
83 p.262, 268; *100* p.87ff, 220
Museum der bildenden Künste, Leipzig

About 1830–1835.[5] Christ, who is symbolized by the moon,
lights up the path of the ship of life as it makes its way in the
darkness of terrestrial existence, although the wind-driven
clouds, representing the adversity of life, conceal this source
of light.

100 The Large Enclosure near Dresden Das Grosse
Gehege bei Dresden [repr. p.36]
Oil on canvas, 73·5 × 102·5 cm.
Lit: *28* p.166; *43* p.116; *57* p.80; *74* p.108, 111, 113;
100 p.129, 132, 121, 227ff
Exh: *Dresden Academy*, 1832 (534)
*Staatliche Kunstsammlungen, Gemäldegalerie Neue Meister,
Dresden*

Painted in 1832,[6] this picture marked a high point in
Friedrich's development as a colourist. It recreates with great
vividness the atmosphere of the time of day just after the sun
has set. The striking perspective of the foreground may well
be the result of the view being taken from a bridge. Both the
ship drifting over the shallow water where it is in danger of
being stranded, and the abruptness with which the avenue of
trees comes to an end in the open country, are images of
approaching death.

101 Figure drawings Staffagefiguren
Brush and ink on tracing paper, 24·8 × 30·5 cm.
Lit: *92*, No. 787; *100* p.130-132, repr. 273
*Staatliche Museen, Kupferstichkabinett und Sammlung der
Zeichnungen, Berlin, G.D.R.*

This shows figures both from 'The Stages of Life' *(No. 102)*,
and the unfinished picture 'Northlight', formerly in the
Nationalgalerie Berlin and destroyed in 1945. The small
landscape sketch is of the Lilienstein in the Elbesand-
steingebirge. There are several tracing-drawings of this kind,
the earliest which dates from 1822, being for *No. 67*. The
purpose of these drawings can be deduced from Friedrich's
method of working. As Carus reported *(p.108)*, Friedrich
first sketched in his compositions on the canvas in pure
outline without making any preparatory drawing for the
whole. As the landscape was painted in, the figures became
obscured. The tracing drawing was taken from the first
outline design so that the figures could finally be carried out
according to the original plan.

102 The Stages of Life Die Lebensstufen [repr. p.42]
Oil on canvas, 72·5 × 94 cm.
Lit: *18* No. 520; *28* p.206; *39* p.27, 42; *43* p.113;
57 p.116f; *74* p.108, 110; *100* p.129, 121ff, 232
Museum der bildenden Künste, Leipzig

About 1835.[7] The old man with his back turned is probably
Friedrich himself.[8] The young boy holding up the Swedish
flag could be Friedrich's son, Gustav Adolf (born in 1824),
and the girl next to him, his daughter Agnes, who was one
year younger. The identity of the other figure is problematic.
The five ships correspond to the five figures on the shore. The
large ship, which is drifting towards the shore, is related to
the figure of the painter, and indicates the closeness of his
death. The sunset and the crescent of the moon emphasize
these thoughts (cf. *No. 48*). *No. 101* is a working drawing
made in connection with the figures.

103 Riesengebirge Riesengebirge
Oil on canvas, 72 × 102 cm.

Lit: *28* p.104ff; *32* p.87ff, 91; *74* p.107
*Nationalgalerie, Staatliche Museen Preussischer
Kulturbesitz, Berlin (West)*

Together with *No. 104* this work belongs to a group of
mountain landscapes from the period around 1830-1835.
Although sometimes described as 'before sunrise' this is, like
No. 100, a rendering of the atmosphere after the sun has set.
The traveller on the rock in the foreground has reached the
end of his life and sees before him the gorge of death together
with the mountain peaks in the distance, which serve as an
image of the hereafter. The calmness of tone – so different
from *No. 22* – is characteristic of Friedrich's late work.

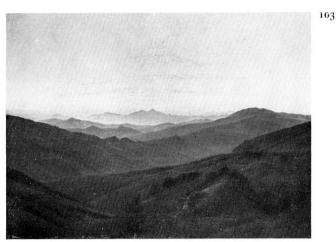

103

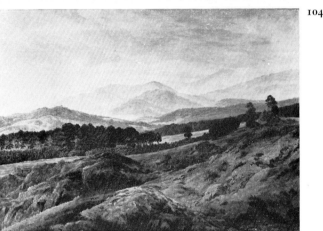

104

104 Landscape in the Riesengebirge Riesengebirgsland-
schaft
Oil on canvas, 72 × 102 cm.
Lit: *17* p.259; *18* No. 505; *28* p.108; *32* p.80, 91;
57 p.92; *69* p.533
Nasjonalgalleriet, Oslo

Unfinished. Acquired from Friedrich's estate by Dahl in
1840. Painted around 1835. The stony path in the fore-
ground, which, as in *No. 29*, comes to an abrupt end, stands
for the end of life. The unsettling way the foreground and
middleground slide off to one side is a feature often found in
Friedrich's late work. The mountain range in the distance is a
vision of the hereafter.

NOTES

1 cf. *Lit. 26* p.203.

2 In the Nasjonalgalleriet, Oslo (*92* No. *382*; *100* repr. *166*).
Like No. *27*, it was also used for the Weimar sepia 'Hünengrab
am Meer' *(Ill. i)*.

3 In Folkwang Museum, Essen (*92* No. *534*; *100* repr. *439*).

4 This work was acquired by the Sächsischer Kunstverein when
it was exhibited at the Dresden Academy who had issued an
engraving of it by C. Peschek in the same year (*60* repr. *9*).

5 The ship is based on a drawing in the Nasjonalgalleriet in
Oslo, dated 6 August 1818 (*55* repr. *43*; *74* p.*43*, note 3).

6 As with No. *98*, this work was acquired by the Sächsischer
Kunstverein when it was exhibited at the Dresden Academy.
An engraving of it was made by Veit who 'corrected' the
curvature of the earth in the foreground (*60* repr. *64*).

7 It was believed for a long time that this picture was painted
before 1815, since the small boy on the shore is holding the
flag of Sweden, the country that ruled Friedrich's homeland
up to the end of the Napoleonic Wars. In recent years, how-
ever, it has been discovered that the fishing tackle in the fore-
ground and the small sailing ship on the right are based on
studies respectively dated 18 August and 4 August, from the
Oslo Sketchbook of 1818 (*55*; *74* p.109; *83* p.267). The
highly evocative colouring is similar to works firmly datable
to the 1830s, like *No. 100*.

8 A portrait of Friedrich painted in 1839 by Caroline Bardua
(*55* repr.) shows him with a hat, cloak, and stick similar
to those in *No. 102*. This characteristic costume of Friedrich's
was mentioned by many contemporaries.

VII

Final Works, 1835-c.1839

On 26 June 1835 Friedrich suffered a stroke. After a period of convalescence in Teplitz, however, his health was sufficiently restored for him to be able to resume painting in oils towards the end of the year. A small group of oil paintings, in which the brush strokes are uncertain and uneven, seem to have been executed after this illness. Nevertheless, his strength continued to fail, and he was not able to finish all the pictures he had started before his stroke. Paintings in sepia and watercolour largely replaced painting in oil. This meant that Friedrich now tended to use watercolours, a technique that he had previously reserved for view painting, for allegorical landscapes. The dating of these sepias and watercolours can only be deduced from the increasing uncertainty of hand displayed in them.

In this last phase of his artistic career, Friedrich limited himself to a few well-tried themes – highland landscapes, dolmens, ruins, rocky coasts under the rising moon, cemeteries, caves and owls. He showed a preference for foreground motifs viewed very closely which, as a result, loom against the sky. In 1839, a year before his death, his last summary drawings appear to have been executed.

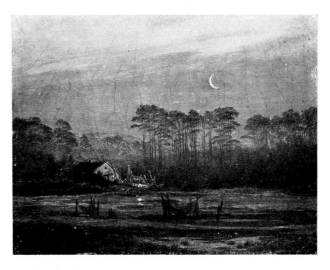

105 **Solitary House in the Pine Forest** Einsames Haus am Kiefernwald
Oil on canvas, 19·5 × 25 cm.
Lit: *54* p.50; *57* p.113; *83* p.247; *100* p.78ff., 173, 205
Wallraf-Richartz Museum, Cologne

Probably a repetition or variant of a picture exhibited at the Dresden Academy in 1825 (643). The uncertainty of the brush strokes and the uneven application of the paint suggest that this work was painted after 1835, when Friedrich was already crippled as a result of his stroke and found it difficult to work in oils. It is the only painting by Friedrich which shows the crescent of the waning moon – a phenomena only visible in the morning. The fishermen await the light of the new day by a fire – the symbol of faith (cf. *No. 98*).

106 **Sea Shore with the Rising Moon** Strand mit Mondaufgang [repr. p.92]
Pencil and sepia, 23·3 × 35·8 cm.
Lit: *17* p.258; *74* p.79; *92* No. 285; *100* p.153, 226
Staatliche Kunstsammlungen, Kupferstich-Kabinett, Dresden

About 1835–1837. The rocky shore is taken from the foreground of *No. 9*. The extremely close view of the objects is characteristic of the late period. Foreground and background are brought into association with each other through the tips of two boulders, which cross the horizon and loom against the sky. Thus the symbols of faith on the terrestrial world balance the unnaturally large moon – frequently used by Friedrich to symbolize Christ and the promise of resurrection (cf. *No. 26*).

107 **Landscape with Grave, Coffin and Owl** Landschaft mit Grab, Sarg und Eule [repr. p.92]
Pencil and sepia, 39 × 38 cm.
Lit: *18* p.142; *57* p.107; *92* No. 362; *100* p.151, 154, 236
Kunsthalle, Hamburg

Painted about 1836–1837. One of the largest sepias produced by Friedrich after his stroke in 1835. The traditional associations of the owl are fully exploited here. As a bird of death and a symbol of religious wisdom, it establishes a link between the coffin and the full moon, which represents Christ (cf.

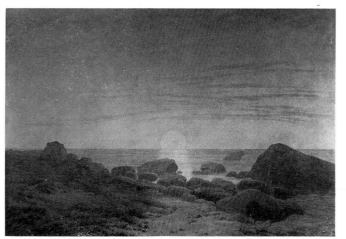

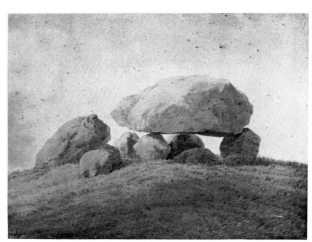

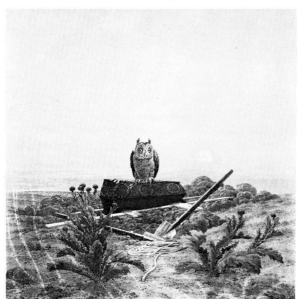

No. 106). While thistles, traditionally associated with melancholy, grow in the foreground, the cliffs in the background reveal a vision of the hereafter.

108 **Owl on a Grave** Eule am Grab
 Pencil, pen, sepia, 17×20·4 cm.
 Lit: *92* No. 365: *100* p.154, 231, 236
 Schlossmuseum, Kunstsammlung zu Weimar

A variant on the theme in *No. 107*. There is a similar composition in the Albertina, Vienna, in which the Owl is replaced by a vulture.

109 **Dolmen near Gützkow** Hünengrab bei Gützkow
 Pencil and sepia, 22·4×30·4 cm.
 Lit: *100* p.79, 155, 240
 The Library of Her Majesty Queen Margrethe II, Queen of Denmark, Copenhagen

About 1837. The study from nature *No. 13* has been used for the cairn grave. Here, however, it is not used as a specific reference to ancient times. Set against the sky, which is also visible beneath the stone covering it becomes, in combination with the grass, a more general image of transience and the promise of eternal life.

110 **Chalk Cliffs on Rügen** Kreidefelsen auf Rügen
 Pencil and watercolour, 31·7×25·2 cm.
 Watermark: 'Whatman 1825'
 Lit: *76* p.120, 122; *83* p.247; *89* p.155ff; *92* No. 649;
 100 p.88ff, 141, 161, 163, 217
 Museum der bildenden Künste, Leipzig

A motif from the Königstuhl on Rügen (cf. *No. 9*). The loose, painterly style places this work after 1835.

111 **Landscape with Crumbling Wall** Landschaft mit
 verfallener Mauer [repr. p.41]
 Pencil and watercolour, 12·2×18·5 cm.
 Lit: *28* p.205; *64* p.62; *92* No. 754; *100* p.159
 Kunsthalle, Hamburg

About 1837–1840. Despite its freshness, this is a composed subject rather than a worked-up study from nature like *Nos. 75* and *96*. As in *Nos. 74* and *97* Friedrich has placed the silhouette of Dresden in the distance and endowed it with paradisical associations. In combination with the gateway, which opens from a shaded narrow foreground onto a broad sunny countryside, this creates a characteristic allegory on transience and eternity beyond.

112 **View over Meadows towards the Riesengebirge**
 Blick über Wiesen zum Riesengebirge
 Pen and watercolour, 14×20·5 cm.
 Lit: *92* No. 557; *100* p.164
 Museum der bildenden Künste, Leipzig

The extremely loose brush strokes imply a dating of 1837–1840. Like *No. 111*, and other watercolours of Friedrich's last years this apparently informal subject contains an allegory. The traveller along the path of life pauses to contemplate the mountain in which he sees the image of the Divine. The house, which is placed directly above the traveller suggests a haven and, hence, the security to be found in death.

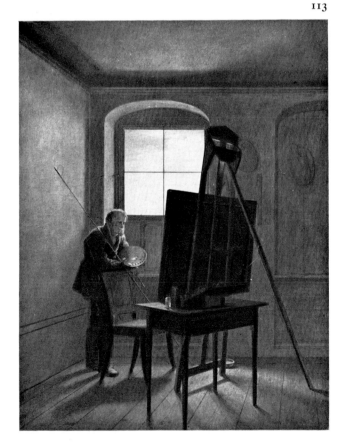

VIII

Friedrich's Circle

Friedrich's influence on the art of his time did not correspond in any way to his importance as a painter. This was no doubt because of the degree to which the effect of his art depended largely on the peculiar quality of his personality.

It is not, therefore, so surprising to find that the Dresden Academy should have considered Friedrich's art unsuitable for the establishment of a school. Only in 1824 was he finally given the limited recognition of being made an associate professor at the Academy, and he was never called upon to act as an official instructor. Nevertheless, Friedrich did take a small number of private pupils. At the time when his reputation was at its height, during the beginning of the second decade of the century, he is only known to have had one pupil. This was Karl Wilhelm Lieber, with whom he fell out because the latter copied his work without understanding it. Towards the end of this decade a number of young Dresden artists, including Ludwig Richter, turned to Friedrich for guidance. For nearly all of them, however, this was to be no more than a short phase in their development. One important exception was Oehme *(see p. 97)*. Next to Oehme, the amateur Carus was the person on whom Friedrich had the most lasting influence. With stronger artistic personalities like August Heinrich and Dahl, it is their very independence that is significant. On the whole, the possibility of a confusion between the work of these artists and Friedrich can be excluded, although some early works by Karl Julius Leypold were until recently thought to be by Friedrich.

GEORG FRIEDRICH KERSTING

Born in 1785 in Güstrow, Mecklenburg and died in 1847 in Meissen. Kersting, like Friedrich, was a pupil at the Copenhagen Academy, which he attended from 1805. In 1808, he entered the Dresden Academy. In 1810, he went on a tour through the Riesengebirge with Friedrich *(Lit:36)*. From 1816–1818 he taught drawing in Warsaw, and afterwards became the director of the painting section in the porcelain works at Meissen, where Friedrich visited him several times. Kersting's speciality was the painting of portraits in interiors, a genre that was especially common in Copenhagen. In these, a man's surroundings were used to reflect his personality. Kersting's interiors seem to have provided a stimulus for Friedrich on a number of occasions (cf. *No. 65*). On the other hand, Friedrich influenced Kersting's manner of painting and, above all, his style of drawing. Sometimes Kersting also tried to adopt Friedrich's allegorical mode of expression but, in general, he limited himself to a faithful transcription of the visible.

Lit: Oskar Gehrig, *Georg Friedrich Kersting*. Schwerin 1931; Gustav Vriesen, *Die Innenraumbilder Georg Friedrich Kerstings*. Berlin 1935.

113 **Caspar David Friedrich in his Studio** Caspar David Friedrich in seinem Atelier [repr. p.93]
Oil on canvas, 51 × 40 cm.
Inscribed: 'G. Kersting 1812'
Nationalgalerie, Staatliche Museen Preussischer Kulturbesitz, Berlin (West)

Friedrich is shown here in the studio in Dresden that he used up till 1820. Like the studio of the house in which he subsequently lived (cf. *No. 65*), this overlooked the Elbe. The unusual plainness and emptiness of this room was remarked upon by several contemporaries (cf. *p. 104*) and the absence of accessories shown here tallies with Carus' description of Friedrich's introspective method of painting (cf. *p. 108*). There are two other representations of Friedrich in his studio by Kersting, one in Hamburg (1811) and one in Mannheim (1819). Kersting painted a pendant to the Hamburg picture portraying Friedrich's friend, the artist Gerhard von Kugelgen, whose cluttered studio forms a strong contrast to that of Friedrich.

114 **In front of the Mirror** Vor dem Spiegel
Oil on wood, 46 × 35 cm.
Inscribed: 'Kersting 1827'
Kunsthalle zu Kiel

In contrast to Friedrich's 'Woman at the Window' *(No. 65)*, this interior emphasizes anecdotal detail. The intimate charm of this work was a common feature of genre painting in Biedermeier Germany.

CARL GUSTAV CARUS

Born in Leipzig in 1789 and died in Dresden in 1869. After studying natural sciences, philosophy, and medicine at the University of Leipzig, Carus practised as a doctor in this city. In 1814, he was called to Dresden as Professor of Gynaecology. He met Friedrich in 1817, and soon struck up a friendship with him. As a painter, Carus was an amateur. He was encouraged by Friedrich and strongly influenced by him up until about 1830. On Friedrich's advice, he undertook a journey to the Island of Rügen in 1819, and to the Riesengebirge in 1820. In 1844 Carus also visited England and Scotland. On the other hand, Friedrich painted a large mountain landscape from drawings by Carus in 1824. Carus' theory of art, which he set out in 'Nine Letters on Landscape Painting' (1815–1824) was evolved independently for the most part, though it had often been taken to be a formulation of Friedrich's view of art. The interest in natural science, which Carus shared with Goethe, predisposed him to see in landscape the manifestation of its own independent life. He mostly used the motifs which he took over from Friedrich for the expression of atmosphere and not for the communication of specific imaginative content. His pictorial structure is loose and is not motivated by any allegorical conceptions. Towards the end of the 1820s his personal ties with Friedrich became weaker, when the latter, after an illness and some disillusionment with the world around him, became increasingly misanthropic. Carus also moved away from Friedrich in his manner of painting. After the latter's death, however, he wrote a short work in memory of Friedrich entitled 'Friedrich the Landscape Painter' *(Lit: 10)*.

Lit: Carl Gustav Carus, *Lebenserinnerungen und Denkwürdigkeiten*. Weimar 1966: Marianne Prause, *Carl Gustav Carus, Leben und Werk*. Berlin 1968 *(Lit. 95)*.

115 **Dolmen in the Moonlight** Hünengrab im Mondschein
Oil on canvas, 33·5 × 43 cm.
Lit: *96*, No. 304
Nasjonalgalleriet, Oslo

This picture shows a dolmen near Nobbin on the Island of Rügen which Carus sketched in 1819. A pencil drawing of the grave, apparently drawn on 20 August 1818 is also in the possession of the Nasjonalgalleriet, Oslo. The picture might well have been executed soon afterwards, and the style of painting is particularly closely related to Friedrich's. A larger variant, once believed to be a work by Friedrich, was destroyed in a fire in Munich in 1931 *(96 : No. 303)*.

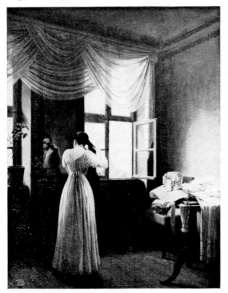

116 **Woman on the Terrace** Frau auf dem Söller
 Oil on canvas, 42 × 33 cm.
 Lit: *96*, No. 363
 Inscribed 'Carus 1824'
 Staatliche Kunstsammlungen, Gemäldegalerie Neue Meister, Dresden

The motif of the woman on the terrace frequently occurs in works by Friedrich, circa 1815–1820. However, the relationship of the figure to the distant landscape is used here to evoke some vague sense of longing rather than to elaborate a specific allegory.

117 **Boat Trip on the Elbe** Kahnfahrt auf der Elbe
 Oil on canvas, 29 × 22 cm.
 Inscribed: 'Carus 1827'
 Lit: *96*, No. 49
 Exh: *Dresden Academy*, 1827 (142)
 Kunstmuseum, Düsseldorf

Described by Carus in a letter dated 15 July 1827 as 'better than anything I have done previously in this genre', this work was well received when shown at the Dresden Academy and was acquired by the wife of Prince Johann Georg of Saxony. Apart from the position of the figures and the view in the distance, the composition is almost identical to a watercolour by Friedrich in a private collection in Oslo (Lit. *100*, repr. 194).

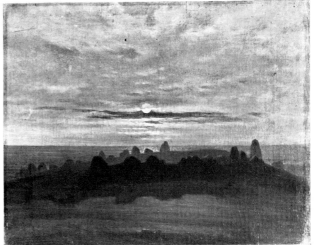

115

118 **Oak Trees by the Sea** Eichen am Meer
 Oil on canvas, 117·5 × 162·5 cm.
 Lit: *96*, No. 325
 Exh: *Dresden Academy*, 1835 (438)
 Staatliche Kunstsammlungen, Gemäldegalerie Neue Meister, Dresden

A major work of Carus' exhibited in Dresden in 1835. It is a recollection of his 1819 journey to the Baltic sea. In its dramatic conception, the picture stands closer to Dahl.

118

JOHAN CHRISTIAN CLAUSSEN DAHL

Born in Bergen in 1788, and died in Dresden in 1857. From 1811–1818, Dahl, like Friedrich before him, studied at the Copenhagen Academy. He went from there to Dresden, where he very soon became a close friend of Friedrich's. After an initial period when he was strongly influenced by Friedrich, he soon developed a style very much his own, which differed from the latter's in its painterly spontaneity of execution. He was also interested in depicting nature for its own sake without allegorical allusions. In 1820–1821, Dahl toured Italy and in 1826, 1835, 1839, 1844 and 1850 he visited his Norwegian homeland. Dahl became best known for his Norwegian mountain landscapes and sea pieces, and the interest in northern landscapes also served to strengthen his ties with Friedrich. After 1823, Dahl lived in the same house as Friedrich where, despite the many things they had in common, his natural disposition and artistic style formed a strong contrast to that of Friedrich. Their friendship remained undisturbed right up until Friedrich's death. If Friedrich was introverted, unassuming and withdrawn in company, Dahl was a man of the world with a talent for business, who managed to bring together a considerable collection of art that was later to form the basis of the collection in the Oslo National Gallery. As a teacher, Dahl was much more in demand than Friedrich. The development of Friedrich as a painter in the 1820's can hardly be understood without taking into account the influence of Dahl.

Lit: Andreas Aubert, *Maleren Johan Christian Dahl.* Kristiana 1920; Leif Østby, *Johan Christian Dahl. Tegninger og Akvareller.* Oslo 1957.

119 **Moonlit Night** Mondnacht
 Oil on canvas, 38·4 × 54·3 cm.
 Inscribed: 'Dahl 1819'
 Kunstmuseum, Düsseldorf

Shown here are the ruins at Tharandt, near Dresden, one of the most popular tourist attractions in the area around the city, which Friedrich also sketched many times. An interesting comparison can be made with a drawing done by Friedrich in 1818 (now in Oslo; *Lit, 100, repr. No. 394*), which shows how Dahl reinterpreted the motif in a way that made the composition more calm and evenly balanced. However, the manner of painting and the colouring, together with the figure seen from behind dressed in 'old-German costume' (see *No. 36*) are all very reminiscent of Friedrich. One knows from Dahl's diary that he sketched Tharandt on the 15 October 1819 and that he painted an outing to Tharandt on 19 October. Perhaps this is a reference to the picture here.

120 **After the Storm** Nach dem Sturm
 Oil on canvas, 28·5 × 36·5 cm.
 Nasjonalgalleriet, Oslo

Painted 1829. This is apparently the earliest shipwreck painting by Dahl. The wreck and the mountains go back to a study made in Bergen on 16 September 1826. Dahl often treated the theme of the wreck on the rocky coast in a stormy landscape. While the subject was used by Friedrich as an indication of mortal transience, it is used by Dahl to express a fascination with the power of the elements.

121 **Copenhagen**
 Oil on canvas, 54 × 72 cm.
 Staatliche Kunstsammlungen, Gemäldegalerie Neue Meister, Dresden

Circa 1835. The use of thin paint over a precisely drawn structure in this work demonstrates the range of Dahl's manner. While the pictorial form and the motif of the figures viewed from the back relate to Friedrich's style, the inclusion of a steamboat by the older master would be hard to imagine.

122 **Danish Winter Landscape**
 Oil on Canvas, 38 × 50 cm.
 Signed 'J Dahl 1838'
 Nasjonalgalleriet, Oslo

The theme of this work is related to *No. 31*, a picture that Dahl was to acquire in 1845. In contrast to Friedrich, Dahl avoids here any religious associations and limits himself to the portrayal of the negative aspects of winter—cold, darkness, hunger, and death.

123 **Dresden in Moonlight** Dresden bei Mondschein
 Oil on canvas, 78 × 130 cm.
 Inscribed: 'Dahl 1839'
 Staatliche Kunstsammlungen, Gemäldegalerie Neue Meister, Dresden

A view from the new city bank onto the Augustus Bridge and the skyline of Dresden, showing the Hofkirche, the tower of the castle and the dome of the Frauenkirche. Despite the dramatic use of light, the picture is very much in the tradition of Bellotto's views of Dresden, and has little to do with Friedrich's views of cities *(Nos. 74, 97)*. In fact, the Dresden Gallery owns a Bellotto depicting a view taken from almost the identical position.

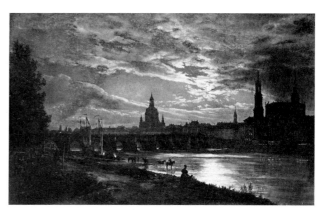

Ernst Ferdinand OEHME

Born in Dresden in 1797 and died there in 1855. He was a student at the Dresden Academy, as well as a pupil of Dahl's, but his style derives less from the latter than it does from Friedrich. From 1822–1825, he stayed in Italy, and after his return, became a painter at the Saxon Court. In 1846, he was made an associate of the Dresden Academy of Art. Ludwig Richter, who was a friend of his, wrote of him; 'Oehme conceives of . . . nature differently than Friedrich and goes his own good way' and 'Thus Oehme had an over-riding taste for so-called atmospheric pictures . . . Oehme was a night bird who loved to flit around at dusk and at night.' (L. Richter, *Lebenserinnerungen*, Frankfurt 1885, p.195)

Lit: *100*, p.83; (see *pp. 45–49*).

124 Cathedral in Winter Dom im Winter [repr. p.46]
Oil on canvas, 127 × 100 cm.
Inscribed: 'EO'. Exh: *Dresden Academy* 1821 (339)
Staatliche Kunstsammlungen, Gemäldegalerie Neue Meister, Dresden

This picture was painted in 1821, when Oehme had received a scholarship to go to Italy from the Saxon crown prince. The choice of motif and strength of drawing derives from Friedrich. It was modelled principally on the 'Monastery Graveyard in the Snow' *(Ill. xv)* which Friedrich painted in 1817–1819, and which was later destroyed in 1945. The multitude of architectural motifs perhaps reflects the contemporary fashion for the Gothic style and the increasing interest in its revival.

125 Procession in the Mist Prozessionen im Nebel
Oil on canvas, 81 × 105·5 cm. [repr. p.47]
Inscribed: 'EO 1828'
Exh: *Dresden Academy* 1828 (347)
Staatliche Kunstsammlungen, Gemäldegalerie Neue Meister, Dresden

The various motifs here, many of which derive from Friedrich, are introduced in order to create a nostalgic and somewhat vague religious atmosphere rather than a specific allegory.

Carl Julius von LEYPOLD

Born in Dresden in 1806, and died in 1874 in Niederlössnitz, near Dresden. From 1820–1829, Leypold was a student at the Dresden Academy and a pupil of Dahl's. Through Dahl, he also established contact with Friedrich, whose manner of painting he imitated up until the 1830s. Precisely drawn branches of dead trees were a favourite motif of his in his early work. Later, Leypold turned more and more to view painting and adopted a freer manner and a more lively colouring.

Lit: Werner Sumowski, *Caspar David Friedrich und Carl Julius von Leypold.* Pantheon XXIX 1971, p.497–504.

126 Entrance to a Church Yard Kirchhofseingang
Oil on canvas, 25·5 × 35 cm.
Inscribed: 'K vL 1832'
Stadtmuseen, Nuremburg

In this work, Leypold modelled himself on Friedrich's pictures of cemeteries like *No. 89* and *No. 90*. The Biedermeier accessories introduce a different, almost sentimental note to the scene. The delicate harmonizing of the grey tones seems to reflect Friedrich's colouristic development in the late 20s and early 30s (cf. *No. 91)*.

Bibliography

1 Catalogues of the Exhibitions of the Kgl. Sächsische Akademie der Künste in Dresden 1801–1840

2 G. H. Schubert, *Ansichten von der Nachtseite der Naturwissenschaften* Dresden 1808, p.301ff

3 F. W. B. v. Ramdohr, 'Über ein zum Altarblatte bestimmtes Landschaftsgemälde von Herrn Friedrich in Dresden, und über Landschaftsmalerei, Allegorie und Mysticismus überhaupt'. *Zeitung für die elegante Welt* 1809, p.89ff, 97ff, 108ff

4 F. Hartmann, 'Über Kunstausstellungen und Kunstkritik.' *Phoebus* I, 1808 (1809), Stück 11, 12, S.57ff

5 G. v. Kügelgen, 'Bemerkungen eines Künstlers über die Kritik des Kammerherrn von Ramdohr.' *Zeitung für die elegante Welt* 1809, p.389ff

6 C. A. Semler, 'Über einige Landschaften des Malers Friedrich in Dresden.' *Journal des Luxus und der Moden* 1809, III p.239

7 F. W. B. v. Ramdohr, 'Über kritischen Despotismus und künstlerische Originalität.' *Zeitung für die elegante Welt* 1809, p.446ff, 453ff

8 (H. v. Kleist), 'Empfindungen vor Friedrichs Seelandschaft.' *Berliner Abendblätter* 1810, p.49ff

9 L. Tieck, 'Eine Sommerreise.' *Taschenbuch Urania für 1834*

10 C. G. Carus, *Friedrich der Landschaftsmaler.* Dresden 1841

11 A. Graf Raczynski, *Geschichte der neueren deutschen Kunst.* III. Berlin 1841, p.222, 225

12 G. H. Schubert, *Der Erwerb aus einem vergangenen und die Erwartungen von einem zukünftigen Leben.* II. Erlangen 1855, p.182ff

13 W. Wegener, *Der Landschaftsmaler Friedrich, Unterhaltungen am häuslichen Herd* 1859, p.71ff

14 G. Parthey, *Deutscher Bildersaal.* I. Berlin 1863, p.459ff, II. 1864, S.847

15 Th. Pyl, 'Caspar David Friedrich.' *Allgemeine deutsche Biographie* VIII. Leipzig 1878, p.64ff

16 A. Aubert, 'Der Landschaftsmaler Friedrich,' *Kunstchronik* 1895/96, p.292ff

17 A. Aubert, 'Caspar Friedrich.' *Kunst und Künstler* 1905, p.197ff, 253ff

18 *Ausstellung deutscher Kunst aus der Zeit von 1775–1875 in der Königlichen Nationalgalerie, Berlin 1906.* München 1906, Nos. 505–536

19 A. Aubert, 'Aus Caspar Friedrichs Nachlaß.' *Kunst und Künstler* 1906, p.295ff

20 A. Aubert, 'Patriotische Bilder von Kaspar Friedrich aus dem Jahre 1814.' *Kunst und Künstler* 1911, p.321, 609ff

21 W. Kurth, 'Holzschnitte von Kaspar David Friedrich,' *Amtliche Berichte aus den Königlichen Kunstsammlungen.* 1914/15, p.229–236

22 A. Aubert, 'Caspar David Friedrich,' *Gott, Freiheit und Vaterland.* Berlin 1915

23 G. F. Hartlaub, 'Caspar David Friedrich und die Denkmals-Romantik der Freiheitskriege' *Zeitschrift für bildende Kunst* 1916, p.201ff

24 P. F. Schmidt, 'Caspar David Friedrich.' *Allgemeines Lexikon der bildenden Künster herausgegeben von Ulrich Thieme.* XIII. Leipzig 1916, p.464ff

25 O. Fischer, *Caspar David Friedrich, die romantische Landschaft.* Stuttgart 1922

26 K. K. Eberlein. *Caspar David Friedrich. Bekenntnisse.* Leipzig 1924

27 F. Wiegand, *Aus dem Leben Caspar David Friedrichs. Geschwisterbriefe.* Greifswald 1924

28 W. Wolfradt, *Caspar David Friedrich und die Landschaft der Romantik*. Berlin 1924

29 K. W. Jähnig, 'C. D. Friedrichs früheste Bilder "Sommer" und "Winter".' *Die Kunst für alle* 1926/27, p.257

30 I. M. Olsen, *C. D. Friedrichs Selvportraet i Kobberstiksamlingen* Samleren 1926

31 K. K. Eberlein, 'Goethe und die bildende Kunst der Romantik.' *Jahrbuch der Goethe-Gesellschaft* 1928. p.1ff

32 G. Grundmann, *Das Riesengebirge in der Malerei der Romantik*. Breslau 1931

33 K. W. Jähnig, 'Eine unerkannte Elblandschaft von Caspar David Friedrich.' *Kunst und Künstler* 1932, p.366ff

34 O. Schmitt, 'Die Ruine Eldena im Werk von Caspar David Friedrich.' *Von der Antike zum Christentum. Untersuchungen als Festgabe für Victor Schultze*. Stettin 1931, p.169

35 K. W. Jähnig, 'Caspar David Friedrich.' *Pommersche Lebensbilder* I. Stettin 1934, p.25ff

36 A. Rohde, 'Caspar David Friedrich in Königsberg.' *Zeitschrift für Kunstgeschichte* 1934, p.109ff

37 H. v. Einem, 'Philipp Otto Runge und Caspar David Friedrich.' *Imprimatur, Jahrbuch für Bücherfreunde* 1935, p.106ff

38 Ch. Hintze, *Kopenhagen und die deutsche Malerei um 1800*. Diss. Berlin 1936

39 K. Leonhardi, *Die romantische Landschaftsmalerei Caspar David Friedrichs*. Diss. Würzburg 1936

40 O. Schmitt, 'Aquatintablätter nach Caspar David Friedrich.' *Zeitschrift des deutschen Vereins für Kunstwissenschaft* 1936, p.421ff

41 E. Hanfstaengl, 'Vier neue Bilder von C. D. Friedrich in der Nationalgalerie.' *Jahrbuch der preußischen Kunstsammlungen* 1937, p.217ff

42 H. Beenken, 'Caspar David Friedrich.' *The Burlington Magazine* 1938, p.171ff

43 H. v. Einem, *Caspar David Friedrich*. Berlin 1938

44 H. v. Einem, 'Wassily Andrejewitsch Joukowski und C. D. Friedrich.' *Das Werk des Künstlers* 1939, p.169 ff

45 O. Schmitt, 'Ein Skizzenbuchblatt C. D. Friedrichs im Wallraf-Richartz-Museum.' *Westdeutsches Jahrbuch für Kunstgeschichte* 1939, p.290

46 German Library of Information. *Caspar David Friedrich. His Life and Work*. New York 1940

47 K. K. Eberlein, *Caspar David Friedrich, der Landschaftsmaler*, Leipzig 1940

48 H. v. Einem, 'Ein Vorläufer Caspar David Friedrichs?' *Zeitschrift des deutschen Vereins für Kunstwissenschaft* 1940, p.156ff

49 E. Gülzow, 'Die Urfassung von C. D. Friedrichs Kreuz im Gebirge.' *Kunst-Rundschau* 1940, p.114ff

50 G. F. Hartlaub, 'Caspar David Friedrichs Melancholie.' *Zeitschrift des deutschen Vereins für Kunstwissenschaft* 1941, p.261ff

51 K. Wilhelm-Kästner, L. Rohling, K. F. Degner, *Caspar David Friedrich und seine Heimat*. Berlin 1940

52 *Caspar David Friedrich Gedächtnisausstellung zum 100. Todestage am 7. Mai 1940*. Dresden 1940

53 K. K. Eberlein, 'C. D. Friedrich, Lieber und Goethe. Mit einem wiedergefundenen Winterbild Friedrichs.' *Kunst-Rundschau* 1941, p.5ff

54 C. v. Lorck, 'Fünf neuentdeckte Bilder von Caspar David Friedrich.' *Die Kunst für alle* 1941, p.145ff

55 L. Grote, *Caspar David Friedrich. Skizzenbuch aus den Jahren 1806 und 1818.* Berlin 1942

56 F. Nemitz, 'Ein wiederentdeckter Caspar David Friedrich.' *Die Kunst für alle* 1941/42, p.269

57 Ch. de Prybram-Gladona, *Caspar David Friedrich.* Paris 1942

58 E. Trautscholdt, 'Etwas von alten Katalogen, gleichzeitig ein Beitrag zu Caspar David Friedrich.' *Kunst-Rundschau* 1942, p.30

59 C. v. Lorck, 'Neugefundene Meisterwerke von C. D. Friedrich, J. E. Koch und C. Blechen.' *Die Kunst für alle* 1943, p.97ff

60 E. Sigismund, *Caspar David Friedrich. Eine Umrißzeichnung.* Dresden 1943

61 H. Beenken, *Das neunzehnte Jahrhundert in der deutschen Kunst.* München 1944

62 O. Schmitt, *Die Ruine Eldena im Werk von Caspar David Friedrich.* Berlin 1944

63 W. Scheidig, 'Caspar David Friedrich, Morgennebel im Gebirge.' *Zeitschrift für Kunst* 1947, Heft 4, p.7ff

64 B. Dörries, *Zeichnungen der Frühromantik.* München 1950

65 K. Lankheit, 'Die Frühromantik und die Grundlagen der gegenstandslosen Malerei.' *Neue Heidelberger Jahrbücher* 1950, p.54ff

66 K. Lankheit, 'Caspar David Friedrich und der Neuprotestantismus.' *Deutsche Vierteljahrschrift für Literaturwissenschaft und Geistesgeschichte* 1950, p.129ff

67 P. O. Rave, 'Zwei Winterlandschaften C. D. Friedrichs'. *Zeitschrift für Kunstwissenschaft* 1951, p.229ff

68 A. Isergina, 'Unbekannte Bilder von Caspar David Friedrich'. *Bildende Kunst* 1956, p.263ff, 275ff

69 M. Liebmann, 'Neuentdeckte Aquarelle von Caspar David Friedrich'. *Bildende Kunst* 1957, p.532ff

70 M. Prause, 'Carl Gustav Carus und Caspar David Friedrich'. *Festschrift Johannes Jahn zum XXII. November MCMLVII.* Leipzig 1958, p.311ff

71 W. Scheidig, 'Goethes Preisaufgaben für bildende Künstler 1799–1805'. *Schriften der Goethe-Gesellschaft* 57. Weimar 1958

72 *The Romantic Movement.* The Tate Gallery and the Arts Council Gallery London. 1959, Nos. 145–159

73 G. Bandmann, *Melancholie und Musik.* 1960, p.132ff

74 H. Börsch-Supan, *Die Bildgestaltung bei Caspar David Friedrich.* Diss. München 1960

75 G. Eimer, 'Caspar David Friedrichs "Auf dem Segler" '. *Zeitschrift für Ostforschung* 1960, p.230ff

76 P. Angerholm, *Neuerwerbungen der Leipziger Graphischen Sammlung aus dem Kreis der Dresdener Romantiker.* Kunstmuseen der DDR 1961, p.120ff

77 E. Platte, *Caspar David Friedrich. Die Jahreszeiten.* Stuttgart 1961

78 W. Hofmann, 'Bemerkungen zum Tetschener Altar von C. D. Friedrich'. *Christliche Kunstblätter* 1962, p.50ff

79 G. Eimer, *Caspar David Friedrich und die Gotik. Analysen und Deutungsversuche aus Stockholmer Vorlesungen.* Hamburg 1963

80 G. Heider, 'Unbekannte Briefe C. D. Friedrichs an W. A. Shoukowski zur Transparentmalerei'. *Wissenschaftliche Zeitschrift der Karl-Marx-Universität Leipzig. Gesellschafts-und sprachwissenschaftliche Reihe Heft 2*, 1963

81 H. Heyne, "Der Dom", ein unbekanntes Gemälde von Caspar David Friedrich'. *Pantheon* 1963, p.370ff

82 I. Emmrich, *Caspar David Friedrich*. Weimar 1964

83 S. Hinz, 'Zur Datierung der norddeutschen Landschaften Caspar David Friedrichs'. *Greifswald-Stralsunder Jahrbuch* 1964, p.241ff

84 A. Isergina, 'Zeichnungen von Caspar David Friedrich'. *Bulletin du Musée de l'Eremitage* 1964, p.28ff

85 W. Stechow, 'Caspar David Friedrich und der "Griper"'. *Festschrift für Herbert von Einem*. Berlin 1965, p.241ff

86 M. Bang, 'Two Alpine Landscapes by C. D. Friedrich'. *The Burlington Magazine* 1965, p.571ff

87 H. Börsch-Supan, 'Bemerkungen zu Caspar David Friedrichs "Mönch am Meer" '. *Zeitschrift des deutschen Vereins für Kunstwissenschaft* 1965, p.63ff

88 W. Geismeier, 'Die Staffage bei Caspar David Friedrich'. *Forschungen und Berichte* 1965, p.54ff

89 H. Börsch-Supan, 'Zwei unbekannte Landschaften von Caspar David Friedrich'. *Zeitschrift für Kunstgeschichte* 1966, p.149ff

90 R. Rosenblum, 'Caspar David Friedrich and modern Painting'. *Art and Literature* 1966, p.134ff

91 *Klassizismus und Romantik in Deutschland. Gemälde und Zeichnungen aus der Sammlung Georg Schäfer, Schweinfurt*. Germanisches Nationalmuseum, Nürnberg 1966

92 S. Hinz, *Caspar David Friedrich als Zeichner*. Diss. Greifswald 1966. (Typescript)

93 L. D. Ettlinger, *Caspar David Friedrich*, Bristol 1967

94 M. Prause, ' "Spaziergang in der Abenddämmerung", ein neues Bild von Caspar David Friedrich'. *Zeitschrift des deutschen Vereins für Kunstwissenschaft* 1967, p.59ff

95 S. Hinz, *Caspar David Friedrich in Briefen und Bekenntnissen*. Berlin 1968

96 M. Prause, *Carl Gustav Carus. Leben und Werk*. Berlin 1968

97 H. Börsch-Supan, 'Caspar David Friedrichs Gedächtnisbild für den Berliner Arzt Johann Emanuel Bremer'. *Pantheon* 1969, p.399ff

98 K. Lankheit, 'Caspar David Friedrichs Entwürfe zur Ausstattung der Marienkirche in Stralsund'. *Anzeiger des Germanischen Nationalmuseums* 1969, p.150ff

99 *Carl Gustav Carus und die zeitgenössische Dresdner Landschaftsmalerei. Gemälde aus der Sammlung Georg Schäfer, Schweinfurt*. Schweinfurt 1970

100 W. Sumowski, *Caspar David Friedrich-Studien*. Wiesbaden 1970

101 H. Börsch-Supan, 'Caspar David Friedrichs Gemälde "Der Junotempel von Agrigent"'. *Münchner Jahrbuch der bildenden Kunst* 1971, p.205ff

102 W. Sumowski, 'Caspar David Friedrich und Carl Julius von Leypold'. *Pantheon* 1971, p.497

Documents and Reminiscences

While no full-scale biography of Friedrich was written by any of his acquaintances, many contemporaries included accounts of his art and character in their correspondence or published works. Selections of these, together with statements by the artist, were first assembled by Eberlein (Lit *26*) in 1924. In 1968 these and other reminiscences were edited by Hinz (Lit *95*). With exception of B.2 and B.10 all the extracts included here can be found in Hinz. B.7 has been translated from the original Russian text in Zhukovsky's complete works.

A. WRITINGS BY FRIEDRICH

1. *Observations on a Collection of Paintings by Living or Recently Deceased Artists*

These remarks were written down by Friedrich around 1830. It is not certain which collection he was referring to, although it was evidently one that contained a representative selection of paintings by contemporary German artists.

Using the form of the aphorism, Friedrich expressed views on art and the creative process that have strong affinities with the Nature-philosophy of Schelling. He also attacked the tendencies of younger generations of artists, in particular the mediaevalizing style of the Nazarenes and the accomplished imitation of the appearance of nature by the naturalists.

The direct, often dryly humorous style, is unmistakably Friedrich's own and contrasts strongly with the elaborate prose found in the description of 'The Cross in the Mountains' that was edited by Christian Semler (A.2).

A selection of these remarks were originally published by Carus in 1841 (Lit *10*). The full text was edited by Eberlein in 1924 (Lit *36*, p.106ff) and has appeared again in 1968 in Hinz (Lit *95*, pp. 84–134). Selections in English can be found in the following publications:
E. G. Holt, *Literary Sources of Art History*, Princeton, 1966, Vol. III, pp. 83–87;
L. Eitner, *Neo-classicism and Romanticism, 1750–1850 (Sources and Documents)*, 2 vols. New Jersey 1970 (Vol. II, pp. 52–56).

'It always makes an adverse impression on me to see a mass of paintings exhibited or stored up like merchandise in a hall or room, where the spectator is not able to contemplate each picture separately without having to see at the same time half of four other ones. Such a piling up of art treasures must, indeed, lose even more value in the eyes of the beholder if in addition to this, and often perhaps quite intentionally, incompatible pictures are exhibited side by side; thus one picture, even without entirely suppressing the other, must still detract from it, and the impression of both is weakened as a consequence. Therefore, I hope it will not be taken amiss if in view of my admittedly depressed spirits my remarks sound rather harsh. I look at pictures only in order to enjoy them, and I prefer to turn quietly away from that which does not attract me, whether it accords with my mood or not. Yet, where should I direct my eye – even the doors and windows are not free of pictures. Still, once I am asked to give my opinion – very well then here it is!'

'The artist's feeling is his law. Pure sensations can never be in contradiction to nature, but only in agreement with her. However, the feeling of another person should never be imposed upon us as a law. Spiritual affinities produce similar works, but this kind of relationship is far removed from mimicry.'

'Man judges his fellows according to what he has done and how he behaves – I suppose he can't do otherwise. But the Highest Being judges according to that which man has omitted to do and the way in which he struggles with himself. Only he who penetrates to the innermost being and sees what is hidden there can judge correctly.'

'What pleases us about the older pictures is, above all, their pious simplicity*. However, we do not want to become simple, as many have done, and ape their faults, but rather become pious and imitate their virtues.'

'Close your bodily eye, so that you may see your picture first with the spiritual eye. Then bring to the light of day that which you have seen in the darkness so that it may react upon others from the outside inwards.'

'Painters train themselves in inventing or, as they call it, composing. Doesn't that mean perhaps, in other words, they train themselves in patching and mending? A picture must not be invented but felt.'

'Observe the form exactly, both the smallest and the large; and do not separate the small from the large, but rather the trivial from the important.'

'It is common amongst painters to want to speak in contradictions; they call it contrast. Crooked against straight, cold against warm, light against dark; these are the fine crutches on which mediocrity hobbles along.'

'If you want to know what beauty is, ask the honourable Aestheticians. It may be of help to you at a tea table, but not before the easel. There you have to feel what beauty is.'

'It is now the inclination of our age to delight in strong hues everywhere. Even the painters vie with each other in this. Nor is this merely a touching up of cheeks and lips, for even the landscape painters exaggerate colours, heightening trees, rocks, water and air. They exaggerate them so much that they are not able, with the limited means available to them, to carry through the heightening that they have undertaken in a harmonious way. I remember by contrast the time when colouring was almost completely ignored, and the use of brown so predominated that oil paintings resembled sepia drawings. Later this colour was displaced by blue, and the blue in turn by violet, and finally green (which despite its prevalence in nature had been almost totally suppressed in landscape painting) had its turn and was recognized. At present, all colours are used simultaneously. The changeable sensibilities of Man have gone through this cycle in the last thirty years and will, perhaps, begin it all over again. It is

*[Friedrich is referring here to the paintings of the earlier Italian and German schools who were taken as models by the mediaevalizing 'Nazarene' painters].

unfortunate for those who either will not or cannot go along with it. Their work will at present be disregarded and undervalued. However, even those who want to fight against the main trend of the times have, nevertheless, to pay homage to it.'

'If you can, then build machines in which the spirit of man is kept and dispensed; but you must not make men that are like machines – without their own will and own energy.'

'The pictures by XX deserve admiration only as thoughts and feelings and not for their skilfulness or dexterity of hand. Above all, they are to be valued highly as the emanations of a beautiful soul and a deep, pure disposition. They do not belong in a collection; in a small, quiet chamber, however, they have their place.'

'This careful steel engraving is admirable for its beautifully treated tonality and has certainly been carried out either by an Englishman or a machine. A German, thank God, could never do such a thing, and the British are proud to be the only ones who can.'

'Apart from his great skill and ability in painting, this man is particularly honoured because he has educated so many accomplished pupils, on whom he has unmistakably imprinted his mark. Whether this is actually so laudable could be brought into question. I believe that this could be seen rather as a cause of blame both for the marker and marked. It would have been more praiseworthy, as far as I am concerned, if the master had not imprinted his mark on his pupils, but had with less vanity and more wisdom respected the inborn quality and inclination of each one of them, and left this undisturbed. For that which nature has specially given to each one of us, is the talent which we must turn to good account and one would like to call out to the students: "Respect the voice of nature within you".'

'In this picture there is a strict and observed, or rather a strict and intended symmetry. However, it does not come from an inner sense for symmetry but is probably no more than imitation. The artist lacks the sacred fire for works of this kind. He has no inner light, religious warmth and exaltation . . . I actually admire this man and his praiseworthy aspirations; for he stands above many of his kind. In this picture however he has misunderstood himself and overstepped the limits ascribed to him by nature. I do not blame the symmetry in this picture, but only its failure. Likewise, I do not blame him for going beyond his own powers, I only draw attention to it.'

'The artist should not only paint what he sees before him, but also what he sees within him. If, however, he sees nothing within him, then he should also omit to paint that which he sees before him. Otherwise his pictures will resemble those folding screens behind which one expects to find only the sick or even the dead.'

'Despite what even many artists appear to believe, art is not and should not be merely a skill. It should actually be completely and utterly the language of our feelings, our frame of mind; indeed, even of our devotion and our prayers.'

'It is doubtful whether the artist altogether knew what he depicted here in this panel, and even more doubtful whether he could have expressed it in words. That which we praise here as well thought-out and cleverly arranged may, in fact, have been achieved by him unconsciously; for the artist was transformed by pure harmoniousness while executing this picture, and his feeling became his law. Only his disposition, his spiritual exaltation, could have brought forth such a fruit as this picture. Just as the pious man prays without speaking a word and the Almighty hearkens unto him, so the artist with true feeling *paints* and the sensitive man understands and recognizes it; while even the less sensitive gain some inkling of it.'

2. *The Tetschen Altar*
(The Cross in the Mountains *(No. 33)*)

When this picture, designed as an altarpiece for the private chapel of Count Franz Anton von Thun-Hohenstein, was exhibited at Friedrich's studio during the Christmas season, 1808, it was violently attacked in the *Zeitung für die Elegante Welt* (17–21 January 1809) (Lit *3*) by the connoisseur Friedrich Wilhelm Basilius von Ramdohr (1757–1822). Ramdohr, while admitting the effectiveness of Friedrich's image, censured it for departing from the conventions of landscape painting honoured by tradition. He furthermore accused him of sacrilege for making a 'landscape creep onto the altar', and associated his nature symbolism with the 'Neoplatonic sophistry' of the Dresden Romantics. Many of Friedrich's friends and colleagues defended his art against Ramdohr's attack. In *Phoebus*, the journal edited by Kleist and Müller *(see p.106)* (Lit *4*), the history painter, Ferdinand Hartmann (1774–1842) affirmed both Friedrich's skill as a painter of natural effects and his right of original expression. Similar points were made by the historical painter, Gerhard von Kügelgen (1772–1820) (Lit *5*). Friedrich himself, who expressed his views in a letter to Professor Schulz on 8 February *(see pp. 16, 63)*, had the following statement concerning the picture and its meaning published in *Journal des Luxus und der Modens* in April 1809 (Lit *6*). The text was edited by Christian August Semler (1767–1825), Secretary to the Dresden Library, who was also active as a writer on landscape painting and landscape gardening. Semler's *Untersuchungen über die höchste Vollkommenheit in den Werken der Landschaftsmalerei* (Investigations into the highest perfection in works of landscape painting) published in 1800, considered landscape as a vehicle for interpreting the feelings of man.

'*Description of the Picture* The cross is raised on high at the summit of the rocks, surrounded by evergreen firs. Evergreen ivy is entwined around its stem. The sun sinks with brilliant rays and the Saviour on the cross shines in the crimson of the evening glow.

'*Description of the Frame* The frame has been constructed according to Herr Friedrich's specifications by the sculptor Kühn. At each side the frame takes the form of a Gothic column. Palm branches rise up from these to make an arch over the picture. Amongst the branches are the heads of five angels, who all look down in adoration onto the cross. Above the middlemost angel the evening star shines in the purest silvery lustre. Below, in a broad inset, the all-seeing eye of God is enclosed by the divine triangle surrounded by rays of light. Ears of corn and vines bow down on either side towards the all-seeing eye, indicating the body of Him who is nailed to the cross.

'*Interpretation of the Picture* Jesus Christ, nailed to the tree, is turned here towards the sinking sun, the image of the eternal life-giving father. With Jesus' teaching an old world dies – that time when God the Father moved directly on the earth. This sun sank and the earth was not able to grasp the departing light any longer. There shines forth in the gold of the evening light the purest, noblest metal of the Saviour's figure on the cross, which thus reflects on earth in a softened glow. The cross stands erected on a rock, unshakably firm like our faith in Jesus Christ. The firs stand around the evergreen, enduring through all ages, like the hopes of man in Him, the crucified.'

B. REMINISCENCES OF FRIEDRICH AND HIS ART

1. *Gotthilf Heinrich von Schubert (1780–1860)*

A student of medicine and theology, Schubert became deeply influenced by the 'Nature-philosophy' of Schelling, with whom he studied in 1800. From 1805 to 1809 he lived in Dresden, where he became a close friend of Friedrich's. The recollections in his autobiography (Lit *12*) refer to this period.

(*Der Erwerb aus einem vergangenem und die Erwartung von einem zukünftigen Leben*, Vol II, Erlangen 1855, p. 182ff.)
'Meanwhile, I had become a close friend of a man from whom one could most frequently find out something about the political storms raging in the outside world. He was not a military man, nor a famous diplomat, but the worthy Pomeranian, Caspar David Friedrich, a landscape painter, held in high esteem in his time by that circle who understood him. I must first talk about this man, the most original among all my Dresden acquaintances, for he belongs to my favourite memories of that period of internal and external turbulence, with its forcible reawakening of German strength, which had lain dormant for many years.

'Friedrich lived way out in the Pirna suburb, on the bank of the Elbe, in a house which belonged, like most houses of this neighbourhood, to people of modest means. The furnishing of his room reflected the neighbourhood, being nothing

but a wooden chair and a table, on which lay the tools of his trade. When he wanted to invite a visitor to sit down, another old wooden chair was brought in from a small room, when there were two visitors a wooden bench from the landing; for in the small room there was, apart from the old chair, nothing but an equally old table and a bed covered with a woollen blanket.

'At first I never tired of just looking at this remarkable man: never have I seen, before or since, a face like his. He certainly could not be called handsome: his face was rather pale and thin, but every muscle, even when not moving, showed a strong trait of character firmly imprinted by his never varying cast of mind. The sad, serious features of his forehead were softened by the childlike, candid expression of his blue eyes; above his mouth lingered a light shadow of grief . . .

'But whoever saw in the painter Friedrich only his profound melancholy knew but one side of him. I have met few people who in the company of others whom they liked had such cheerful, easy-going ways and so much sense of fun. With a most serious expression he would talk and tell stories which produced endless laughter. Wherever he went, if he felt at ease with the gathering, he brought with him high spirits and a happy manner.

'When he was sitting at his work deep in thoughts and children from the neighbourhood came to see him, he would chat and joke with them, as if he was a child himself. One neighbour's little daughter frequently asked him to give her pictures. He could never refuse a child anything and certainly not her, pleased as he was with the child's artistic inclinations. As he had nothing else, he gave her small sketches he had made. But one day, when the little girl had approached him so often with the same request, he asked her, "what do you do with all these pictures?" "I use them to wrap up my things," replied the little one.'

2. G. H. von Schubert, contd.

During the period that he was in Dresden, Schubert gave lectures dealing with animal magnetism, prediction, and clairvoyance. These were published in 1808 under the title *Ansichten von der Nachtseite der Naturwissenschaft* (Views on the Dark Side of Natural Science) (Lit 2). The description of an early version of the *Times of Year* (cf. *Nos. 75–82*) that Schubert introduced into his text, is the first detailed account of the meanings that lay behind Friedrich's imagery.

'Here I could not do better than follow closely the work of my friend, the landscape painter Friedrich, and tell faithfully the story of the development of our own nature as it is depicted by him in the four seasons of the year and the four stages of human life. I shall do so even at the risk that my words may lag far behind his brush.

'We do not know what profound charm lies over the beginning of childhood. It may be that it is glorified by an echo of the unknown dream whence we came or by that reflection of the divine which hovers in its purest form above the quiet

and the childlike. When we wake from that dream we find ourselves in the morning glow of an everlasting spring day and no trace of a bygone autumn tinges its bright green. We awake among flowers by the clear source of life, where the eternal sky is mirrored in its virgin purity. The wind does not strive yet beyond the brink of the nearby hills. We seek and understand in Nature the flowers only and we still perceive life as an image of playful, innocent lambs. There the first ray of that longing which guides us from the cradle to the grave touches an early unfolding mind and unaware of the endless distance, which separates us from the eternal source of light, the child's arms open wide to grasp what he believes to be within his reach. But his first steps already are an error and from the lovely hill of childish dreams where we perceived the first rising rays, we hurry downward into the deep bustle of life, where another twilight surrounds us.

'The clear source soon swelled into a river, the inner striving, grown stronger and more powerful, carried us out further and further. Indeed, the hours of dawn were soon over; far behind us are left the green hills of childhood with their spring flowers and the dream of playing lambs. Brighter and grander shines the sun rising towards its zenith and the fresh trail is not yet threatened by any obstacles. When in the glittering hours of noon the blossoming world opens itself so freely to the inner eye, when to the keen mind — yet unaware of the limits of its aspirations — the distant high clouds appear like distant mountains, still to be reached easily in the end, then in the sweet time of roses all deep longing seems to have found its fulfilment. There, where the lily weds the rose, where slim trees with dark green branches entwine, youthful love clasps its arm round us. There the blissful heart no longer needs the outside world, we only dream of the still, lonely hut on a green mount, of the pastoral song of the turtle-dove and the lonely valley. For moments all further striving is forgotten and for the first time — maybe also for the last—we rest in perfect, blissful contentment. For look! among the roses and lilies there also stood the tall sunflower which with its faithful head follows the path of the eternal light. A deeper longing in us has as yet not been stilled and reawakens the eternal ideal with a stern voice.

'There in the interplay of many aspirations mid-day is reached and passed; past is the time of roses and lilies. Evening reveals the land in its last and strongest aspect, at the time of its maturity. The flowers which before have delighted the heart, are over, only a few have born fruit, more remained barren and upon the autumnal soil there blossoms with the shade of the evening light the late, lonely autumn crocus* whose fruit will only ripen in another spring. The dreams of quiet huts on blossom-covered hills, the song of the turtle-

*[The autumn crocus, which blossoms in autumn while its leaves and seed pods do not appear until the following spring, is called in German 'Die Zeitlose' (the timeless one).]

doves have been supplanted by the crude noise of the city.† But at last, past mid-day it has become clear to the mind what that profound striving, that longing within us, desires. See these immortal heights with their three-peaked summit, lofty above the flying clouds, shrouded by everlasting snow, but still in untroubled serenity, gleaming in the rays of the sun, a high symbol of the eternal light. There the soul strives with its highest powers towards the immortal heights. But the impulse of passions within us has turned into a river carrying ships down its way. In vain we often struggle with its waves in order to reach the other bank and the high mountains; only in the hours of exultation the spirit rises towards the immortal heights like that eagle who has left the clouds and the river far behind. Now that the inner striving has grown weary on the last part of the path which was full of rocks and crags here, on this side of the river a place of rest is found beneath the cross which rises peacefully above the cliffs. At last the mind understands that the abode of that longing which has guided us so far, is not here on earth. Speed on then, river, down your way! Where your waves flow into the infinite sea on a far distant shore we have heard of a last place of rest. There indeed the inner fire shall cool, the deep wound shall heal. Cease blooming then, poor autumn crocus, when winter approaches—you one, late blossom which does not bear fruit. A new, distant spring beyond winter, will ripen your fruit, you wonderful flower.

'At last, see, the sun of man's power and glory has sunk. The last part of the way was barren and lonely. All blossoms have gone, so has even the fruit which they had brought us. For fate has taken back its gift which we had thought to be ours for ever. Before our very eyes part of our work which seemed built for eternity has fallen into ruins and is forgotten by the young world. Only the will, the striving within us which has persevered to the very grave, becoming all the while purer and better, has remained ours; and in it we put our inner trust. The quiet coast where the once so powerful stream has become lost in the ocean has been reached and the grey wanderer finds himself lonely among the graves. The deep-rooted longing which has guided us so far, is still not satisfied but, alas, the promise of the summer which should have brought it to fruition, has been a vain hope and the season of snow covers the crop of a future spring. And there the moon shines in full brightness through the ruins of an ancient, noble past. The sky reveals itself above the sea once more in its clear blueness as it did in our early childhood. There in a prophetic glimmer we get the vision of the coast of a far-away land across the sea. We have heard of its ever-lasting spring and how in it our innermost being, which we bring there as a bud, will ripen. Then take away, time, even the last debris of our life on earth, take away for a while even the memory of the path we have followed and let us, if it be

the command of your eternal law, arrive slumbering in the fatherland which we have desired for so long.

'So, when we contemplate the formation of the human mind and its development from the cradle to the grave, amidst earthly striving another higher one may be perceived which even seems to contradict the first and which, at least in the bustle of life, can only rarely or never blossom. The lofty world of poetry and the artist's ideals, even more the world of religion, can never fit completely into our life on earth and tends to resist a fusion with its elements.'

3. *Ludwig Tieck (1773-1853)*

This celebrated Dresden Romantic writer had closer connections with Philipp Otto Runge than with Friedrich. However this extract from his autobiographical novel *Eine Sommerreise* (A Summer's Journey), which is based on notes made in Dresden around 1805, shows a sympathy with Friedrich's objectives.

(*'Eine Sommerreise'*; Schriften, Vol.23, Berlin, 1853, pp17–18.) 'It is that religious mood and stimulus which for some time now seems to revive our German world in a strange way, it is that solemn sadness which Friedrich tries to express and to support most sensitively in his themes of landscape painting. This endeavour finds many friends and admirers as well as— still more understandably—many opponents. Historical, and to an even greater degree, many church paintings have often been completely reduced to symbol and allegory: while landscape seems to be rather more suited for awakening meditation, dreaming and satisfaction or joy in the representation of reality, which in itself engenders a gracious longing and fantasizing. Friedrich on the contrary rather seeks to evoke a certain sentiment, a real aspect with definite thoughts and concepts, which combine and fuse with that sadness and solemnity. Thus he tries to introduce allegory and symbolism in light and shadow, living and dead nature, snow and water, and also in the living figures. Indeed, by means of a definite clarity in his ideas and a purposefulness of his imagination, he attempts to lift landscape above history and legend; landscape, which had always appeared to us as so vague a subject, as a dream or a chance occurrence. This is a new endeavour and it is astonishing how much he has often achieved with few means. Thus a new spring is approaching us in art and poetry as in philosophy and history.'

4. *Heinrich von Kleist (1777–1811)*

In 1808 the writer Kleist lived in Dresden where he was a member of a patriotic group of writers and artists that included Friedrich, Adam Müller (1779–1829) and Theodor Körner (1791–1813). During this period Kleist and Müller issued *Phoebus,* a magazine devoted to the arts that published Hartmann's defence of *The Cross in the Mountains.* In 1809 Kleist moved to Berlin, where he became associated with the Heidelberg Romantic writers Clemens Brentano (1778–1842) and Achim von Arnim (1781–1831). From October 1810 to

†'In childhood we still see by the green bank of the brook nothing but flowering shrubs; in youth, beyond the stream, a few scattered huts, in manhood, beyond the bank of the river, a large city. In old age we see a churchyard.'

March 1811 Kleist published the *Berliner Abendblätter*. When Friedrich's *Monk by the Sea (Ill. xii)* was exhibited at the Berlin Academy during the autumn of 1810 it was reviewed for the *Berliner Abendblätter* by Brentano and Arnim. Kleist, making use of his editorial prerogative, considerably expanded this review, adding a number of characteristically striking observations, including the following:

(*Berliner Abendblätter* 12 Blatt, 13, 10, 1810, s. 47-48)
'Nothing could be more sad and eerie than this position in the world, the only spark of life in the wide realm of death, a lonely centre in a lonely circle. The picture with its two or three mysterious objects appears like the apocalypse, as if it were dreaming Young's "Night Thoughts" and because of its monotony and boundlessness, with nothing but the frame as a foreground, one feels as if one's eyelids had been cut off.'

5. *Johann Wolfgang von Goethe (1749–1832)*

Goethe's admiration for Friedrich's skill became overlayed in later years by an aversion for his subject matter, which he equated with the mediaevalizing tendencies of German revivalist artists, in particular the Nazarenes.

(Letter to Johann Heinrich Meyer; Goethe Gesellschaft, 1917, Vol. 32, pp. 305-6.)
'Enclosed, dear friend, you will find Friedrich's works of art, well secured and mounted, as they had reached me. I regret very much that we could not see them together, for how rare is a completed achievement; so rare, indeed, that even when it appears in the most extraordinary manner one should enjoy it and value it highly.'

6. *Johann Heinrich Meyer (1760–1832)*
(in collaboration with Goethe)

This famous attack on modern revivalist art, first published in *Kunst und Alterthum* in 1817, was signed by Johann Heinrich Meyer (1760-1832) the Swiss artist who assisted Goethe in his didactic schemes for the visual arts.

('Neu-deutsche Religiös-patriotische Kunst' (1817); *Goethe, Gedenkausgabe, Zürich* 1949, Vol. 13, p. 723)
'The above-mentioned Friedrich is still the only one who tried to endow landscape paintings and drawings with mystic-religious significance. However, he differs from those who aim at a similar effect by using figures in that he does not endeavour to draw from old masters directly but from nature. His inventions all have the laudable merit that they have been thought out. But since sombre religious allegories do not on the whole agree with charming and beautiful representation, and, since, moreover, he is either unaware of or chooses to ignore the art of light effects, and also disregards softening and harmonizing in his use of colour, it is his neat sepia drawings that satisfy the eye better than his paintings. Because of this neglect of the rules of art Friedrich finds himself at the same disadvantage as all those who share his taste, whatever

their special subject might be. A work of art should certainly stir the spirit of the onlooker and give expression to his sensibilities. But precisely because it has to be looked at, the eye also demands soothing satisfaction, and why should the artist not use in a meaningful way the colouring, pleasant light effects and forms of beautiful nature? It is precisely the skilful union between the spiritually important and the sensually moving which is the triumph of true art.'

7. *Vasili Andreyevich Zhukovsky (1783–1852)*

A Russian poet and translator who introduced into Russia leading writers of English and German Romanticism, including, Goethe, Schiller, Bürger, Scott and Byron. After serving in the Napoleonic wars he became in 1815 a member of the Tsar's entourage, and was appointed tutor to the heir to the throne in 1826. Travelling widely, he visited Dresden several times. The following description is an account of his first meeting with Friedrich in 1821. In later years he gave Friedrich financial support, and also arranged for the Russian Royal Family to acquire a number of his pictures.

(Letter of Zhukovsky to the Grand Duchess Alexandra Fedorovna, 23 June 1821.)
'. . . I must still give an account of the rest of my life in Dresden. I met there a number of interesting people, but I shall mention only two of them; the painter Friedrich, and 'Sternbald'* Tieck. I found Friedrich looking exactly as I had imagined him, and we became very close acquaintances as soon as we met. There is nothing idealistic about him, nor did I ever expect to find this in him. Those who know him only from his nebulous pictures, where nature is represented only from its dark side, and therefore would expect to meet a pensive melancholic, pale-faced man, with a glaze full of poetic dreaminess, would be very mistaken: Friedrich's face would not appear striking to anyone seeing him in a crowd. He is a lean, middle-sized man, with fair hair and white eyebrows overshadowing his eyes; the outstanding feature of his face is its candidness; such is also his character; every word of his breathes candidness. He speaks without oratory, but with the liveliness of a sincere feeling, particularly when dealing with his favourite subject—nature, with which he seems to have a family relationship; he speaks of nature in the same way as he represents it, without any affectation, but with originality. Nor is there any affectation in his pictures. On the contrary, they please us by their precision, each of them awakening a memory in our mind! If you find in them more than what strikes the eye, this is due only to the fact that the painter did not look at nature as an artist seeking nothing but a model for his paintbrush, but as a man who always sees in nature a symbol of human life. The beauty of nature captivates our mind not by that which it provides for our senses, but by that unseen which it awakens in our soul, mysteriously reminding our soul of life and of what is beyond it. Friedrich

*[A reference to the highly popular novel 'Franz Sternbald's Wanderings' by Ludwig Tieck (see 3)]

neglects the rules of his art: he does not paint his pictures for the eyes of an art connoisseur, but for those souls who are just as familiar with his model, that is, nature, as he is himself. Critics may well be disappointed with him, but the best of critics—impartial feeling—is always on his side. This is also how Friedrich judges works by other painters. Several times we went together to the gallery. Looking at many pictures, he often could not tell me whom they were by; generally speaking he has but scant knowledge of things you can find in textbooks on painting and can learn by heart. For all that he points out such beautiful traits, and shortcomings that only a mind trained in the study of nature (which he knows by heart) would notice. All his remarks were strikingly just and original, but then the just and the original are the same.

'I found at his home several pictures he had begun, and one of them you would certainly want to possess. It could be a counterpart to that which you already have: Moonlit Night. The sky is stormy, but the storm has receded, and the clouds have gathered on the distant horizon, leaving half of the sky quite clear. The moon is rising just above the clouds, whose fringes it lights brightly; the sea is still; the low shore is covered with rocks, and an anchor is lying there. In the distance, at the farthest edge of the sea, one sees a sailing boat coming towards the shore; she is eagerly expected. Two young women are sitting on the rocks and looking at the sail with hope and resignation. Two men, less patient in their hope, have leapt over the rocks and are standing, surrounded by water, looking in the same direction. More rocks are in front of them, but beyond their reach.

'The picture has just been begun, but the drawing is wonderful. Everything is simple and expressive.

'Friedrich has now been given a task: someone wants to have two pictures—one representing an Italian landscape in all its luxuriant and magnificent beauty, the other – the awe-inspiring nature of the North. It is the second that Friedrich has undertaken to paint; he does not know what it will be. He is waiting for the moment of inspiration, which frequently comes to him, as he told me, in a dream. "Sometimes," he said, "I try to think and nothing comes out of it; but it happens that I doze off and suddenly feel as though someone is rousing me. I am startled, open my eyes, and what my mind was looking for stands before me like an apparition — at once I seize my pencil and draw; the main thing has been done."

'I liked Friedrich so much, and felt so akin to him, that I invited him to join me in my travels. I had sufficient money for that purpose. But he refused, and I liked him even better for his refusal. "You want to have me with you," he replied, "but the 'I' that you like would not be with you. I must be entirely by myself, and know that I am alone, in order to see and perceive nature completely. Nothing should stand between her and myself. I must give myself to my surroundings, must merge with my clouds and cliffs, in order to become what I am. Should my very closest friend be with me,

he would destroy me. And were I to go with you, I should be of no use either to you or to myself. I happened once to spend a whole week in Uttewalder Grund, among cliffs and fir-trees, and all that time I did not meet a single living human being. I admit I would not recommend this method to anybody, even for me it was a bit too much. One could not help being invaded by melancholy. This should convince you that my company could not be pleasant for anyone." '
(*V. A. Zhukovsky Polnoe sobranie sochinenii pod redaktsiei P. N. Krasnova ed W. O. Wolf*, Petersburg – Moscow n.d. pp.957-8).

8. *Carl Gustav Carus*
(see p. 94)
(*Lebenserinnerungen und Denkwürdigkeiten*, Leipzig, 1865-1866, pt. 2, p. 207)

'It was of great importance to me to find out something about Friedrich's method when planning his pictures. He never made sketches, cartoons or colour studies for his paintings, because he claimed (and certainly not without reason) that imagination tends to cool down through such aids. He never began a painting until it stood lifelike before his mind, then he drew onto the neatly stretched canvas, first lightly with chalk and pencil, then the whole of it properly and definitely with a quill pen and Indian ink, and soon proceeded to lay on the underpainting. Therefore his pictures in every phase of their development gave a definite, well ordered impression of his personality and of the mood which had originally inspired them.'

9. *Johann Christian Claussen Dahl*
(see pp. 38, 96)
(A. Aubert, 1905, Lit *17* p. 198)

'Friedrich has in no way been a child of fortune and, as is often the case with the profoundest of men during their life-time, it happened that he was misinterpreted by most people and truly understood only by a few. His contemporaries saw his pictures as constructed ideas without any truth to nature. Many bought them, therefore, as no more than curiosities or, especially during the wars of liberation, because they sought and found in them a particular – one might say politically prophetic – meaning . . .'
'Artists and art connoisseurs saw in Friedrich only a kind of mystic, because they themselves were only looking out for the mystic. They did not see Friedrich's faithful and conscientious study of nature in everything he represented. For Friedrich knew and felt quite clearly that one does not or cannot paint nature itself, but only one's own sensations, which must, nevertheless, be natural. Friedrich saw in a particularly tragic way—which, if not affected, was certainly exaggerated—the limits of what can be represented in painting.'
This was indeed a consequence of his inate quality, and had it not been so, he would not have been able to have been what he was: one of the most original and individual men and

artists I have ever known. His like will not be found again. Many have imitated him, yet none have understood how to recreate that silent sense of the spirit of nature that was so characteristic of Friedrichs' art, and which gives his pictures, despite an apparent stiltedness, their peculiar attraction.'

10. *Adrian Ludwig Richter (1803–1884)*

Like many of the younger generation of Dresden landscape painters, Richter found himself during the 1820s questioning the allegorical principles of Friedrich's art. The following extract comes from his diary in Rome, dating from a time when he was being strongly influenced by the art of Joseph Anton Koch (p. 15).

(Ludwig Richter, *Selbstbiographie*, Frankfurt, 1885, pp. 386-7)
Sunday, 30th January (1824)
'Our gathering at Thomas' yesterday evening was once again highly interesting; we got into a discussion on art, which I readily turned towards Friedrich's conception of natural objects, since I myself wanted to be sure about it.'

Attempts have often been made to decipher and explain the important language of nature; for example the geometrical basic forms of bodies: line, point, circle, triangle; each one expresses something and awakens some further sensation in us, the line extension, the point contraction, the wavy line movement, etc. Thus one has gone further and compared, for example, the birds with thoughts, that fly swiftly on light wings, far and near, in all directions. One compared the fish to sensation; it lives quietly in its liquid element, and the smallest movement stirs the water in rings, and the rings extend far away and fill the whole surface. Whether one takes all this lightly, considers it unimportant or not, one does indeed become aware of the living spirit that moves through the universe and gives to every small flower, every rock, every line, colour and shade its peculiar character, whereby these things affect our disposition and arouse in us those inexplicable sensations.

In connection with this spiritual conception of nature we began now to speak of Friedrich; it seems to me that Friedrich's method of conception leads in a false direction, that could be highly epidemic in our time; the majority of his pictures exhale that morbid melancholy, that feverishness that grips every sensitive observer so forcefully, but which always produces a disconsolate feeling — this is not the seriousness, not the character, nor the spirit and importance of nature, this has been *imposed* onto it. Friedrich chains us to an abstract idea, making use of the forms of nature in a purely allegorical manner, as signs and hieroglyphs—they are made to *mean* that and that. In nature, however, every thing expresses itself; her spirit, her language lies in every shape and colour. A beautiful scene of nature, it is true, also awakes only one feeling (not a thought), but this is so all-embracing, so grand, powerful and intense, that every allegory seems in comparison dried out and shrivelled up. The liberation of the spirit, the feeling of freedom in a broad, beautiful, enlivening space, this is principally what nature can affect us with so beneficially. It is an unfortunate error of our time, and shows its tension, weakness, and sickliness, that it becomes so willingly taken in by gloomy, feverish images. (Byron and in a better sense Friedrich). They shatter us, then suddenly tear off the thread, and abandon us to our stirred-up sensations.

Chronology

1774	5 September	Born in the harbour town of Greifswald, in the part of Pomerania then belonging to Sweden and ceded to Prussia in 1815. The son of Adolf Gottlieb Friedrich, a prosperous soap boiler and candle maker. Though living in Greifswald since 1763, both father and mother (Sophie Dorothea Bechly) originated from Neubrandenburg.
		Friedrich was the sixth of ten children. His younger brother, Christian (1779–1843), who became a joiner, made woodcuts from a number of his designs *(Nos. 21–23)*.
1781		Death of Friedrich's mother. The family is subsequently brought up by a housekeeper, 'Mother Heiden'.
1787	8 December	Friedrich's brother, Christoffer (b. 1775) dies while trying to save him from drowning.
c. 1790–1794		Studies under Johann Gottfried Quistorp (1755–1835), drawing master to the University of Greifswald.
1794–1798		Continues studies at the Copenhagen Academy, where he is taught, amongst others, by the landscape painter, Christian August Lorentzen (1749–1828), Jens Juel (1745–1802), and the history painter, Nicolai Abildgaard (1743–1809).
1798	October	Following a brief stay in Berlin, arrives in Dresden. Apart from visits to his homeland and tours through central Germany he is to remain in Dresden for the rest of his life. Until 1807 works mainly as a sepia painter.
1801	January–	
1802	July	Returns to Greifswald. Meets the painter, Philipp Otto Runge, with whom he is to later have closer relations in Dresden. Visits to the Island of Rügen; 16–22 June 1801, and May 1802.
1805		Awarded by Goethe half the Weimarer Kunstfreunde prize for two sepias *(Nos. 24 and 25)* contributed to the Weimar annual Exhibition.
1806	May–June	Visits Greifswald and Rügen.
	October	First meets Gotthilf Heinrich Schubert *(p.104)*.
1807		Reported to have begun painting regularly in oils *(p.61)*.
	August–September	Visits northern Bohemia, possibly to make landscape studies for 'The Cross in the Mountains' *(No. 33)*.
1808	December	Exhibits 'The Cross in the Mountains' in his studio. The controversy it arouses *(p.104)* attracts widespread attention to his work.
		Associates with the 'Phöbus' group of writers, which include Kleist, Müller & Körner *(p.106)*.
1809	April–May	Visit to Greifswald.
1810	July	Journey through the Riesengebirge with the painter, Georg Kersting *(see p.94)*.
	18 September	Goethe visits Friedrich's studio in Dresden.
	November	Exhibits the 'Monk by the Sea' *(Ill. xi)* and 'Abbey in the Oakwood' *(Ill. xii)* at the Berlin Academy, where they are bought by the Crown Prince, later Friedrich Wilhelm IV of Prussia. Elected a member of the Berlin Academy.

1811	June–July	Tour of the Harzgebirge. Visits Goethe in Jena (9–10 July) on return journey.
1812		'Morning in the Riesengebirge' *(No. 38)* acquired by Friedrich Wilhelm III of Prussia when exhibited at Weimar.
1813	July	Retires to the Elbsandsteingebirge during the French occupation of Dresden.
1814	March	Contributes 'Herman's Grave' *(Kunsthalle Bremen)* and ' "Chasseur" in the Woods' *(No. 43)* to the patriotic exhibition held to celebrate the liberation of Dresden.
1815	August–September	Visit to Greifswald and Rügen.
1816	4 December	Elected a member of the Dresden Academy, receiving a yearly stipend of 150 talers.
1817		Prepares designs for the restoration of the interior of the Marienkirche, Stralsund *(No. 53)* First meet the doctor and amateur artist, Carl Gustav Carus *(see p.94)*.
1818	21 January	Marries Caroline Bommer. Visits Greifswald and Rügen with his new wife.
1819	August	After the birth of a daughter, Emma, moves to a larger house which, like his former dwelling, is on the banks of the Elbe. From 1823 shares this house with the painter, Johan Christian Claussen Dahl *(see p.96)*.
		August Heinrich (1794–1822) exhibits at the Dresden Academy as a pupil of Friedrich. Takes a number of private students during the early 1820s and also influences pupils of Dahl in particular Oehme and Leypold *(p.97)*.
1820		Visit to Friedrich's studio by Grand Duke Nicolas, afterwards Nicolas I of Russia, who later acquired a number of his paintings through the agency of the Russian poet, Zhukovsky *(p.107)*.
	18 March	Visit to Friedrich's studio by Peter Cornelius.
1824	17 January	Appointed an Associate Professor at the Dresden Academy. When the Professor in landscape, Johann Christian Klengel, dies on 19 December, Friedrich is not invited to take up his teaching post.
1825		Exhibits 'The Watzmann' *(No. 77)* at the Dresden Academy.
1825–1826		Suffers illness. Last visit to Rügen, made in order to restore health.
1828	May	Visits Teplitz, Bohemia.
1831		'Evening on the Baltic' *(No. 98)* exhibited at the Dresden Academy. Bought by the Sächsisches Kunstverein.
1832		'The Large Enclosure' *(No. 100)* exhibited at the Dresden Academy. Bought by the Sächsisches Kunstverein.
1834		Visit to Friedrich's studio by David D'Angers.
1835	26 June	Suffers a stroke.
	August	Able to take a six weeks cure in Teplitz after Tsar Nicolas I had bought a group of his pictures. Owing to ill health now works mainly in sepia and water colour.
1838		Exhibits last works – a selection of drawings – at the Dresden Academy.
1840	7 May	Dies in Dresden.
	10 May	Buried in the Trinity Cemetery, Dresden.

List of Lenders

Nationalgalerie, BERLIN (West) 65, 66, 67, 76, 77, 103, 113
Staatliche Schlösser und Gärten, Schloss Charlottenburg, BERLIN (West) 38, 51, 68, 69
Staatliche Museen, Kupferstichkabinett und Sammlung der Zeichnungen, BERLIN (GDR)
 36, 75, 101
Private Collection, BIELEFELD 43
Kunsthalle, BREMEN 90
Wallraf-Richartz Museum, COLOGNE 13, 64, 93, 105
Library of Her Majesty Queen Margrethe II, Queen of Denmark, COPENHAGEN 109,
Royal Museum of Fine Arts, COPENHAGEN 4
Schloss Cappenberg, Museum für Kunst und Kulturgeschichte der Stadt DORTMUND
 40, 95
Staatliche Kunstsammlungen, Gemäldegalerie Neue Meister, DRESDEN 31, 32, 33, 37
 58, 91, 94, 98, 100, 116, 118, 121, 123, 124, 125
Staatliche Kunstsammlungen, Kupferstich-Kabinett, DRESDEN 10, 11, 12, 21, 22, 23,
 35, 87, 88, 106
Kunstmuseum, DÜSSELDORF 117, 119
Freies Deutches Hochstift, Goethemuseum, FRANKFURT 59, 97
Museum der Stadt, GREIFSWALD 5
Kunsthalle, HAMBURG 1, 2, 15, 27, 70, 74, 78–86, 92, 107, 111
Niedersächsisches Landesmuseum, HANOVER 56, 60–63
Städtische Kunstsammlung, KARL-MARX-STADT 47
Kunsthalle zu KIEL 114
Gemäldegalerie der Stiftung Pommern, KIEL 50
Museum der Bildenden Künste, LEIPZIG 9, 89, 99, 102, 110, 112
Städtische Kunsthalle, MANNHEIM 3, 16, 44, 45, 73
Sammlung Winterstein, MUNICH 14, 96
Germanisches Nationalmuseum, NUREMBURG 53
Stadtmuseen, NUREMBURG 126
Nasjonalgalleriet, OSLO 7, 8, 28, 49, 104, 115, 120, 122
Visitors of the Ashmolean Museum, University of OXFORD 19, 20
Staatliche Schlösser und Gärten, POTSDAM-SANSOUCCI 42, 48
Národní Galerie, PRAGUE 71
Staatliches Museum Heidecksburg, RUDOLSTADT 34
Sammlung Georg Schäfer, SCHWEINFURT 46, 52, 54, 55
Staatliches Museum, SCHWERIN 39
Staatsgalerie, STUTTGART 41
Staatsgalerie, Graphisches Sammlung, STUTTGART 6
Albertina, VIENNA 18, 26
Kunsthistorisches Museum, Neue Galerie, VIENNA 29, 30
Schlossmuseum, Kunstsammlungen zu WEIMAR 17, 24, 25, 72, 108
Familie Bührle, ZURICH 57